The World's Top Photographers

Photojournalism

A RotoVision Book

Published and distributed by RotoVision SA
Route Suisse 9
CH-1295 Mies
Switzerland

RotoVision SA
Sales and Editorial Office
Sheridan House, 114 Western Road
Hove BN3 1DD, UK

Tel: +44 (0)1273 72 72 68
Fax: +44 (0)1273 72 72 69
www.rotovision.com

10 9 8 7 6 5 4 3 2 1

ISBN-10: 2-940378-05-3
ISBN-13: 978-2-940378-05-0

Art Director Tony Seddon
Design by Lanaway

Reprographics in Singapore by ProVision Pte.
Tel: +65 6334 7720
Fax: +65 6334 7721

Printed in Singapore by Craft Print International Limited

The World's Top Photographers

and the stories behind their greatest images

Photojournalism

Contents

Introduction

...of an iconic image. Perhaps one from the illustrious world of fashion; maybe they will remember a famous face; or there's a good chance it will be a well-known commercial photograph.

But ask yourself this: which photographs carry the most important messages? What are the images that make you raise questions about the way our planet is governed? Which pictures have the power to change your perception of the world?

There is bloodshed and genocide, pollution levels are rising dramatically, the polar ice caps are melting, species are being driven to extinction… yet few seem to care because it does not affect their daily lives. The sad fact is that many look at these events as detached voyeurs, often blaming the messengers for the message they bring. We don't like what we see, so we ignore it.

But it is these messengers, these photojournalists who are some of the world's greatest and most unique photographers, who are surely in the most fortunate position of all. It is they who

...cameras that we can see, smell, hear, touch, think, and perhaps reconsider.

This book showcases the work of 30 unique people who, in my opinion, genuinely merit the description "World's Top" to an international audience. Here, they discuss their careers and working methods, and, importantly, offer readers a critical appraisal of their landmark images to date.

Regardless of subject—some happy, some devastatingly sad and poignant—the photographs in this book are a celebration. Collectively they capture voices from all over our amazing world, with different styles from different cultures, offering events that generate both the lightest and deepest of human emotions.

These pictures and the people who took them serve as a catalyst that stirs our awareness, intelligence, and, above all, conscience. The photographs throughout this book are cross section samples of the state of our wonderful and ever evolving planet. The world really is your oyster.

ANDY STEEL

Korem Camp,
Ethiopia, 1984 *(right)*
David Burnett

Melaboh, Indonesia,
2005 *(bottom)*
Dan Chung

Inlandsis, Greenland,
1995 *(below)*
Carsten Peter

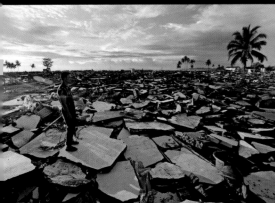

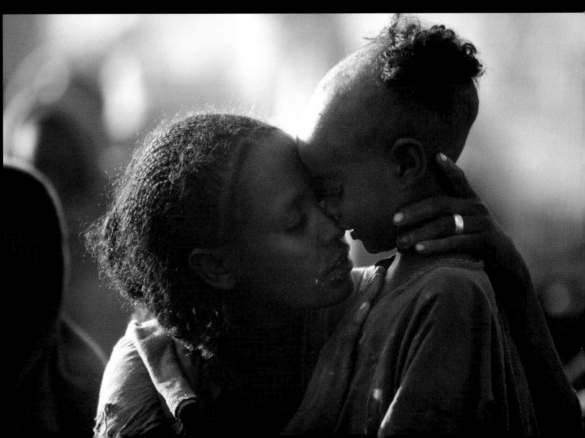

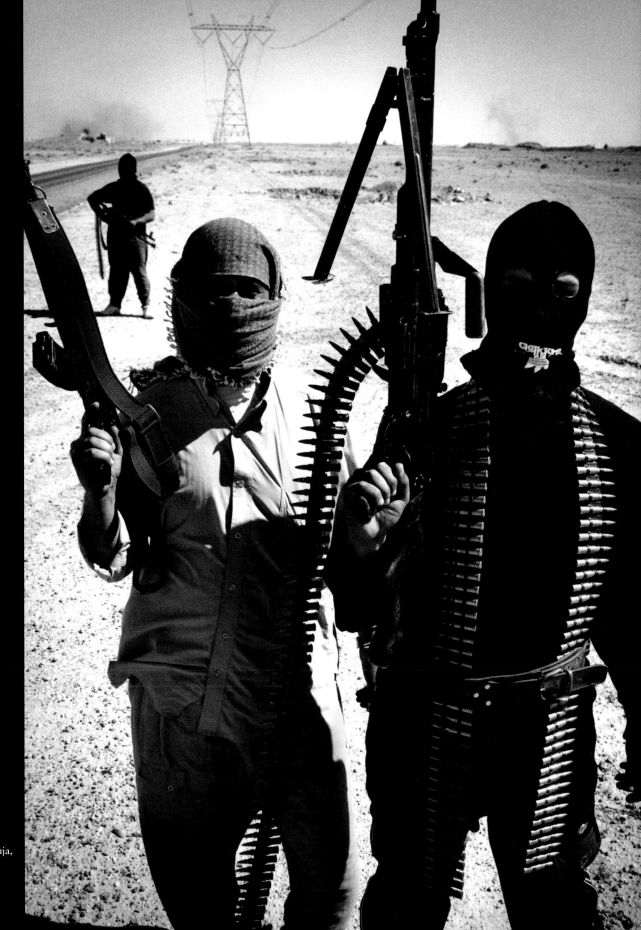

In the desert near Falluja,
Iraq, April 2004
Paolo Woods

Eve Arnold

A legend in her own illustrious lifetime, American photojournalist Eve Arnold was the first woman to work as a photographer for the famous Magnum Photos agency, and hitherto one of only five to do so.

Her humble beginnings (she was one of nine children, born in 1913, to Russian-Jewish immigrants) gave her personality a sympathetic edge that enabled her to exploit the character of her subjects better than most. Her upbringing also developed her renowned empathy for those suffering from poverty.

She is best known for her benevolent, intimate images of actress Marilyn Monroe on the set of Monroe's 1961 movie *The Misfits*. The famous actress trusted Arnold more than any other photographer. "She was going places but she hadn't arrived," Arnold recalled. "It became a bond between us… Marilyn was very important in my career and I think I was helpful in hers."

Due to Arnold's fresh approach toward her subjects and protective nature of them after a shoot, she is famed for her ability to capture a closeness that is not easy for other photographers to grasp.

For many, however, Arnold's best international work encompasses her photographs of the likes of Queen Elizabeth II, Malcolm X, and Joan Crawford. She has also traveled extensively, photographing in China, Russia, South Africa, and Afghanistan.

Her success is all the more impressive since she had virtually no formal training in the art of photography, apart from a six week course at the New School for Social Research, in New York, which she entered in 1952.

Her teacher, however, was the legendary Alexey Brodovitch, the then art director of *Harper's Bazaar*. With his encouragement, Arnold embarked on a career as a photographer at a time when magazine photojournalism in America was at its height—but also at its most sexist. She commented at the time: "I didn't want to be a woman photographer… that would limit me. I wanted to be a photographer who was a woman."

In 1954, Arnold's fresh quality and intelligent choice of subject matter brought her to the attention of Robert Capa, the head of Magnum Photos, the prestigious international cooperative for photographers. Capa invited her to join the group and she became its first American female member. Her mastery of the color processes and techniques, popular in the 1950s, was extensive and assured, although she always preferred the impact and charisma of black and white.

Within a few years, Arnold had become the star photographer for *LIFE* magazine during its heyday, capturing untouchable public figures such as Senator Joseph McCarthy and General Eisenhower at revealingly unguarded moments.

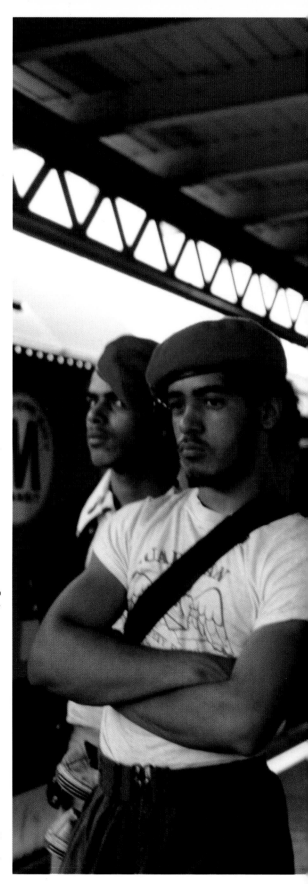

Guardian Angels, Bronx, New York, US, 1984
The Guardian Angels made a name for themselves by working with street gangs and fending off muggers in New York's busy subway during the 1980s.

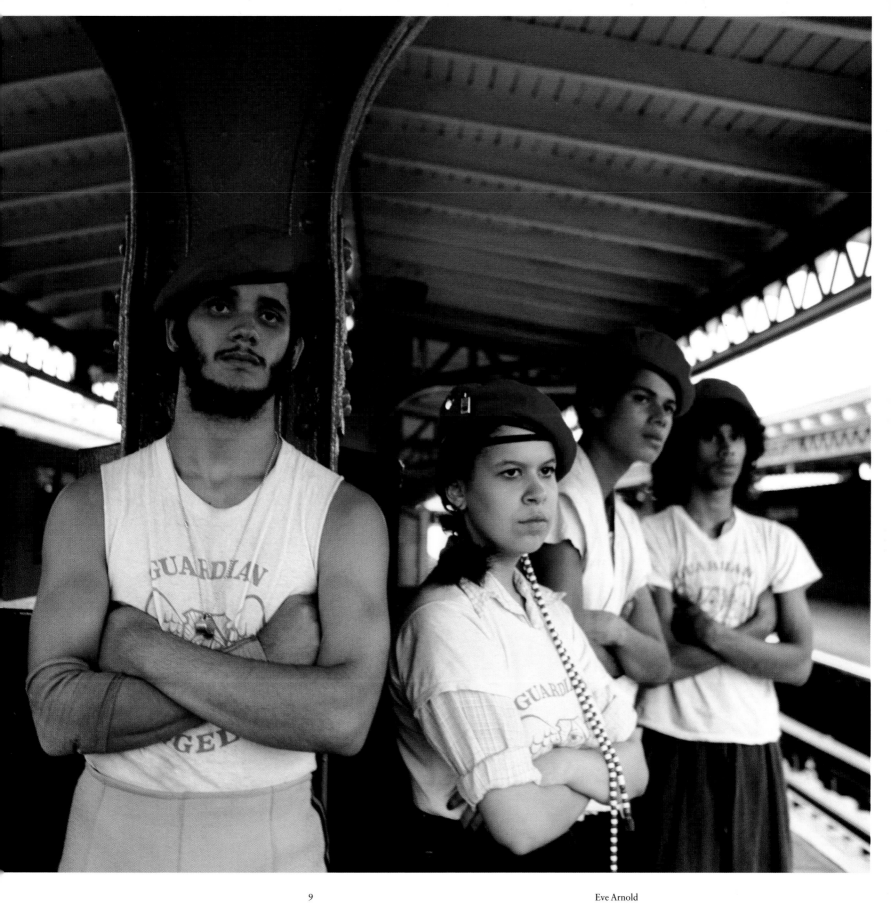

9

Eve Arnold

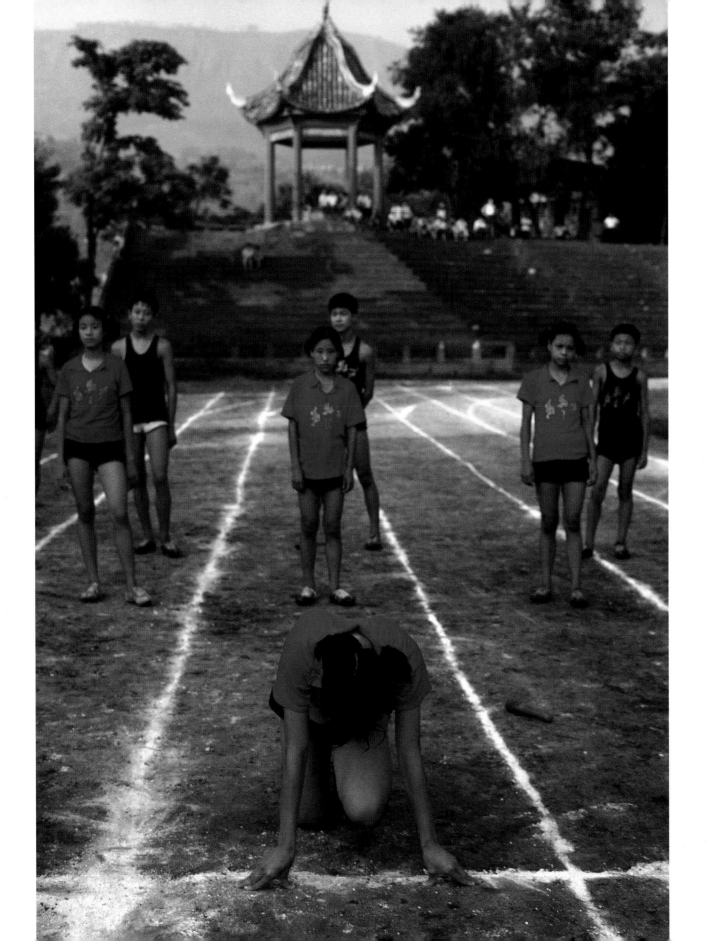

She also took great pleasure in capturing with her camera the lives of ordinary people, exploring such themes as birth, family, tragedy, and racial prejudice.

In the early 1960s Arnold moved to England for her son's education, and to work on the newly launched *Sunday Times* color magazine. In addition to photographing statesmen and celebrities, she also made a photographic record of the status of women around the world.

Following her photography throughout China, she landed the first major solo exhibition of her China work at the Brooklyn Museum, New York, in 1980. In the same year, she received the National Book Award for her book *In China* and was awarded the Lifetime Achievement Award from the American Society of Magazine Photographers.

In 1995, she was made a Fellow of the Royal Photographic Society (FRPS) and was elected Master Photographer, the world's most prestigious photographic honor, awarded by New York's International Center of Photography.

She was the recipient of the Kraszna-Krausz Book Award for her book *In Retrospect*, in 1996, then, in 1997, received an Honorary Degree of Doctor of Science from the University of St. Andrews, UK, an Honorary Degree of Doctor of Letters from Staffordshire University, UK, as well as the degree Doctor of Humanities from Richmond, the American International University in London. In the same year, she was appointed a member of the Advisory Committee of the prestigious National Museum of Photography, Film, and Television in Bradford, UK. She has published 11 books.

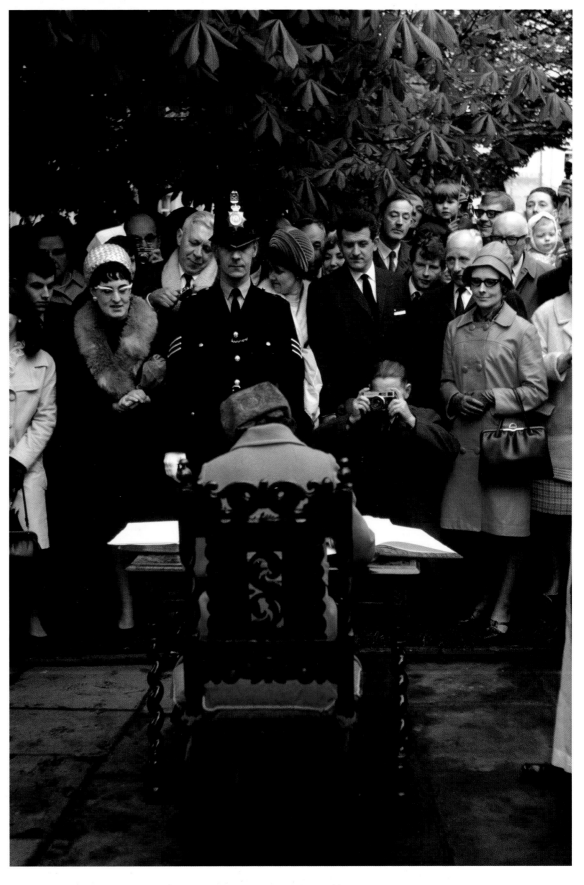

Wan-hsien, China, 1979
Young athletes competing. Athletes throughout the 1970s and 1980s became thrilling new subjects as photographers caught them in motion, while, in China, poor parents would literally beg coaches to take their children.

Cheshire, England, 1968
A policeman stands guard as the British public lines up in front of Queen Elizabeth II.

Eve Arnold

Patrick Brown

Patrick Brown didn't plan to become a photojournalist. He fell into it by chance.

"Originally, I was a set builder for theater and dance companies, and it was here I first started using a camera to photograph dancers. In hindsight, it was most probably the best schooling for photography I've had.

"Things changed dramatically when I became very ill a few years ago and a surgeon called Dr. Robert Weedon saved my life," Brown recalls. "A few months down the line, I was reading an article about the same surgeon and I ended up following him to Malawi, Africa, selling my surfboard and car to help fund the trip." Brown spent six weeks documenting Weedon's work, sparking off a "totally different direction" in his photographic career—and in his lifestyle.

His images became a major exhibition in Australia, raising thousands of dollars for charity and winning him the Australian Kodak Photographer of the Year Award.

Brown, who was born in Sheffield, England, and grew up traveling around the world with his family, finally ended up in Perth, western Australia.

He is now based in Bangkok, Thailand, mainly producing documentary photography and photo essays. His most recent work focuses on the border regions of Thailand, dealing mainly with social and political issues.

"I couldn't survive in Perth—it's one of the most isolated cities in the world," he admits. "Becoming the kind of photographer I am wasn't a conscious decision but one which gradually evolved. But I have always had this travel bug that I had to get out of my system."

Throughout his days photographing dancers, Brown developed a taste for life and movement that has influenced his photography ever since. "I like to capture the immediacy of a situation," he says. "I'm lucky because I can do my own projects and it's always been my aim to be in complete control of my own images."

Brown's photographic forays along the rugged Thai–Burmese border—he has been based in Thailand since 1999—have sparked an enduring fascination with the jungles of Asia and the events and issues surrounding them.

Among other worldwide publications, his images have appeared in *The Observer*, *The Independent*, *Time*, and *Der Spiegel*. He has also received a World Press Photo Picture of the Year Award and a 3P Foundation Grant for his project on the wildlife trade in Asia.

"I don't tune my work so that it appeals to the widest possible audience," he underlines, "because if I did, then I might as well shoot garden chairs. When I'm behind the lens, I try to photograph for myself and no one else. And I can't photograph with a commercial element in mind because I won't get the shots that I went to get in the first place."

Brown's photographic style is not drawn by headline news; he prefers instead to document social issues that aren't perhaps most obvious to people in the West. "I don't like to follow crowds. It's not my character. But I like the fact that my photography shows me so many different walks of life and gives me a passport to meet so many interesting people. I enjoy going to places others wouldn't dream of going. That's my job: to tell a visual story with a difference."

Ranong, Thai–Burmese border
The flesh trade is flourishing along the border, where prostitution runs alongside decades of poverty and military conflict. These two sex workers, from upcountry Burma, prepare for the evening ahead in the south Thailand border town of Ranong, both under house arrest until they pay their debts to the mamasan who runs the brothel. The HIV rate in this region is extremely high, estimated at a shocking 30 to 40 percent of the general population.

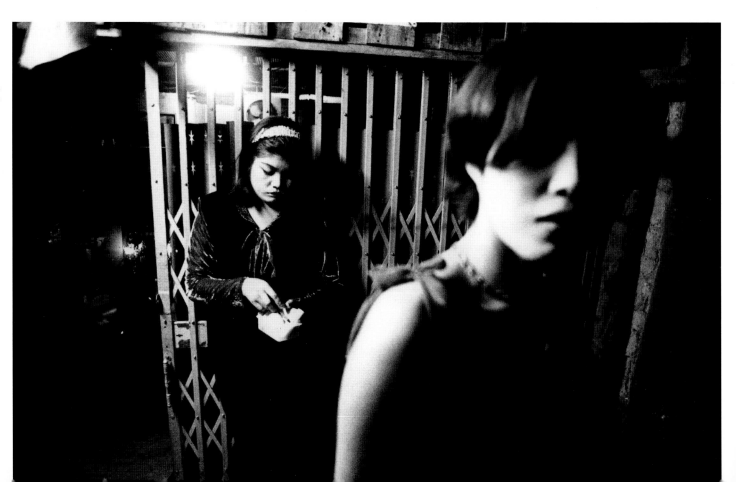

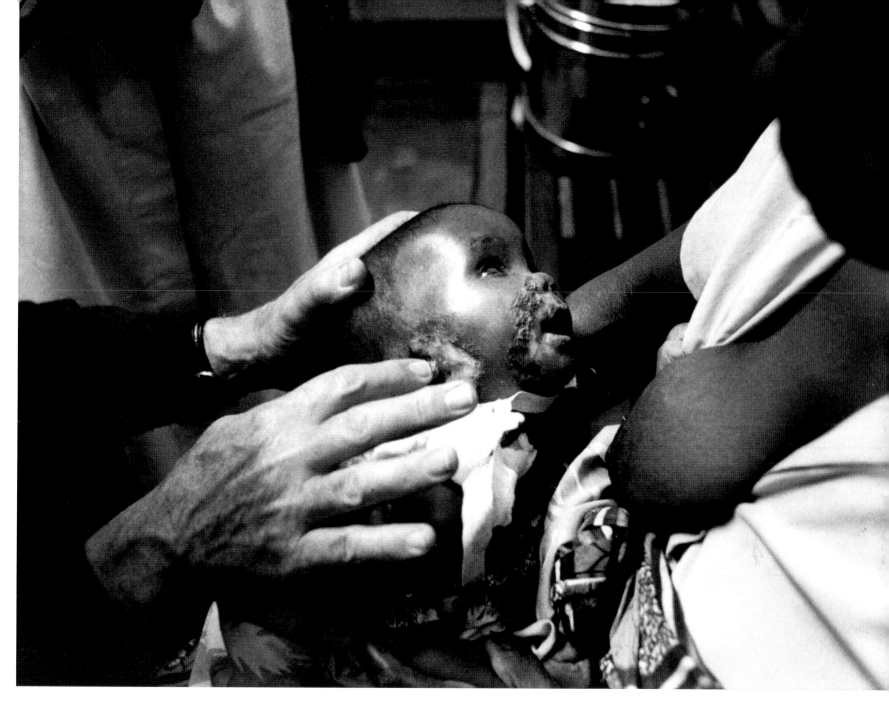

Brown's kit bag consists of two Nikon FM2s and a Rolleiflex. He likes to shoot in low-light conditions, without flash, with short focal lengths to get as close to his subjects as possible. "Shooting this way gives my images movement," he stresses, "so I can demonstrate a bit of life. Shooting handheld in the later hours of the day gives me the type of light I like to work with best. I'm not so concerned with the mechanics and technique of photography, but more with the emotion that photography can capture."

His images have been shown at the Reportage photo festival in Sydney and Melbourne, Australia, the Tokyo Metropolitan Museum of Photography, Japan, FotoFreo in Perth, Australia, and Visa Pour l'Image in Perpignan, France. He is currently working on a book about the pan-Asian trafficking of endangered wildlife, journeying from the jungles of Assam to the chaotic mega cities of China.

"Ultimately," says Brown, "the West is so consumed with itself that it looks at the world through rose-colored glasses. It doesn't want to be confronted by all the things happening elsewhere. I want to help alter that perspective, and photography enables me to do that."

Zomba, Malawi, 1994
Australian surgeon Dr. Robert Weedon performs demanding and desperately needed medical work at a time of great change—notably, the end of "President for Life" Hastings Banda's notorious 28-year rule (1966–1994). Based in the town of Zomba, Dr. Weedon was the only Western-trained surgeon for some 2.5 million people.

Patrick Brown

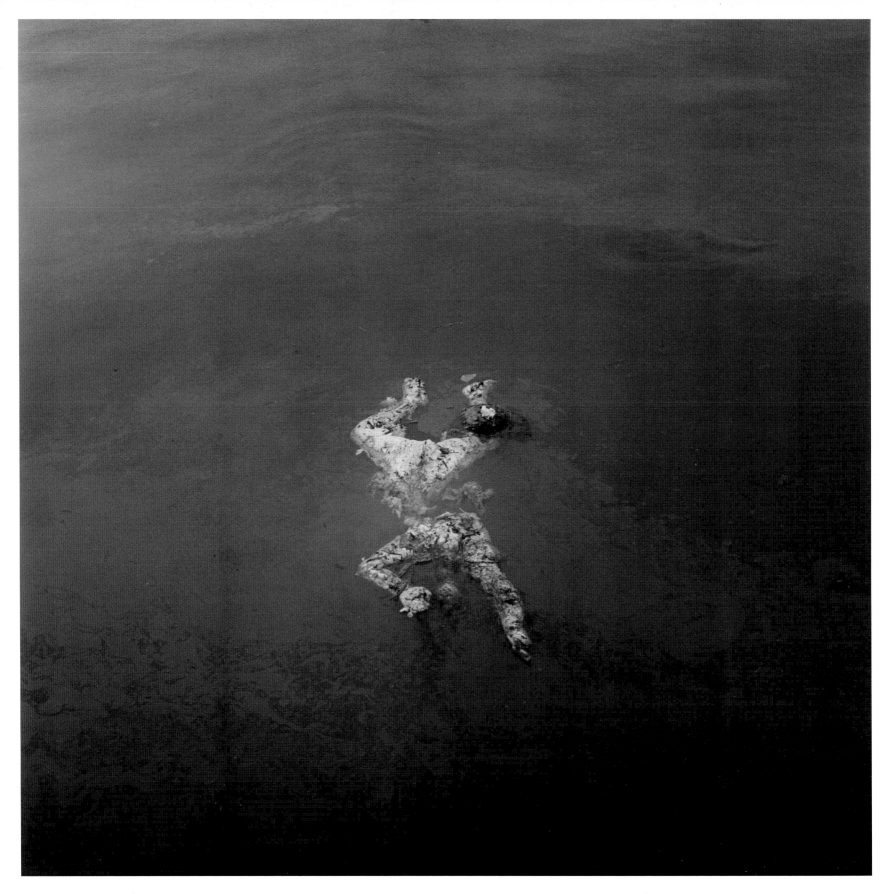

Kaziranga, India, 2003
A woman cries after being arrested for possession of two rhino horns that her brother and husband had poached two days earlier from Kaziranga National Park, India. She is crying because her Muslim husband has just divorced her by repeating "I divorce you" three times, in front of a male witness, who was her brother. The only evidence linking the two men to the crime is their association with the woman, so by divorcing her, the two men are likely to receive only a light punishment. The woman, in contrast, faces the death penalty.

Scotland Yard's animal protection unit, London, UK, 2005 *(right)*
An officer displays a tiger's head seized during a nearby raid in London.

Banda Aceh, Indonesia, 2005 *(left)*
The decomposing, headless body of a child floats in a canal following the tsunami. Two weeks after the wave hit Banda Aceh, recovery teams were still pulling out an incredible 3,000 bodies each day.

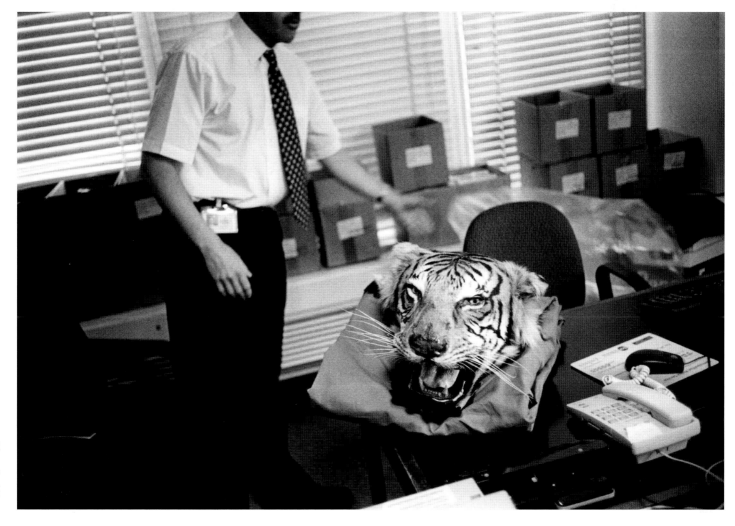

Patrick Brown

David Burnett

For more than three decades, veteran photojournalist David Burnett has been the eyes of the world, taking pictures of the famous and the infamous, documenting war, famine, grief, and joy.

Burnett remembers his first photos: "I started taking pictures for my high school year book. Finding out how to take pictures was a real discovery for me."

His lucky break came when he went to New York as a third year college student and was hired by *Time* magazine: "During the summer of 1967, I managed to get 11 pictures published and that really got me motivated."

He graduated from Colorado College in 1968 with a BA in Political Science and began working freelance for *Time*, and later *LIFE* magazine, at first in Washington DC, and then in Miami.

No one individual has recorded history with the same distinguished variety: Burnett has photographed Olympians in victory and in the agony of defeat. He's covered the Indo–Pakistani war, the Iranian revolution, and the fall of Salvador Allende in Chile. He's photographed the late Pope John Paul II, US presidents Kennedy, Johnson, Nixon, Ford, Reagan, Carter, Clinton, and Bush; Cuba's Castro; Russia's Brezhnev, Gorbachev, and Yeltsin; Iran's Khomeini; Microsoft's Bill Gates; and Intel's Andy Grove; as well as fashion models, movie stars, and royalty.

His career-defining body of work, however, came about in Vietnam when he was sent there in 1970 while shooting for *LIFE*. Burnett recalls: "I was 24, fearless, and I needed to be where the big story was. It was then I realized the power of photography. Upon my return to the US, the work of photojournalists in Vietnam had created this feeling that it was proper to be suspicious of what people in government were trying to tell you."

Burnett remains surprisingly philosophical after witnessing so much poignancy during his two years in Vietnam: "I came to this agreement with myself that I was there as a photographer. I was not there as a diplomat, a nurse, a teacher, or anything else. There was no real reason for me to be there if I was not going to be shooting pictures. I made that decision before I arrived in Vietnam and I stuck with it."

He says he would still not choose to work in any other genre, such as fashion or commercial photography. "Making money is important but, for me, the idea of chasing a picture for a unique story is more fulfilling, especially when it comes off. I'm happy to take recommendations from people, but I have the final say on how the images and feel of the work are interpreted."

In 1975, Burnett cofounded Contact Press Images, in New York, and since then he has traveled extensively, working for

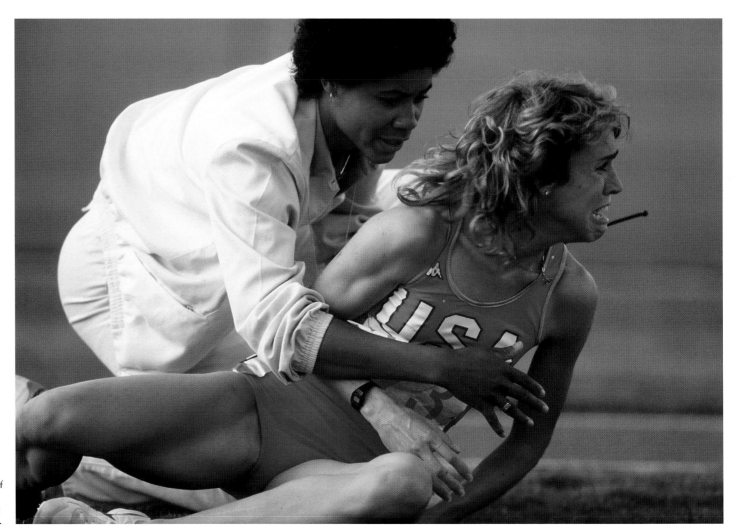

Olympic Games, Los Angeles, US, 1984
The US favorite for gold, Mary Decker, falls following an encounter with British rival Zola Budd, during the climax of the 3,000 meter women's final. People today are still divided as to whose fault the accident was.

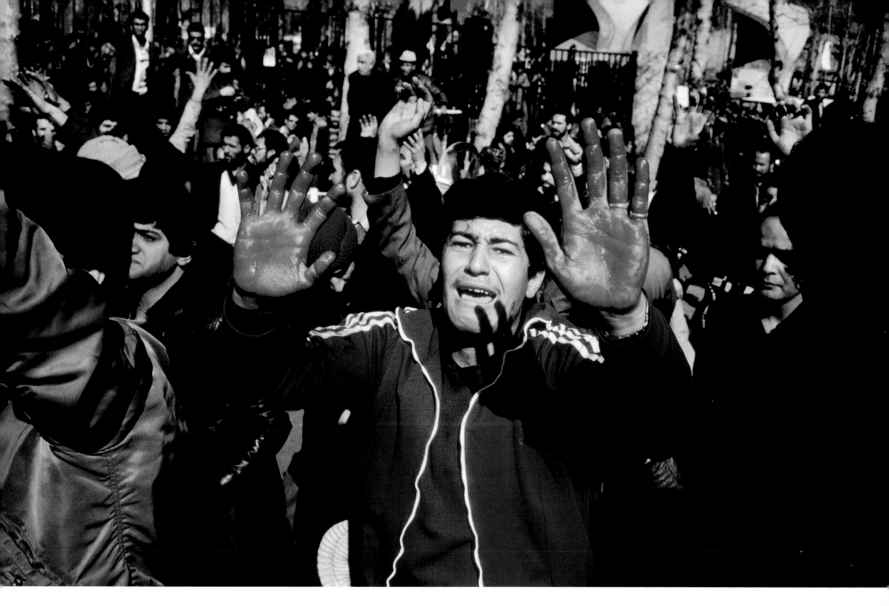

Tehran, Iran, January 1979
An anti-Shah demonstrator covers his hands with the blood of a fallen martyr the day before the return of Ayatollah Khomeini to Tehran.

most of the major photographic and general-interest magazines throughout the US and Europe. He has also worked on major advertising campaigns, including projects for the Union Bank of Switzerland, Kodak, Rolex, Merck, and the US Army.

He has swept all the major contests, winning (among numerous others) the Overseas Press Club Award for Best Photo Reporting from Abroad, in addition to the Premier Award in the 1980 World Press Competition for a photograph at a Thai nursing camp. His news photos go beyond merely documenting the events: "They interpret the mood."

Nowadays, Burnett works with no less tenacity, although he is, by his own admission, "taking a few less risks." He admits: "I've kind of stopped going to places where teenage kids carry machine guns. I've been there and I've photographed those things. I've got a family, I've got other things to do, and I want to stay away from that. My thought process as a photojournalist during my twenties and thirties was very different to what it is now. I am a better photographer than I am a businessman, but I'm enjoying getting better at that part, too."

One has to respect his sentiments, especially when you consider some of his close encounters with death. "Every story has its moments," recalls Burnett. "I was arrested in Chile after the coup back in the 1970s. I was with a bunch of friends and we were driven from a cemetery where Salvador Allende was buried by the cops. They put coats over our heads and I had to endure the most unpleasant of interrogation circumstances. I wasn't actually tortured, but I could hear other people being less fortunate. I realized then, as I realize now, just how close it all was. I certainly don't wish to repeat the experience."

17 David Burnett

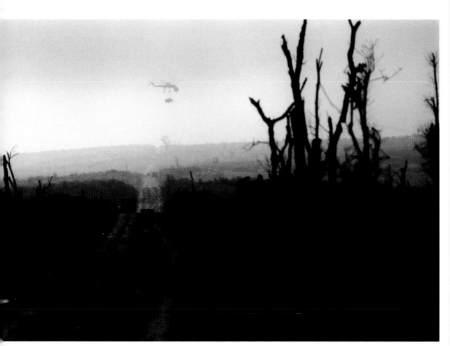

Khe Sahn, Vietnam, February 1971 *(above)*
A US helicopter lifts cargo to a base near the Laotian border during the invasion of Laos, part of a joint US/South Vietnamese effort to prevent supplies coming via the Ho Chi Minh trail to the North Vietnamese Army (NVA). Says Burnett: "The operation ended up costing the US a lot more than they actually got out of it."

Korem Camp, Ethiopia, November 1984 *(right)*
Burnett uses his camera to demonstrate to the Western world the widespread famine and starvation throughout northeast Africa. He reflects: "It's still happening today, even though the West continues to generate more and more wealth."

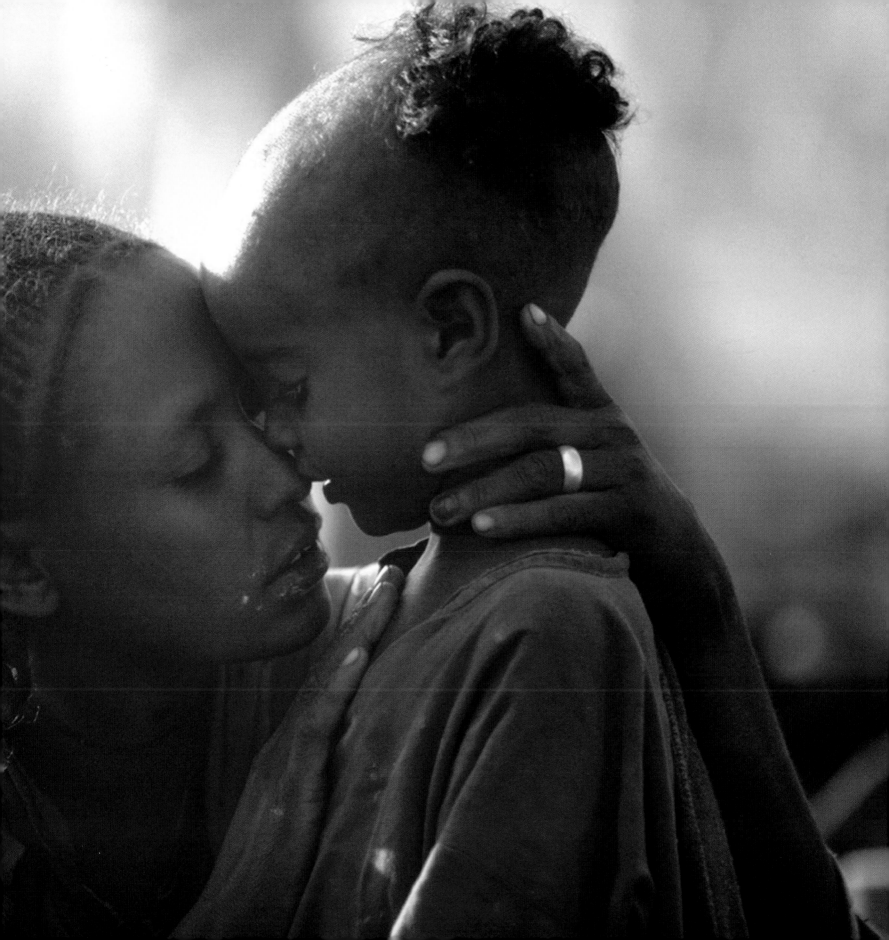

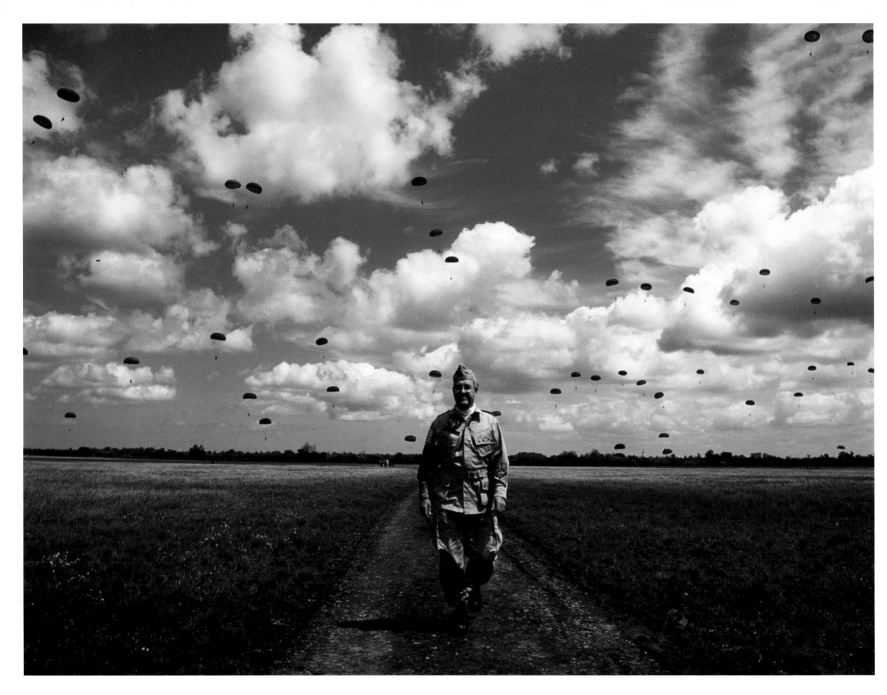

Sainte Mère l'Eglise, Normandy, France, June 1994
101st Airborne paratroop battalion veteran Bob Williams on the 50th anniversary of D-Day. Williams leaves the landing field after recreating the jump he made 50 years earlier, while a sea of paratroopers fills the sky behind him.

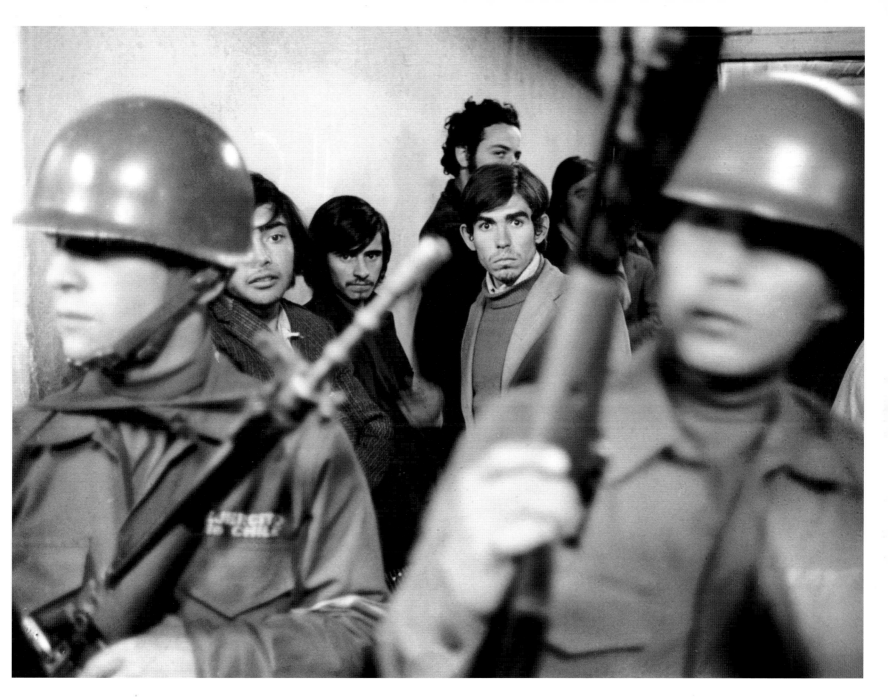

Chile, 1973
The government had been
overthrown two weeks before this
image was taken. Burnett recalls:
"I was on the aircraft which had
the first group of journalists to be
allowed into Chile following the
coup. Prisoners were being kept at
the National Football Stadium and
the authorities were reluctant for
journalists to take pictures. But
during this brief moment, when the
guards were looking elsewhere,
I managed to get this shot."

David Burnett

Larry Burrows

Larry Burrows was the photojournalist who became famous for his harrowing pictures of the US involvement in the Vietnam War.

Only WWII combat photographer W. Eugene Smith has risked his life as much to be the eyes and ears of many.

Such was his intrepid approach to camera work, that Burrows died with fellow photojournalists Henri Huet, Kent Potter, and Keisaburo Shimamoto, while working for *LIFE* magazine during a US Army operation in Laos in 1971. He is especially well known for his charismatic photographs onboard a Huey UH-1 helicopter for his seminal series, "One Ride with Yankee Papa 13."

Burrows was born in London in 1926. He left school at 16 and got a job in *LIFE* magazine's London bureau, where he printed thousands of pictures by Robert Capa, among others. It would be hard to exaggerate the effect this apprenticeship had on his subsequent career. Capa practically invented the genre of combat photography and defined the standards by which it would be judged. "If your pictures aren't good enough," he declared, "that's because you're not close enough."

To his colleagues, Burrows quickly became known as either the bravest man in Vietnam or the most short sighted. He fell into the habit of edging right up to death and yet managed to maintain his patience and calm in a world of frenzy.

He was also meticulous in his technique, obsessed with producing strong, technically perfect images, seen to dramatic effect in a black and white photograph published in *LIFE* in April 1965. Burrows was photographing a marine helicopter squadron gunner, 21-year-old James C. Farley, when the squad came under heavy fire from Viet Cong forces. One of the helicopters went down and the helicopter Burrows was on landed nearby, attempting to rescue the injured crew. By the time they were airborne again, two badly wounded men were sprawled on the floor of the helicopter. One of them died, but what makes the photograph of this event astonishing is the ability Burrows had to keep focused on Farley, capturing the full horror and emotion through his lens as the scene unfolded.

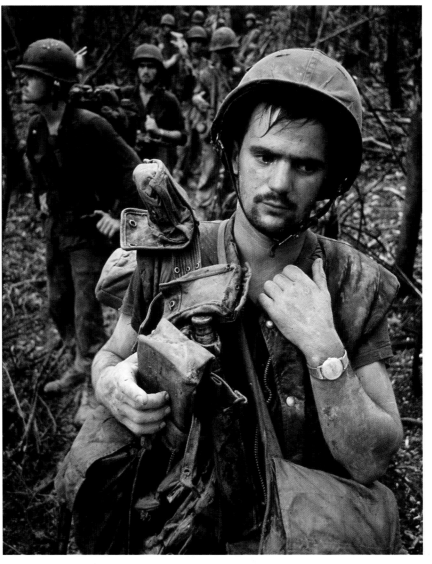

Demilitarized zone, Vietnam, 1966 *(left)*
A dirty and exhausted US marine on patrol with his platoon on the dividing line between South and North Vietnam, known as the "DMZ."

Da Nang, Vietnam, 1965 *(right)*
Helicopter squadron gunner chief James C. Farley with jammed machine gun, shouting to his crew, as fatally wounded pilot James E. Magel lies beside him.

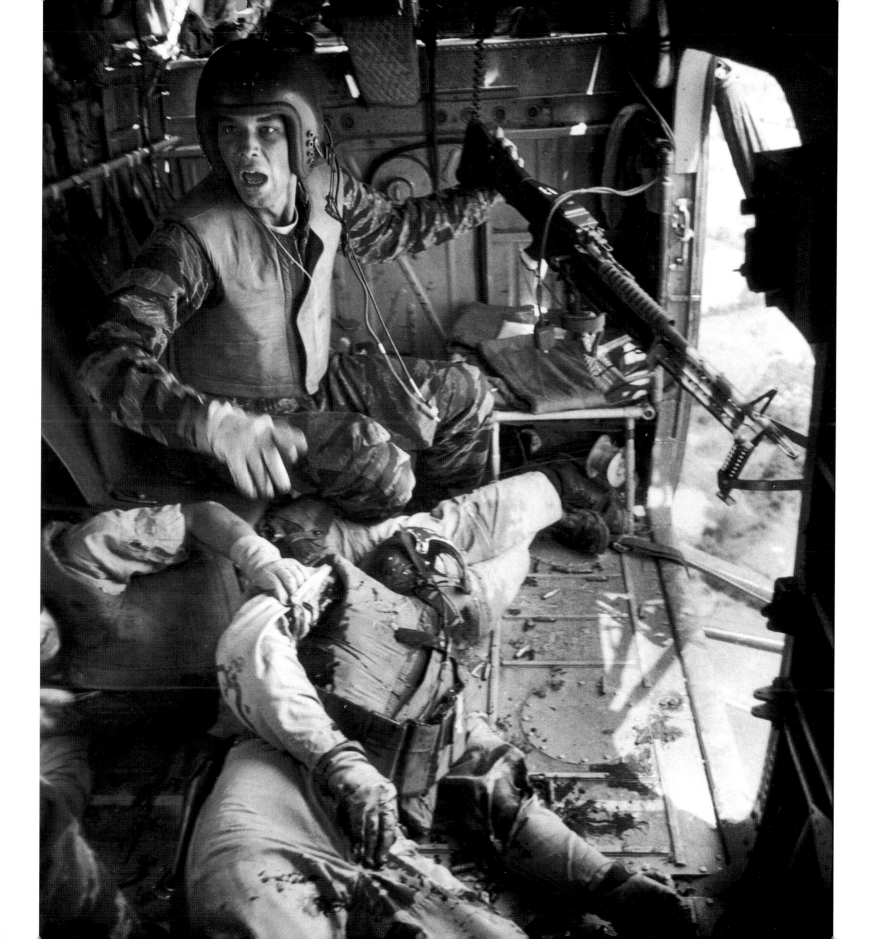

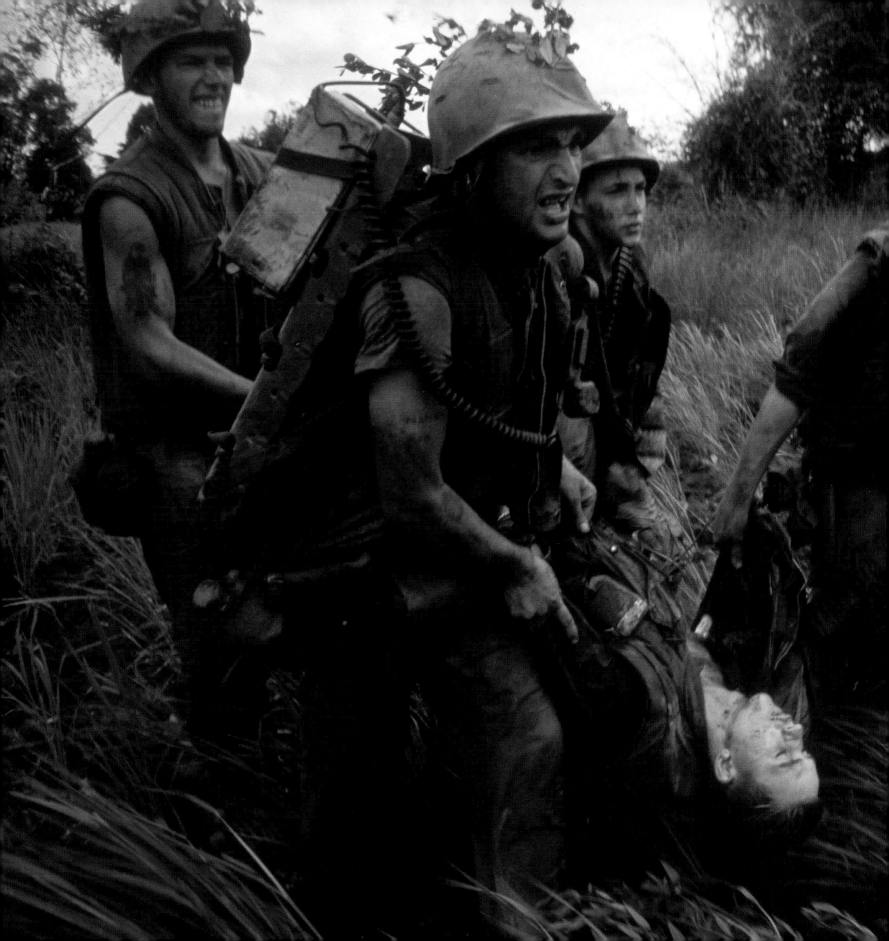

Such was Burrows' involvement and commitment to the Indo-China conflict that he became, in many ways, a frontline soldier. He once commented that, "The faces all over Vietnam look more tired and dazed than I have ever known." Indeed, in Roger Mattingly's well known 1971 portrait, that fatigue is etched into Burrows' face. He looks exactly like one of the combat-numbed soldiers he had so often pictured, demonstrating how the gap between the photographer and his subjects was shrinking, lethally.

Burrows has always been praised for his humanity and compassion, but what really sets him apart is his ability to photograph suffering and death with such technique and accurate composition. He is a legend because of his skills as an artist, as well as the traits he had in common with his frontline subjects.

Although Burrows will always be recognized as one of history's preeminent war photojournalists—with his trademark spectacles and camera around his neck—he also took pride in revealing the beauty of life, from the architectural wonders of the Taj Mahal to the eccentricities of British humor.

He was a three time winner of the Overseas Press Club's Robert Capa Gold Medal Award for "superlative photography requiring exceptional courage and enterprise." Among his many other accolades, Burrows was also named the Magazine Photographer of the Year in 1967 by the National Press Photographers' Association (NPPA).

He repeatedly took photographs of wounded men being helped by their comrades, even when they were themselves wounded. It seems Burrows was drawn to such scenes because they dramatized an ethical dilemma so vividly as to effectively resolve it. One might say he literally gave his life to help warn others of the dangers of war.

With combat reporting around the world so different now from what it was during the war in Indo-China, one wonders whether the likes of Burrows' photojournalism will ever be seen again.

Dong Ha, Vietnam, 1966
Marines recover the body of a comrade while under fire during the Vietnam conflict, with photojournalist Catherine LeRoy in the rear.

Larry Burrows

Dan Chung

Dan Chung, *The Guardian* staff photographer, is internationally respected for his captivating press images, having won the Nikon Press Awards in 2002 and earned the prestigious accolade of Photographer of the Year at the Guildhall Picture Editors' Awards in 2004.

"I started taking pictures at about 12 and my passion has never stuttered," reflects Chung. "My father was a keen photographer and he's had a pretty strong influence on me—it was my main hobby at school and subsequently at university."

While studying geography, Chung took time out from college in 1992 to photograph the election campaign of former UK Liberal Democrat party leader Paddy Ashdown, after which he decided to make a career in photojournalism.

"I think press photography is really a job for people who are passionate about news. The money is pretty good, but there are other ways to make a living that are far less dangerous. I don't really get paid differently to many people I went to university with, who ended up choosing much safer careers."

Chung turned professional in 1993 when he joined the *Derby Telegraph* as a trainee, and his work has evolved to the point where he has become one of the world's most respected photojournalists. Is it fair to say that, like many other successful photographers, Chung has had a lucky break? "If I'm honest, I'd have to say yes," says Chung, "because when I first started out I was assigned to cover an event at [amusement park] Alton Towers, when a man in shorts carrying a young child came up to me and asked: 'Who are you and what types of pictures do you like to shoot?' He turned out to be the then picture editor of *The Times*, and he offered me several weeks of work experience and a front-page image. I would never have landed my first local news agency job without this bit of luck."

As most leading photojournalists will point out, successful photography is about a combination of many factors, and being close to the action is just one of them. Not only do they have to be in the right place at the right time, but they also need the right camera, lens, composition, lighting, and the means to get the pictures back to their publication in time for deadlines.

"Luck is also a factor," stresses Chung, who has worked for news agency Reuters. "But, as my boss says: 'You make your own luck.' With experience, though, you learn to increase the odds in your favor."

The Guardian assigns Chung on a day-to-day basis, so he never knows what's coming next, except for big sporting events such as the soccer World Cup. "I'm given a fairly free hand to shoot what I like on most assignments; I think my slightly 'sideways' outlook fits well with what the papers want. I'm a photojournalist, first and foremost, so it's important for me to capture the things I see. My responsibility is to record events in a truthful manner and to keep my audience interested."

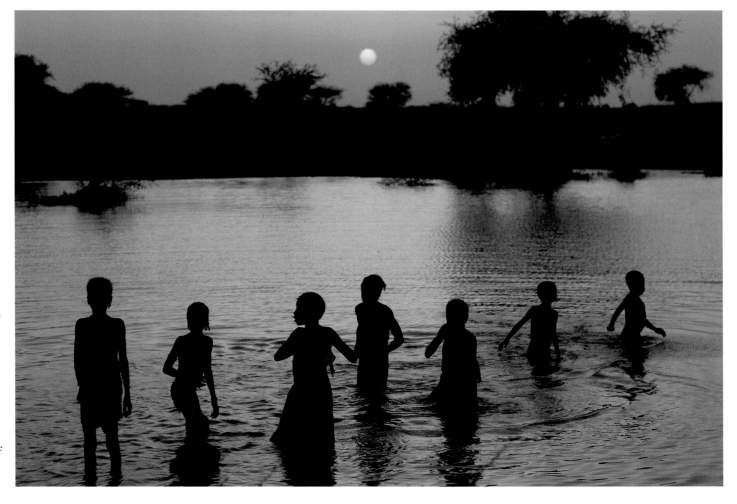

Tahoua, Niger, 2005
During the time Chung spent covering the famine in Niger, he visited the town of Tahoua and came across children playing in a pool of water at sunset. "It was strange to see the sight of apparently fit and playful children, when I had witnessed so many other children near to death in a feeding center only a few miles down the road. It seemed that there was food to buy, but that many people at the bottom of the economic ladder could not afford anything and were forced to starve."

Balakot, Kashmir, 2005
Men search for bodies in the rubble of a large building in Balakot, in the disputed region of Kashmir. This area was at the epicenter of the 2005 earthquake that is thought to have killed almost 90,000 people. A week after the earthquake, help from the international community was slow to arrive. Meanwhile, the local people continued to try to find survivors, often having to dig with their bare hands in the hope of finding the remains of friends and loved ones.

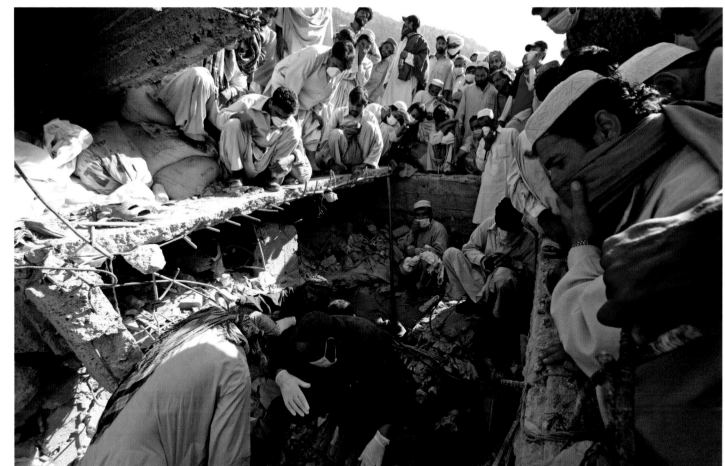

Muzaffarabad, Kashmir, 2005
In the aftermath of the earthquake, an injured girl lies on a trestle table, tended by poorly equipped medical staff in the makeshift hospital at Muzaffarabad's Neelum stadium in Pakistani-administered Kashmir. The hospital was staffed by the Pakistani Army and volunteers, who struggled to cope with the large numbers of injured people arriving hourly. The hospital had poor facilities and was dimly lit, with blood covering the floors. At one stage during a thunderstorm, doctors were forced to continue working and operating by candlelight.

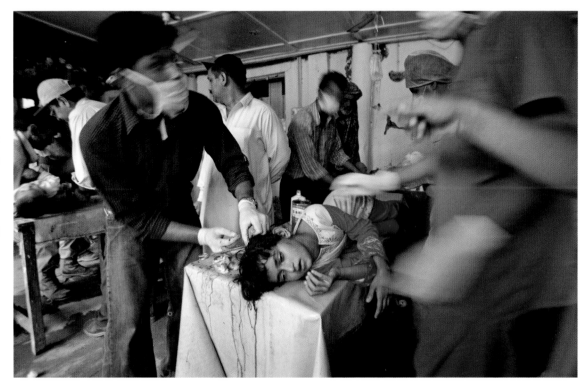

Dan Chung

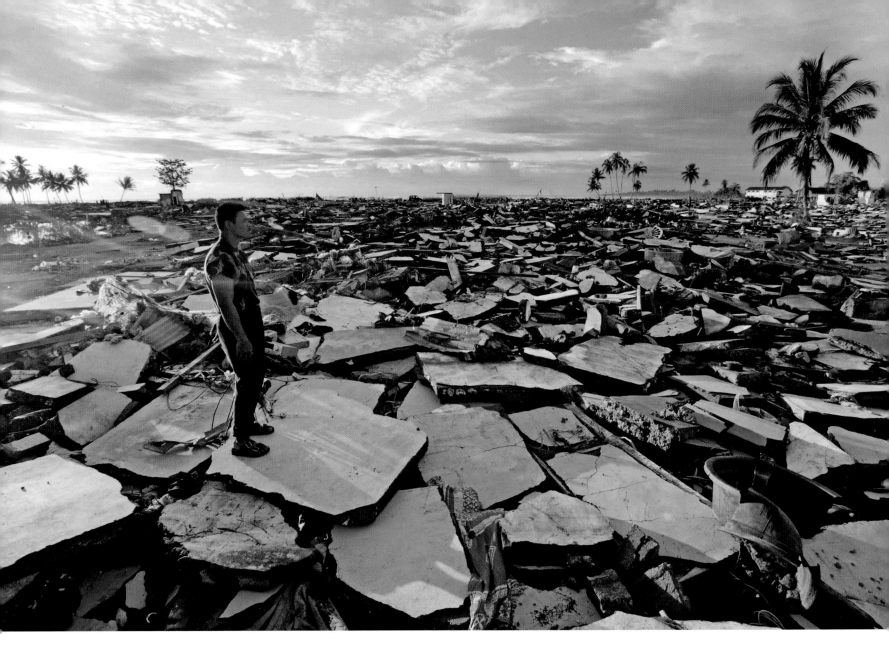

Melaboh, Indonesia, January 2005
On the waterfront in the town of Melaboh, an Indonesian man stands alone amid the devastation left behind by the 2004 tsunami. The brightly colored concrete slabs were all that remained of the waterfront buildings. After the disaster, it took Western journalists and aid workers over a week to reach this area because all roads in and out were impassable. The Indian Ocean tsunami killed 275,000 people (more than 168,000 in Indonesia alone), making the event the single worst natural disaster in recorded history.

Like most opportunistic news photographers, Chung likes to get close to his subjects and show the human side of people. Naturally, there are times when things can simply gel together in a picture, and this is precisely what he tries to capture. His photography, while fairly conventional, tends to use strong graphic lines and shapes that occur naturally when subjects move.

"I use a Canon EOS 1Ds Mark II," enthuses Chung, "because there's nothing else out there that's better right now. I can shoot full-frame digital images with excellent quality and still have great handling at the same time. Most photographers needing speed use Canon, and Canon really listens to what the photojournalists say." Of course, the camera would be nothing without lenses, and Chung carries focal lengths ranging from 15 to 500mm, which take care of just about every eventuality. "My favorite is the 135mm f2 unit—it's just so sharp! But I suppose my most-used lenses are my 16–35mm f2.8 and 50mm f1.4."

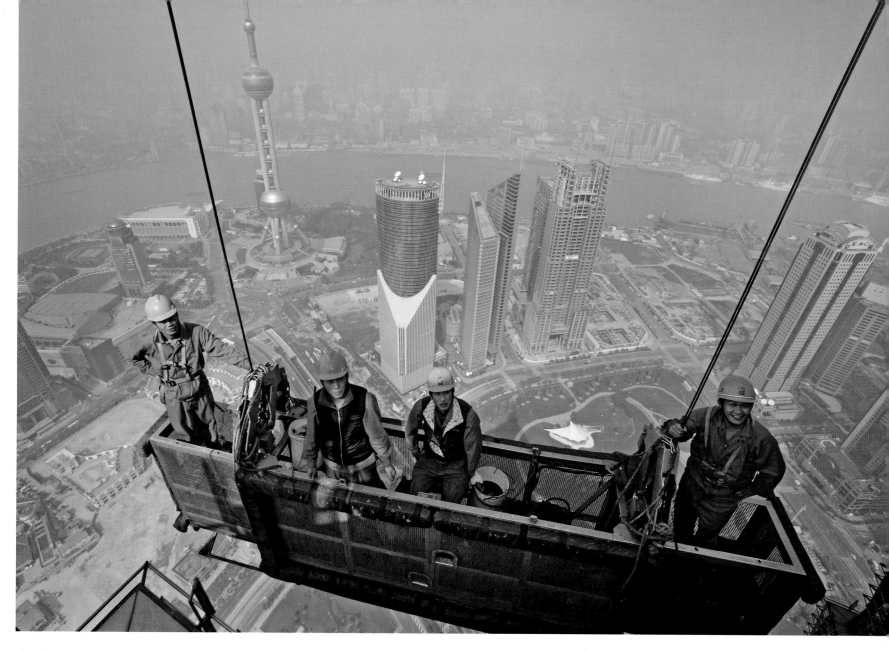

Shanghai, China, 2004
Window cleaners at the top of the Jin Mao Tower, the tallest building in Shanghai, and currently home to the Grand Hyatt Shanghai, the world's highest hotel. The 88-storey building is a symbol of Shanghai's economic success as China continues to develop rapidly in the 21st century. To get the photo, Chung had to lean intrepidly over the edge of the building, with one of the other window cleaners holding on to his belt to prevent him from falling over the edge.

Dan Chung

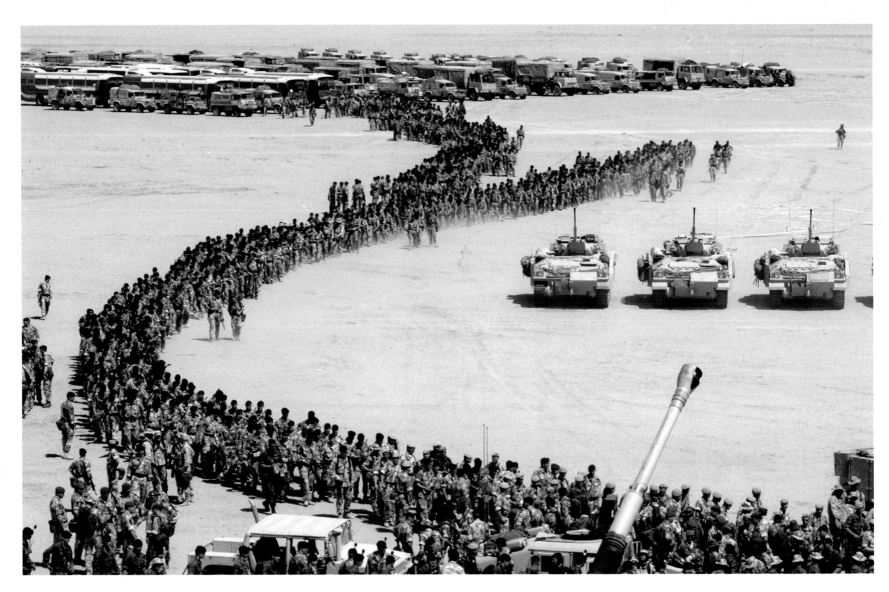

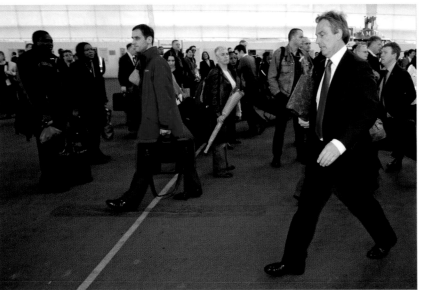

London, England, 2005
British Prime Minister Tony Blair walks through crowds of rail passengers at St. Pancras Station in London, as he dashes between different events during the frantic 2005 election campaign. In an election characterized by staged photo opportunities, it was one of the few occasions when the Prime Minister was seen to walk through a crowd of regular Britons.

Kuwait, 2003
Ahead of the start of the invasion of Iraq in 2003, the tanks and soldiers of Britain's 7th Armoured Brigade gather in the Kuwaiti desert for an address from American Lieutenant-General Jeff Conway, Commanding General of the 1st Marine Expeditionary Force.

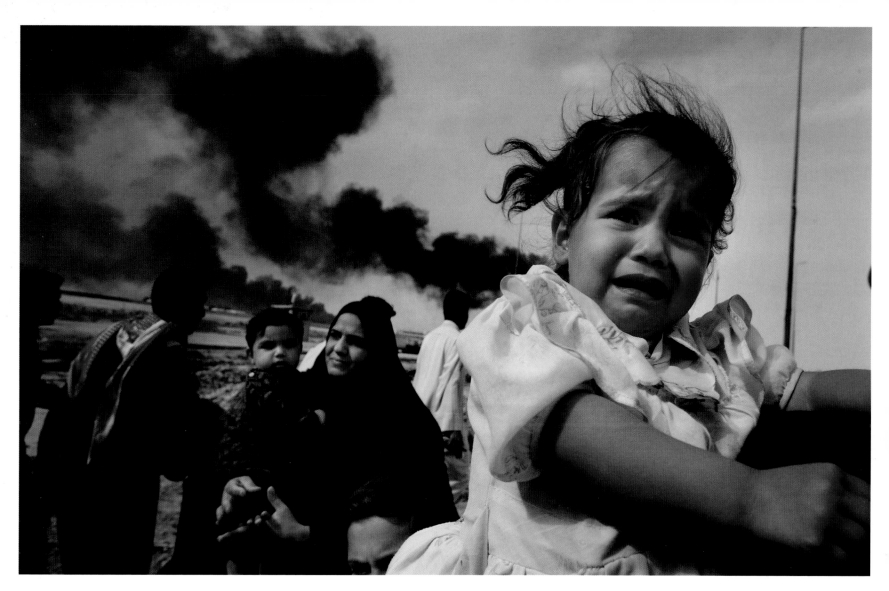

Basra, Iraq, 2003
A young girl is carried out from the city of Basra in southern Iraq during the second Gulf War, as oil fields burn in the background. Many families fled across one of the city's bridges, manned by British soldiers, in the days preceding its fall to coalition forces.

Because of the nature of his work, Chung finds some pictures more challenging than others. He says it's hardest to take pictures when people are showing deep sorrow after terrible tragedies. "After the [2005] earthquake in Pakistan, there were so many walking wounded and seriously injured people everywhere. It was extremely disturbing and I photographed a type of graphic injury on a scale that I had never encountered before. When recording this kind of event, you really have to try and switch off to complete your assignment.

"I once spent two days photographing a 10-year-old Iraqi girl in Basra who had had her leg blown off during a coalition bombing. She lost her mother and brother in the attack, and every time she talked about it, she burst into tears. I started taking a couple of frames, but then I stopped. The camera can only act so much as a barrier to my emotions."

Dan Chung

Arko Datta

Arko Datta was born in Delhi, India, in 1969 and was attracted to photography from an early age.

"I think I was about 10 when I developed a taste, even before I was a teenager," he recalls. "My mother bought me this Box Brownie camera [so-called after its designer, Frank Brownell] and I used to cycle for hours with this thing over my shoulder, photographing trees, buildings, and whatever I could find."

After graduating with a degree in economics, Datta undertook postgraduate study in journalism and mass communication before being offered a staff photographer's role at the *Indian Express* newspaper in Madras.

"I was lucky to meet the right people, who encouraged me to follow this path. Rasheeda Bhagat was my first boss and I really liked her right from the start. She allowed me to do a variety of photographic assignments and helped to fine-tune my shooting skills. I consider it lucky to have fulfilled my ambition with this kind of support."

Datta later joined AFP in Calcutta and then, in 2001, hit the big time with Reuters. In the course of his career, Datta has covered events ranging from the cricket World Cup and the Olympics to Mother Teresa's funeral and the separatist movement in Kashmir.

"It makes sense for me to document real life. This is what inspires me and, even though I can appreciate them, I have never been attracted to any other forms of photography like fashion or commercial work. I like doing things that are creative, and news photography in particular allows you to express your creativity on the one hand, but on the other it is also very relevant. Photojournalism is where creativity and relevance meet and that, to me, is very important."

Datta says current affairs and news *demand* to be photographed. Although it is essential for his work to be seen by the masses, it is also important for it to be seen by those in a position who can make a difference. "I get the first view of my photographs, so it's almost impossible for me to shoot with others in mind when a situation in which I react presents itself.

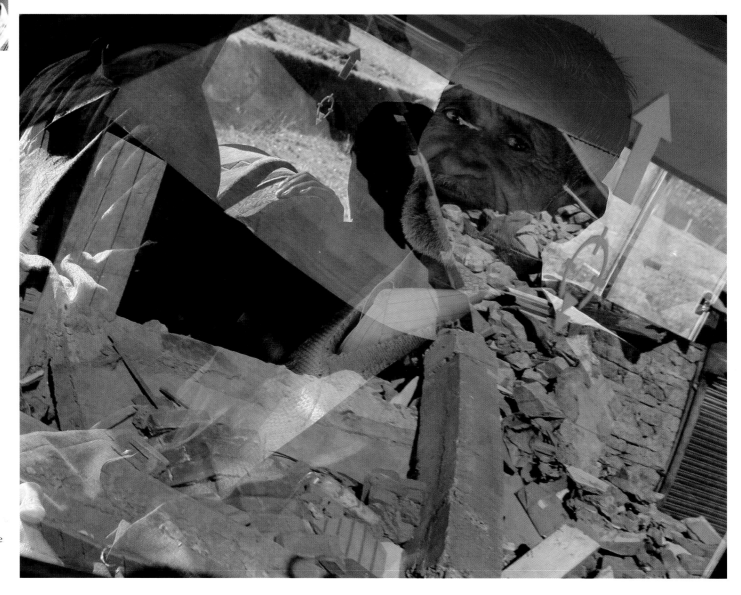

Tangdaar, Kashmir, October 2005
Reflection of rubble from a quake-destroyed house on a car window as an earthquake survivor looks out at the village of Tangdaar, in Indian-administered Kashmir.

Tikrit, Iraq, September 2003
The shadows of a US marine
and a detainee are cast on a wall
after an early morning raid by
the 1st Battalion (22nd
Regiment) of the fourth division
of the US army in Tikrit, about
110 miles (180 km) northwest
of Baghdad. US forces had
arrested four people during
raids on homes of suspected
Saddam Hussein loyalists.

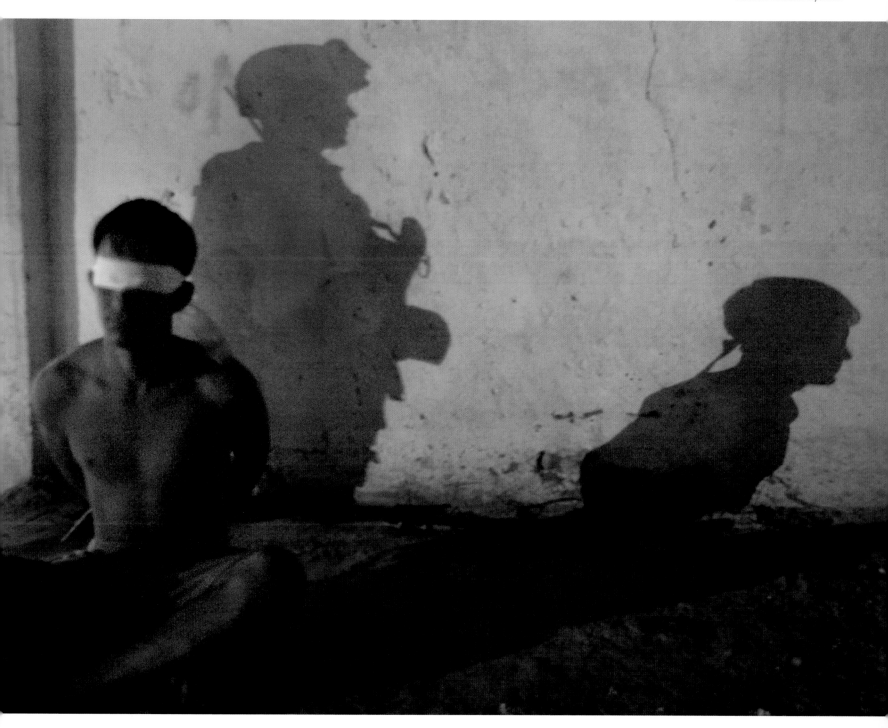

Arko Datta

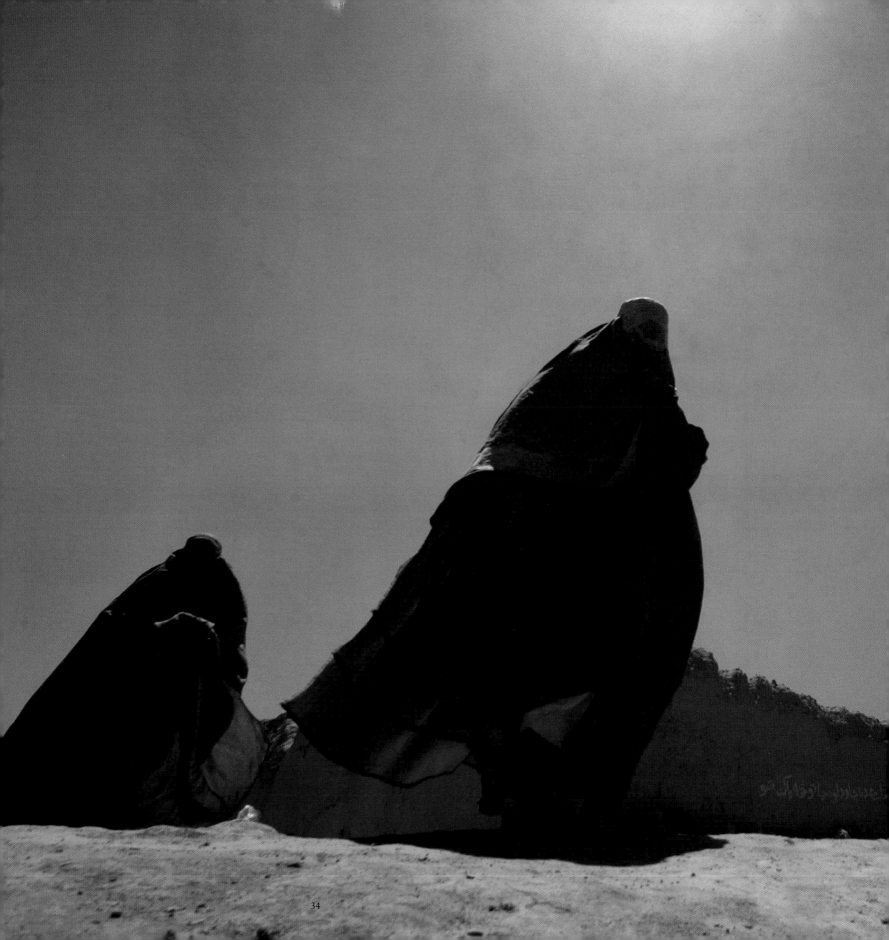

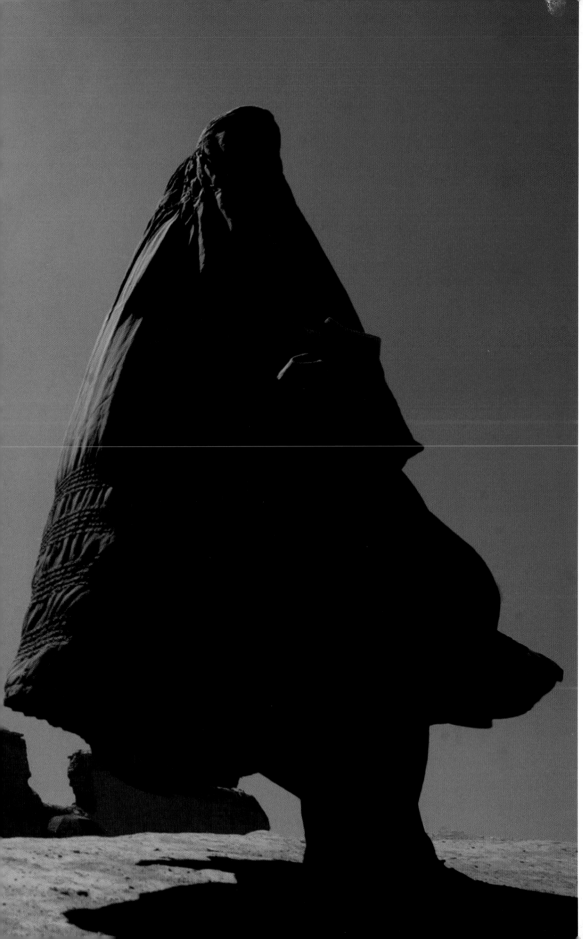

Because of where I have been and the things I have seen, if I think an image has impact, then I am confident others will feel the same way. I want to play my part in recording history."

Currently based in Mumbai in India, Datta has won numerous prizes and the Picture of the Year in Mumbai's annual photojournalism awards in 2004, two Publish Asia Awards, and the Best Photojournalist of the Year 2003 from *Asian Photography* magazine. Importantly, Reuters named him its Photographer of the Year for his work throughout 2004.

For all his achievements, Datta says he still finds the emotional aspect of his work very challenging. "One doesn't realize how one can be affected by these types of circumstances; things which used to be important to me aren't anymore. While covering all kinds of human tragedy over the years, one does learn, to a certain extent, to deal with them. But I do allow my camera to act as an emotional barrier. I try to keep my mind focused on my work, though it's easier said than done, especially while witnessing extreme devastation and misery. I'm a completely different man now from when I started out, and I have a different set of priorities."

The one particular event that changed Datta, he admits, was the communal riots that took place in Gujarat in India's Western Province, during 2002. "It was very shocking," he remembers with deep sadness. "Of course I have seen the devastation of the recent tsunami, but during this event hundreds of people— not soldiers but ordinary people—were killed right in front of me. I wanted to do something, but I was powerless and I hid behind my camera. I have since tried to reason with the whole event in my head, but I cannot. It haunts me to this day."

Datta says that many of the world's best photojournalists aren't necessarily the best photographers. "Of course their images have to be esthetically good," he underlines, "but often the best ones are those who can cope with the emotional side of what they see."

Like many within the trade, he practices his passion with Canon equipment. Despite the emotional circumstances that often surround him, Datta acknowledges that thinking about the technical side of his work, although second nature, can take his mind off things. "I say to myself: 'You've got a job to do,' and I'll begin to think of lenses, focal lengths, and shutter speeds. Sometimes it's the only way."

Kabul, Afghanistan, June 2003
War widows walk toward a queue for their monthly ration from CARE, an international humanitarian organization. According to CARE, there are at least 10,000 war widows in Kabul.

Arko Datta

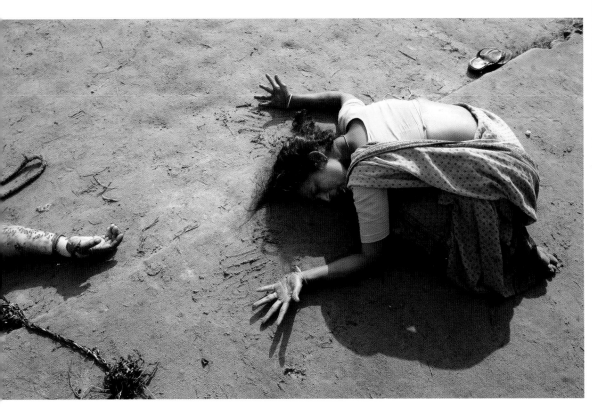

**Cuddalore, India,
December 2004**
An Indian woman mourns the
death of a relative who was
killed in the infamous tsunami,
some 110 miles (180 km) south
of the city of Madras.

**Nagapattinam, India,
January 2005**
An Indian tsunami survivor
and her daughter carry relief
provisions past debris and
destroyed houses being burned
by Indian workers in a fishing
hamlet 219 miles (350 km)
south of Madras.

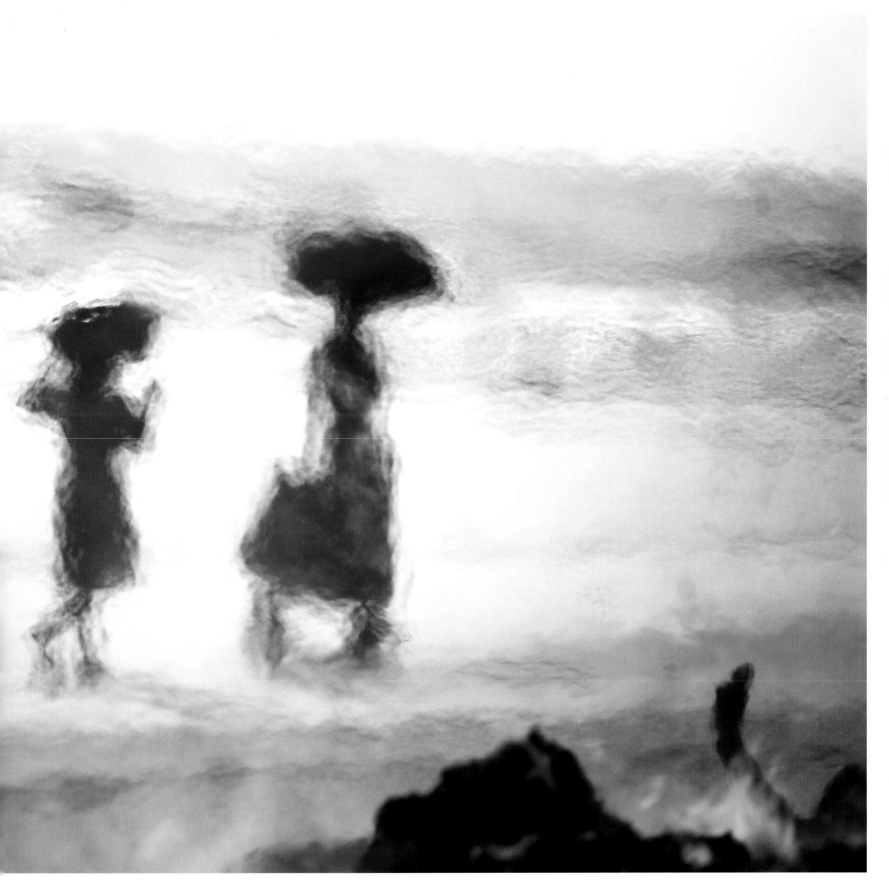

Arko Datta

Adrian Fisk

"My interest in photography began when I was quite young," recalls Adrian Fisk, "when I was traveling with a friend in 1991. I was doing some voluntary work in Bangladesh when this amazingly destructive cyclone hit the south of the country.

"My friend and I were mistaken as journalists because I was carrying a camera, and I had this clear moment in my mind that I wanted to travel and take photographs. I realized that a camera could be a passport into almost any situation."

Upon returning to the UK from his world travels in his early twenties, the Australian-born Briton made an important decision to study photography for three years at college in Blackpool, UK. "Even though the course had a fashion and advertising bias, I went in a photojournalist and I came out a photojournalist. I'm an outdoor kind of guy and I think I would feel frustrated if I was stuck in a studio most of the time."

Fisk's first paid assignment came in the form of a photo essay for the *Independent on Sunday*, to document the demise of London's traditional cafés in the mid-1990s. "It was actually a really exciting commission," remembers Fisk fondly, "and quite an important milestone in British society—just a couple of years later, I realized that four or five of the cafés I'd been photographing had disappeared. For me, it was a great thing to be involved in documenting such an important shift in British culture."

Fisk, whose first professional camera was a "trusty old" Canon F1, says the travel bug has been a huge motivation for his career as a reportage photographer. "I like exploration and I like discovering new places and things to photograph. The geography of the planet is huge and it seems to me as though not many [people] dedicate themselves to discovering what it has to offer.

"I generally shoot the things I want and people tend to employ me on the strength of my experience—if you're the type of photographer who waits for the ideal commission to fall into your lap then you could be waiting for a long time… I just like to get out there and press the shutter button."

Fisk says that if you initiate stories yourself, then you shoot with more freedom, and this is a vital part of evolving as a leading photojournalist. "If it's you who thinks of the idea for a picture in the first place, then you can play around with it a bit more, rather than having to stick to a brief. I think this is an important factor in becoming a good photographer. On the other hand, if you have a straight commission, then you're not going to experiment as much because you don't want to screw it up."

Like many pioneering photographers, Fisk believes that a good photojournalist is one whose work is capable of reaching the widest possible audience. He tries to speak to as many people as possible through his imagery.

"One of my concerns with photojournalism magazines is that they tend to be bought by photographers and journalists, which means that one hell of a lot of important images are communicating with the wrong audience. You're already speaking to an educated readership, when really it should be the public at large that you want to influence."

Even though Fisk travels a lot to Nepal, India is the place closest to his heart. He says that not only is the country one of the most interesting in the world, but the early part of the millennium is also the most exciting time to visit since its independence from Britain in 1947.

"India is at a point of mass change, particularly with its middle-class population of almost 250 million. It has one of the most amazing political scenes on the face of the planet and I just have to go there to document everything as it unfolds."

Fisk rates creativity as one of the most important motivating factors. He underlines that in news photography in particular, he can express his creativity, while also producing relevant photographs that carry a strong political message.

"On many occasions, I've found myself in the most unlikely situations with the most unlikely people. I feel extremely privileged because I get to see such an array of subject matter… In the past few months I've covered a range of subjects including illegal snake charmers, India's human hair trade, and I've been running around after bulls in fields. It is this unlikely variety that makes me love my job. On the other hand, though, I do spend many hours alone and it can be quite difficult to maintain momentum when I'm feeling tired."

In terms of the quality and uniqueness of his images, Fisk says a key aspect of his photography is to try and pull a main character or individual out from the frame, and to concentrate on that individual. "Generally, I like to shoot with a very shallow depth of field… it's important for me to think and conceive of my pictures in the way that the camera lens records them. I like to pull my characters out by keeping them sharp, while anything else in front or behind the main character is out of focus."

Fisk's equipment of choice is a Canon EOS 20D with a fixed 35mm lens. "Owning a digital SLR makes the work I do easier, while enabling me to experiment more than with film; I can just fire off the shots. I had my gear stolen a while back and I had to go back to using film for a couple of weeks, which proved a real pain. The 35mm lens I own—with the Canon camera I use—is equivalent to using a 50mm lens, so it frames a scene at the same focal length as the eye. Personally, I really like the continuity of shooting at a consistent focal length. That point where everything you want comes into the frame… That is what I am always striving for, and it is rare that I am perfectly happy with my pictures."

Like any good photojournalist, Fisk says it can be difficult to switch off when confronted with an emotional scenario. "I do find extremely harrowing scenes quite difficult, because I am human. Sometimes I feel intrusive because I'm sticking my camera into what is often a very private moment. Frankly, I would be very surprised if any photographer said they were capable of completely switching off.

"Throughout my career—particularly soon after leaving college—I think I've lost some important shots because sometimes I haven't had the ability to shove my camera into a situation which feels wrong."

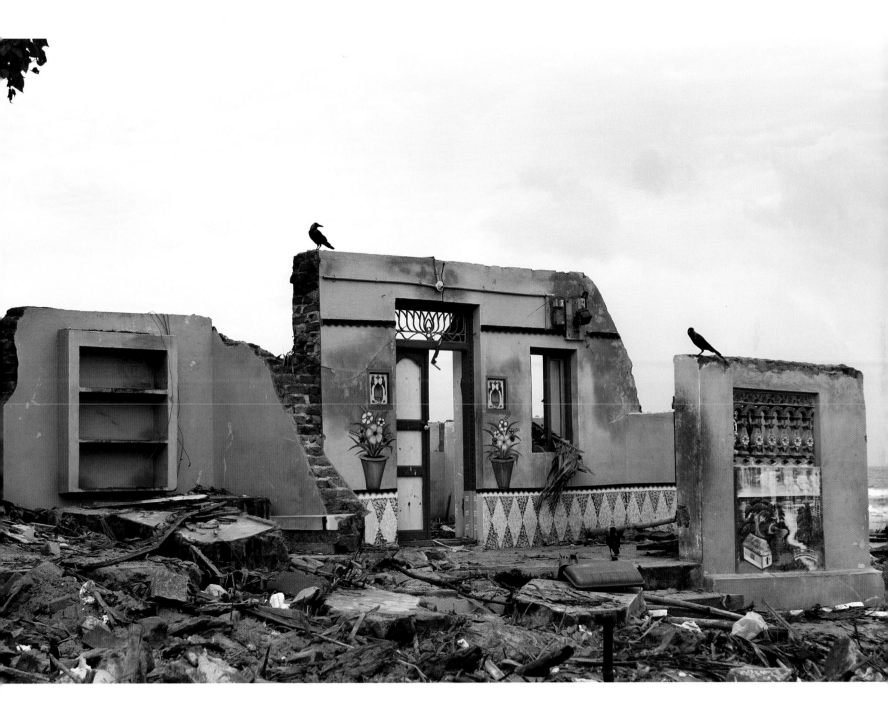

Nagapattinam, India, 2005
The 2004 tsunami destroyed the seafront of the small town of Nagapattinam in south India; in this area alone, 7,000 people were killed. Fisk wanted to shoot an image that showed how one day the seafront was an area of bustling happiness and the next a devastated landscape, void of human life. While walking on the beach, he saw this house and thought that so much care had gone into the beautifully painted flower pots that they enhanced the chaos that surrounded everything. "The crows appeared like [harbingers] of death while the sea seemed strangely calm and innocent," he says. Shot with Canon EOS 20D, $^{1}/_{160}$ sec at f/4.5.

Adrian Fisk

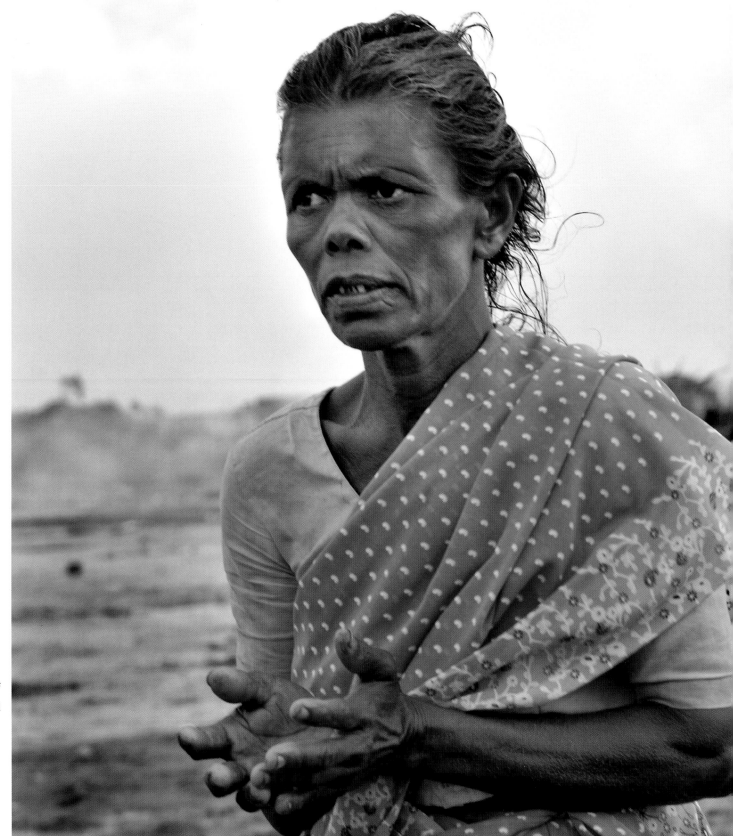

Nagapattinam, India, 2005
Sixty-year-old Janaki survived the tsunami in 2004, but 12 of her family did not. Her husband, two sons, two daughters-in-law and five grandchildren were all killed. "A week after the tsunami hit Nagapattinam, I found Janaki walking around in a horrified daze, such was the extreme devastation to the area," says Fisk. "She couldn't find the remains of her home and was in a severe state of shock looking for members of her family. In the background the body collectors are searching through a wrecked home. They were to find a pregnant woman, her husband, and two small children. To make sure I get the picture I want, I usually shoot several frames of any given situation, but on this occasion Janaki's face was a living embodiment of the horror that surrounded her. One shot was all that was needed." Shot with Canon EOS 20D, $1/160$ sec at f/4.5.

Adrian Fisk

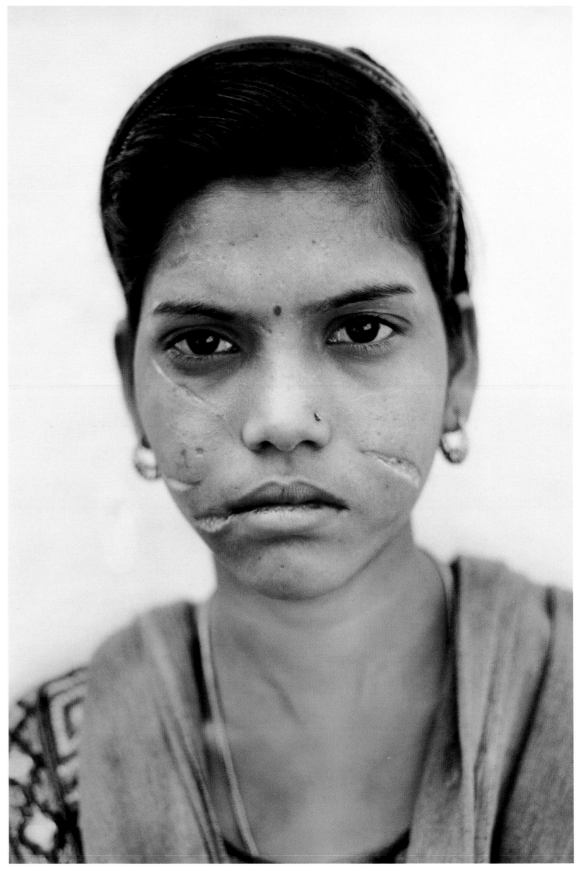

Gwalior, India, November 2000
Fisk wanted to capture an image that reflected the terrible dowry abuse that was taking place in India. At the time when this photo was taken, the official statistics for Indian women being murdered because they were unable to meet their in-laws' dowry demands was put at 5,200 a year.

Fisk says: "The hardest part of the story was getting women who had been attacked to come forward and be photographed. I was in a police station specifically for women in a town called Gwalior in central India when 19-year-old Alka Dahori walked in, asking for police protection. She had been forcibly married to a criminal family and was refusing to meet their dowry demands, which included a scooter, a color television, and several hundred pounds in cash. Earlier in the year, Alka's husband, incited by his mother, had attacked Alka's face with a razor blade because of her refusal to meet their dowry demands.

"Her story was tragic and she would have to carry those scars for the rest of her life, for no other reason than her in-laws' petty greed. I was deeply moved by her strength and her desire to try and carry on with life. As I photographed her, I saw in her eyes not only a grim determination, but also the great pain and anguish she had suffered. She left the police station disguised. The day before, her husband had gone to her parents' house and said he was going to kill them as well as Alka." Shot with Canon F1n, $\frac{1}{250}$ sec at f/1.8.

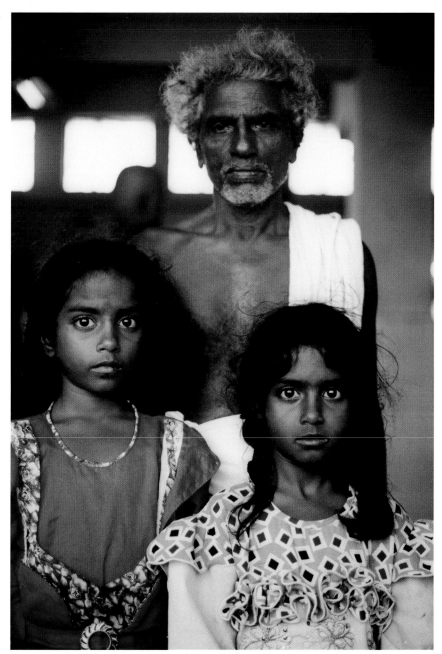

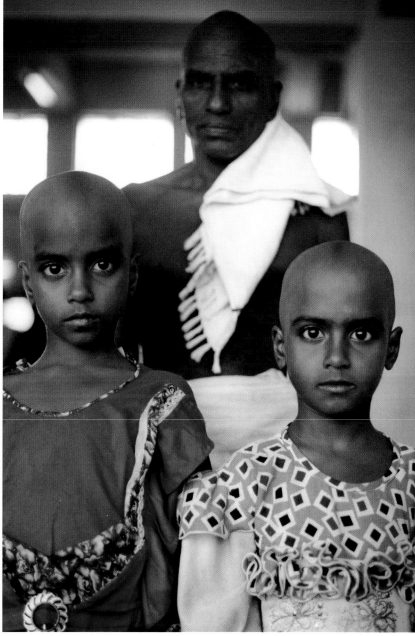

Baliji temple, India, 2000
The human hair trade in India is a multimillion dollar business. Much of the hair is used for wig-making in the West, and the best of this hair comes from south Indian temples. The most famous is the Baliji temple a few hours north of Madras. It is the most extraordinary place: each day, thousands of pilgrims make their way up the long hill to the temple and then sacrifice their hair to the Hindu temple deity. "I thought the most effective way of showing this," recalls Fisk, "was to show a before and after shot of a family, but the problem was I was not allowed to shoot in the hair-cutting hall. I knew the only way to get the shot I wanted was to sneak in and hang around, trying to make myself understood in what I wanted. People didn't understand and I wasn't able to find them once their hair had been cut. In the end, it took a stressful two days before I managed to get these pictures of this farmer and his two young children. To date, this is the longest time I have ever spent on a photograph." Shot with Canon F1n, $1/120$ sec at f/2.8 and $1/60$ sec at f/1.8.

Adrian Fisk

Newbury, England, 1996

The UK's road protest movement had reached its pinnacle, with what became known as the "third battle of Newbury." The British government had embarked on a mass road-building plan to try and ease the congestion being caused by the steady increase of cars across the UK. The 9 mile (14.5 km) Newbury bypass was hugely controversial and thousands protested against it, many taking to living in trees that were on the proposed route.

Fisk remembers: "Police would arrive each morning in a different area and try to remove protestors so that contractors could carry out clearance work. They made hundreds of arrests, many arbitrary. The [man] in the picture looks resigned to his fate, but in fact he's plotting his escape—just a few minutes after this photo was taken, he managed to get free and run off." Shot with Canon F1n, $^1/_{125}$ sec at f/5.6

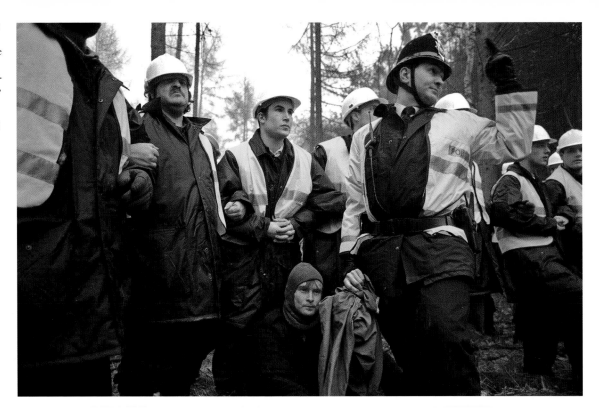

Newbury, England, 1996

The road protest movement forced many to live in the trees along the proposed bypass route. On average, the tree houses would be anything from 40–90 feet (12–27.5m) high. A good head for heights was always an advantage and Fisk was constantly amazed that more people were not injured in the process of getting in and out of the tree houses. Getting into a tree house was a slow and complicated affair. Like the protestor in the picture, Fisk had to do a maneuver called "prussiking," which enabled him to go up a single rope which could then be pulled up afterward to stop unwanted visitors. The men in yellow jackets are intelligence officers who would monitor and film all the protestors' movements. Fisk remembers: "For me, the protestor's face in the picture reflects the uncertainty of which way the campaign was going. In the end, the bypass was built. Ironically, in its first week of operation, two people were killed on the new road." Shot with Canon F1n, $^1/_{60}$ sec at f/2.8.

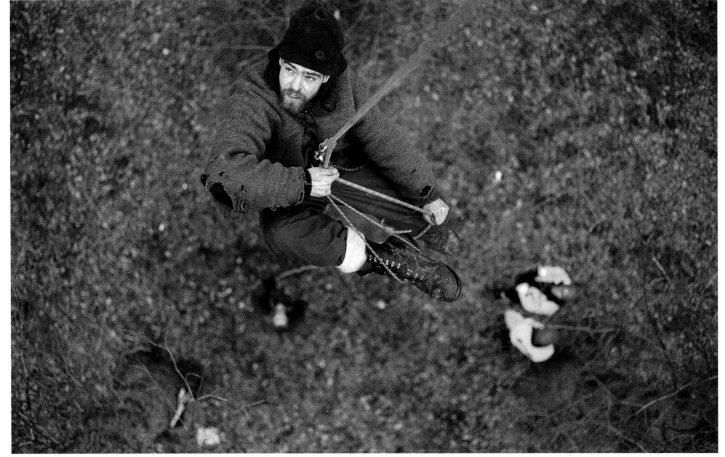

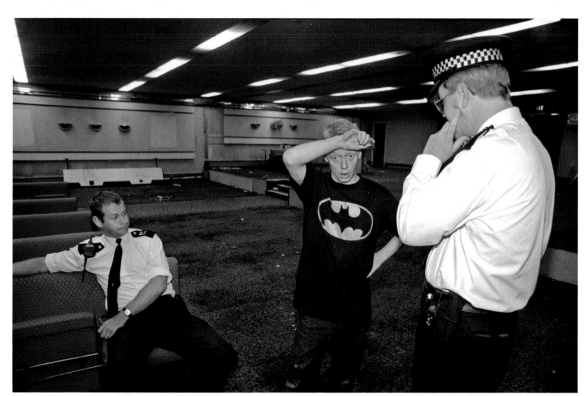

London, England
"I loved the energy of the illegal rave scene in London during the late 1990s. The parties were known as 'squat parties' because the organizers would squat in disused offices, factories, and many other empty buildings. Many that came to the parties were part of the environmental and anti-globalization movement, which, when the crowd mixed with hard techno music and a dazzling quantity of drugs, made for some unique pictures," says Fisk. "At first, the organizers of the parties were very wary of me taking pictures and I was vetted before they gave me access... I became the first photographer to comprehensively document the squat party scene."

This photo always makes Fisk smile: "It typified the game the police and party organizers went through each Saturday. 'Batman' is being asked to prove that he lives in the building, which is an old bingo hall in south London. By proving this, he could then claim section six of the squatting act, which would mean a court order had to be passed to remove the party organizers from the building. This would generally take three weeks, allowing the parties to go ahead. Somehow, 'Batman' succeeded and, a few hours later, 1,000 people were dancing around in exactly the same spot." Shot with Canon F1n, $1/30$ sec (flash) at f/8.

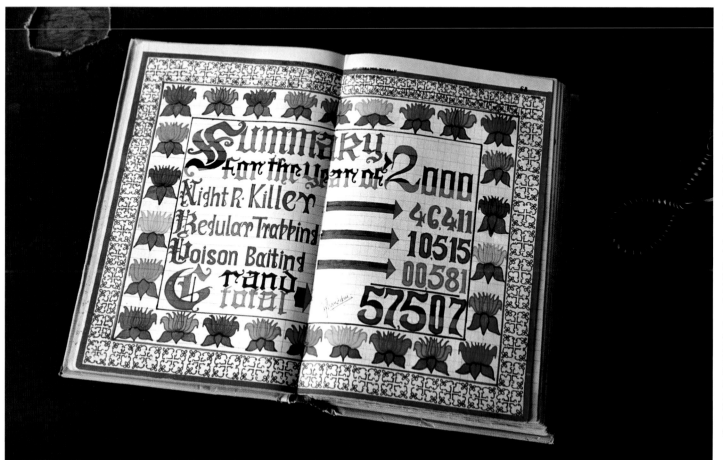

Mumbai (formerly Bombay), India, 2003
"I love [Mumbai]," says Fisk, "and I particularly love it at night. Because of the old English architecture in south [Mumbai], the area seems to take on a Gothic air." Fisk was working on a story about the "night rat killers" of Mumbai: armed with a bamboo stick and a flashlight, they each have to kill 30 rats a night in order to be paid by the municipal authorities. Over 400,000 rats a year are killed in this manner, making it the most effective form of pest control in the city. The city is divided into 12 wards, A to L, and the head of D-ward pest-control unit would at the end of each year get his assistant to illustrate the statistics for rats killed that year. It would take the assistant four days to complete.

"It struck me as an unbelievable waste of time and reflected the inefficiency of India's municipal departments. Like so much of what one sees in India, the scene was like one from a film, this particular one felt like a take from a Hammer House of Horror filmset." Shot with Canon EOS 1, $1/80$ sec at f/2.8.

Adrian Fisk

Tim Hall

It's several degrees below freezing and an icy Antarctic blizzard is blasting all around you. To most, this would be an unbearable situation, but to photojournalist Tim Hall, it is where he feels most at ease.

"I love working in polar regions and going on expeditions. This is where I do the majority of my photography and this is where my reputation lies," he says. "It is a major attraction for me to get away from everyday life in the UK to the simplicity of living in the wilderness and record events."

Retirement from the Royal Navy's Photographic Branch in 1999 has enabled Hall to fulfil many personal ambitions. "I joined the Navy when I was 19 as a marine engineer and, after about five years of service, I became very interested in photography. I decided to retrain as a photographer and [have spent the last] 22 years working in this particular field."

For Hall, photographing in Antarctica has always been special, having visited the region soon after leaving the Royal Navy. "I went to work on a project in Antarctica when I first left the Navy—primarily on a non-photographic basis—but I already had a growing reputation for photography in polar regions. Following on from this, I started to work on various expeditions.

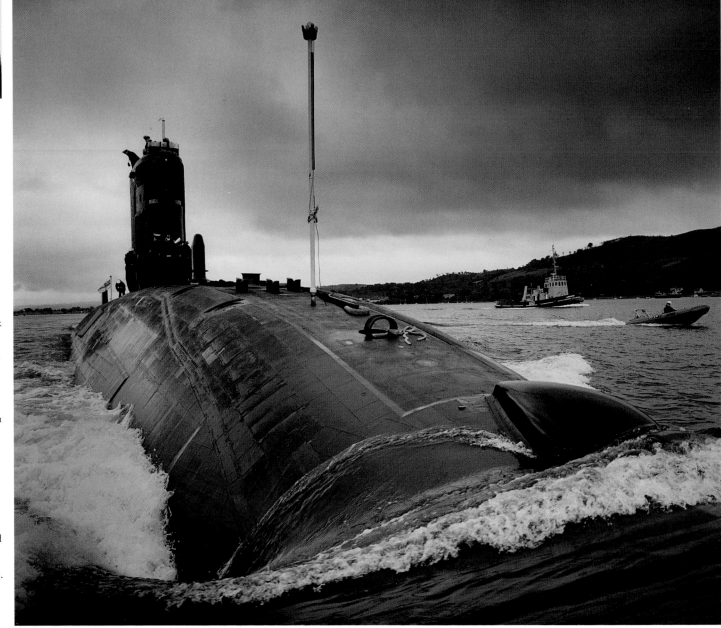

HMS *Triumph* arriving in the Gairloch, Scotland, 1995
"HMS *Triumph*, one of the Royal Navy's Trafalgar-class submarines, being escorted back to base in the Gairloch, on the west coast of Scotland. I took this 'super wide-angle' photo by hanging precariously over the back of a high-powered, rigid-inflatable police boat. Surfing on the submarine's bow-wave, I used a Hasselblad SWC camera to get the right composition. The bow of the submarine was only 6 feet [1.8m] away and I held the camera close to the water's surface, to capture this dynamic shot for use as a PR image for the Royal Navy. The overcast sky added to the threatening mood of this awesome boat, and I emphasized it some more in the darkroom, breaking the rules. I burned in the sky until it was almost black. The power of this vessel, as it surges through the cold, dark waters, can almost be heard, as it is about to run you down."

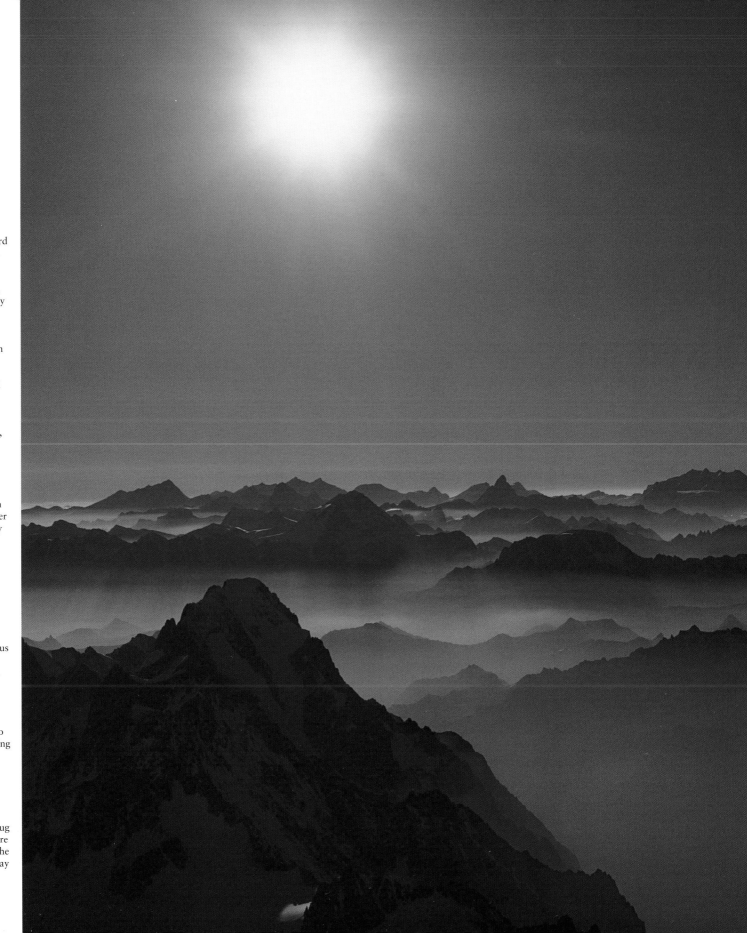

From the summit of Mont Blanc, France, 1992

"My view from the summit of Mont Blanc (approximately 3 miles/4,807 meters), Europe's highest peak, facing east toward the Materhorn in Switzerland. One day, in my quest for adventure and images of the highest mountains in the Alps, I soloed Mont Blanc all the way from the Chamonix valley, arriving at the summit alone, just a couple of hours before dawn. I carried little more than my mountaineering clothes, some water, and a Hasselblad CM500, allowing me to travel fast and light, making the complete round trip in a little over 24 hours. On reflection, I realized what a risk I'd taken, because climbing such a route would probably be politely described as 'madness' in mountaineering circles.

"So there I was, huddled in a hole that I'd gouged out with my hands in the snow, to shelter me from the icy wind. I eagerly awaited the dawn with a mixture of elation and fear of my isolation on the top of Europe. When the dawn arrived, it warmed my body and rewarded me with this awesome light display that only those who venture into the high mountains can ever experience—a truly momentous reward for my audacious efforts. The downward climb, while rapid, was thwarted at one point by a precipitous ice fall, which I only overcame thanks to a chance meeting with some other climbers, who allowed me to abseil down using their rope. By mid-afternoon, I was encamped in one of the many bars in Chamonix, recovering from my 28-hour round trip. I watched the visiting tourists in the street outside, buying postcards, smug in the knowledge that they were never going to see the best of the high mountains in the same way I had done!"

Hall says that being able to take strong images in these types of climates is born from a combination of things; however, being able to offer experience in other areas of any given trip is equally important.

"Often, an expedition needs people whom others can rely upon, so I sometimes operate as a consultant and the photography comes as part of that."

Antarctica—perhaps the last great wilderness on earth—lures Hall the explorer, as well as Hall the photojournalist. Not surprisingly, the rewards are immense and he brings back pictures that are absolutely stunning.

"I don't think my photographic style is particularly artistic," he admits. "But I like to record things exactly as they are… Where I win is in the composition. A little while ago, I went to a picture library to try and get my work accepted and someone there told me: 'If I was starting a picture library again and I needed a name for it, I think I'd call it Ordinary Pictures Ltd, because it's the ordinary pictures that sell every time.' I've always remembered that. While everyone else may be running around looking for the perfect artistic shot, they may be overlooking the simple things that can make an image even stronger."

Because of his intensive photographic training in the Royal Navy, Hall encounters little technical difficulty, "I know what I can and can't do with my camera."

He explains: "I don't have a problem with things such as bright light reflecting from the snow. Most modern digital SLRs are very accurate and I don't like to follow too many technical rules. If you mess around with the exposure too much, you can end up making it look unnatural and dreadfully inaccurate."

And, as most experienced photographers will tell you, the quality of the light is key to getting the best possible shots: "One thing I love about working in the mountains and snow is capturing the incredible texture. Too often, I see pictures from people who shoot in the snow where they have failed to capture the beautiful texture."

Throughout his career, Hall has also traveled extensively to Zimbabwe, the French Alps, and the US. Not surprisingly, being one of the world's leading photojournalists, danger is never far away. "I often think 'What the hell am I doing here?' There have been a few times when I've not been sure whether I was going to make it back from a trip. I remember photographing a rhinoceros and I was quickly reminded of someone who

Ice arch in the Gerlache Straits, Antarctica, 2002
"Picking our way through the icebergs in the Gerlache Straits, between the Antarctic Peninsula and Brabant Island, late one night, we came across this extraordinary iceberg. The ice arch—created by the combination of erosion by the sea and the iceberg capsizing as it broke up—was an especially grand example of nature's beauty. This compelled us to stop for an impromptu photo shoot. Having found that an inflatable boat was too unstable to get the shot in the dim light, I took this image using a Nikon D1, having landed on a narrow ice reef that surrounded the lagoon in the foreground. I narrowly escaped sliding into the freezing water in the process. I've never felt that it was a particularly strong image, but the demand for its use illustrates to me how I must allow others to be the final judge of my work."

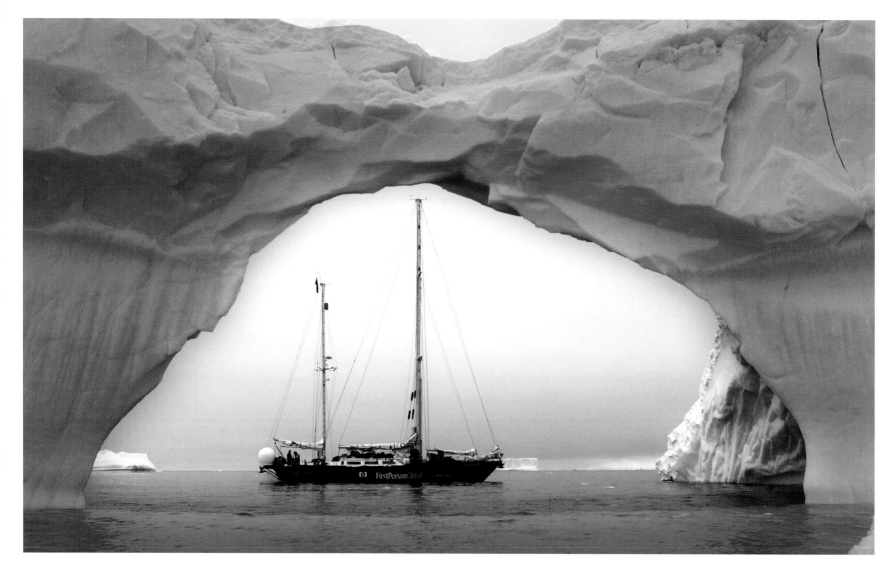

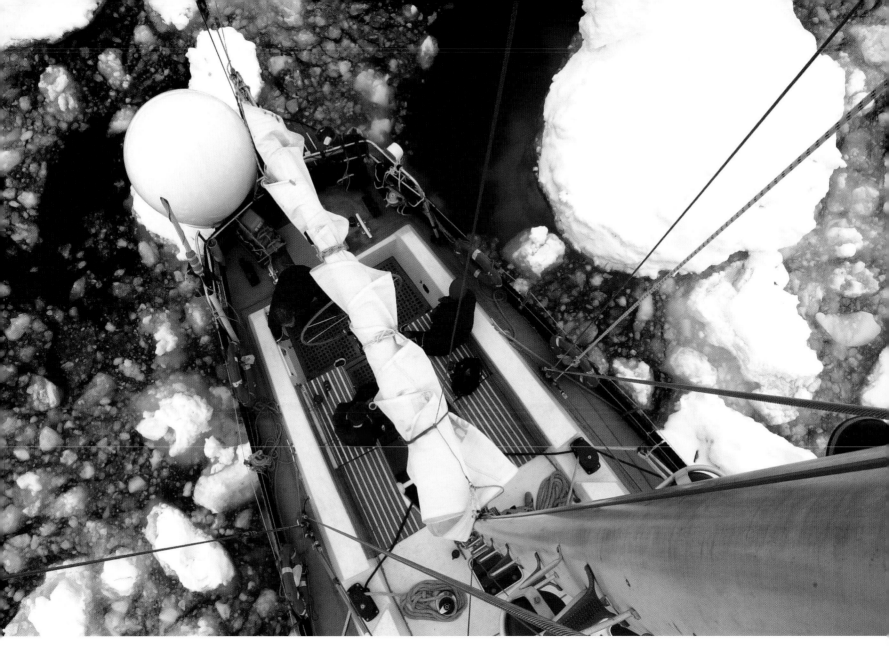

Ice warriors, Antarctica, 2002
"I shot this image with specialist yachting publications in mind, to illustrate articles about sailing in Antarctica. It's almost impossible to photograph a yacht when you are sailing on it and going places, so it calls for some agility and imagination to bring the yacht's situation into frame. As it turned out, my frequent trips to the top of the yacht's 92 foot (28m) mast achieved this. It was also an ideal way of getting as far away as possible from the rest of crew, which gave some relief from the tensions of living in such close confinement for weeks."

Tim Hall

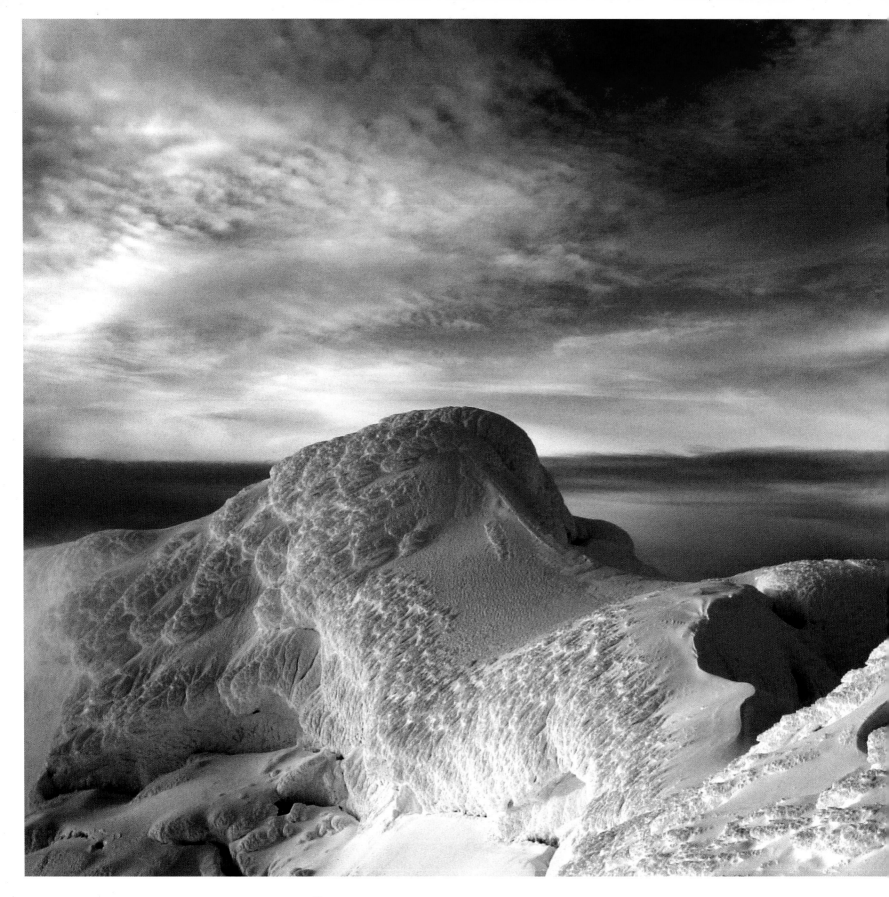

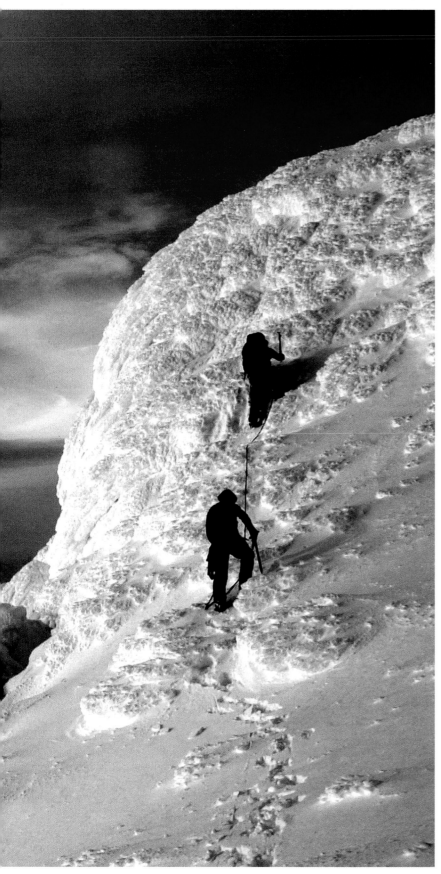

warned me that if one is going to charge you, it's best to stand your ground before moving to one side at the last minute. That's exactly what I did. But after it had passed me six times and come back for more, I'd had enough! I've also been on expeditions where people have had accidents and been seriously injured, which can be pretty worrying."

Is there anywhere Hall won't travel to? "No," he says, "I don't think there is anywhere I wouldn't go; I'd even go to Iraq if I had to."

The equipment he takes with him on expeditions must be reliable in extreme cold, but the real limiting factor is physical. Even though his Nikon F90 35mm film cameras have rarely let him down, he has taken the digital route for the past few years. "Digital is a photographer's best friend in the snow and I fail to see how anyone can still prefer film. Although I have an arsenal of Nikon gear, I tend to hire a lot of equipment these days because I recently lost much of my kit in the sea. I absolutely love the latest Nikon D1 and D2 series cameras."

Lenses, too, are equally important for getting the job done in such extreme circumstances. "I always feel that if you can't shoot with a 50mm fixed lens, then there's a good chance you're missing the point. I'm not the sort of person who goes around with an arsenal of lenses, simply because I've got to carry this stuff up mountains or along difficult terrain. But I do have a 35–70mm lens that I find reliable, and I've also got fixed 24mm and 300mm units. I can handle most eventualities with these."

As if his life hasn't already been exciting enough, Hall plans to undertake more expeditions to Antarctica, because there's something about the place that continually draws him back.

"I just love the variety and the fact that I don't know what lies around the next corner. I've realized in recent years that I would like to run my own expedition and, ultimately, this is my career goal. My previous travels have opened the doors to so many incredible experiences and I can take great satisfaction from the work I have done. Thankfully, I'm not one of these people who could ever say they had spent years sitting on their butt never doing anything interesting!"

Climbing Mount Pendragon, Elephant Island, 2002
"This image was taken during a yacht-based mountaineering expedition to the Antarctic Peninsula, when I was working as a civil photographer and expedition advisor to a British Army Antarctic Expedition team. Toward the end of the expedition, as we were returning north to the Falkland Islands, we called at Elephant Island, where Ernest Shackleton's ill-fated 1914 expedition had been marooned after the ship *Endurance* was crushed in the ice of the Weddel Sea.

"Most of our own expedition were tired of the rigors of expeditioning at this stage, so I was dispatched ashore with my 'enthusiasm' and the three strongest remaining members of our team, to lead an assault on the highest mountain on Elephant Island. First climbed in 1976, the mountain is named Mount Pendragon in honor of Prince Charles—Pendragon being the ancient title for a British or Welsh prince. I relished the challenge, if only to get us off the yacht, the confines of which had lost any attraction to me and my companions weeks ago.

"As the sun dipped toward the horizon, casting a warm glow on these distant summits, we raced toward Pendragon, pausing occasionally to take photographs. We were racing against time and I knew that I had only minutes of light remaining before night drove us downhill again into the darkness. My efforts were rewarded with an incredible photo opportunity; for me the pictures meant a whole lot more than just reaching such a remote and inaccessible mountain top."

Tim Hall

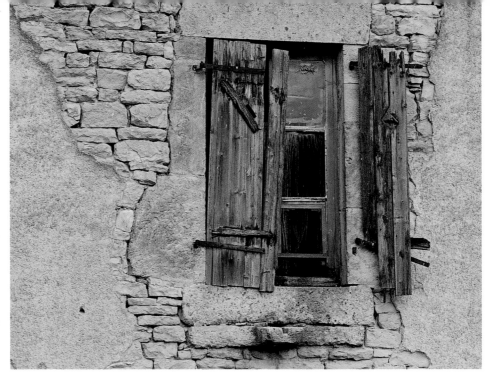

Windows in a deserted landscape, France, 1996

"Traveling through France, I've always been struck by how deserted the rural villages and buildings appear, despite being surrounded by well-maintained farmland. It's as though the population work the land, but leave the buildings to be reclaimed by nature. I'm always saying to myself, 'Incredible and beautifully cultivated farmland as far as the eye can see, dozens of villages, but where are the people?' I decided to try and capture this feeling of deserted loneliness with my camera. I've always been drawn to the crumbling details in the buildings—little things that you'd miss if you looked at a building as a whole. I wanted to capture some of these 'everyday details' in case the dilapidated buildings either fell into ruin or the fashion changed and they were all renewed or modernized. The textures and details in this image tell a story like the lines in an old man's face. Every time I look at this image, I half expect an elderly person to appear at the window, but they never do—they probably passed by for the last time years ago, or perhaps they are in the fields."

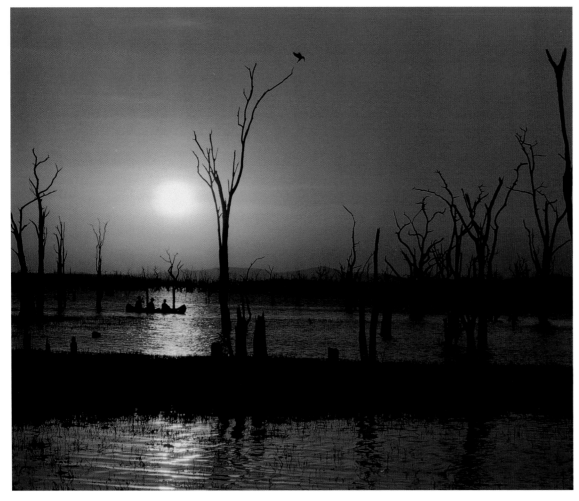

African sunset, Lake Kariba, Zimbabwe, 1994

"Captivated by the changing light over this woodland valley, drowned between 1958 and 1963 following the building of the Kariba Dam, I set up a 35mm camera on a tripod to do a time-lapse sequence through a 24-hour period. I was photographing and producing an audio-visual show for the British Schools Exploring Society (BSES). I planned to use the sunrise as the opening scene and the sunset as the closing scene for the show. To achieve the shoot, I had to stand alone throughout the night and day alongside the tripod to warn off any crocodiles, hippopotami, or other wildlife that should come along by chance and knock the tripod over, thus ruining the sequence.

"During the evening, I was stunned by the sunset. The following day, I asked some of the BSES members who came by to paddle past in a canoe at precisely 1800 hours. At the allotted time, they passed exactly as arranged, but ignored my calls for a second take and happily disappeared into the distance. Only when I processed the film some weeks later, back in the UK, did I see the humming bird above the tree—an unforeseen reward for the long and frightening hours I spent guarding my equipment in the darkness of the African bush."

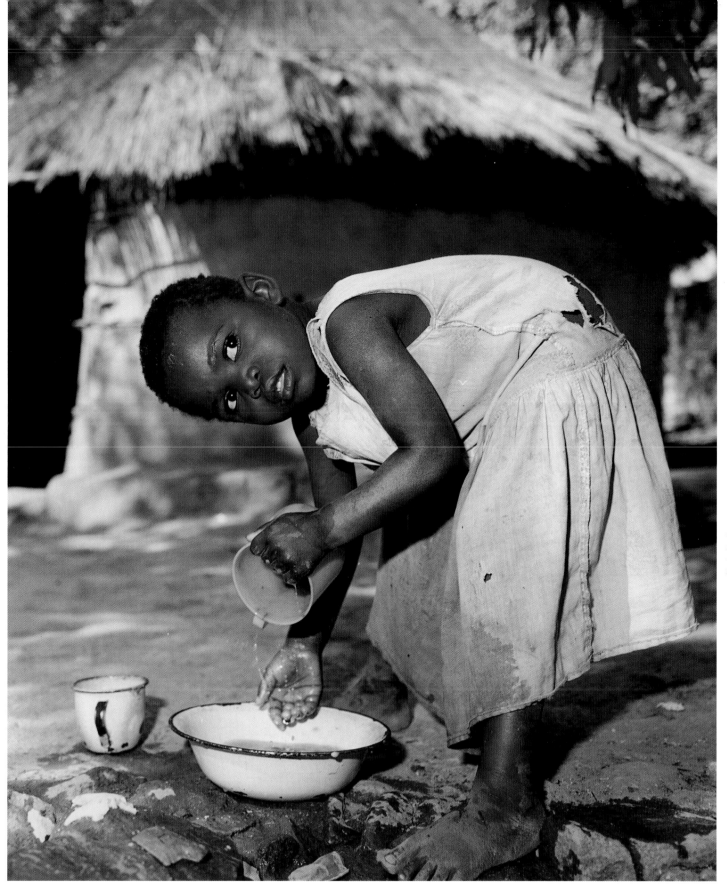

Dhewu's daughter, Tengenenge, Zimbabwe, 1994

"While traveling in Zimbabwe on an assignment, I visited the village of Tengenenge, which is home to a community of artists and sculptors. My planned day visit turned into a seven-day stay when one of the artists, Dhewu Bangura, challenged me: 'Do you want to know how hard it is to chisel stone? Here's a hammer and chisel, help yourself to a piece of rock and have a go!'

"He was perhaps initially a little irritated by the intrusion of my camera into his world, but I took up his challenge. At the day's end he opened his hut to me, shared what little food he and his family had, and, over the next six days, taught me how to carve rock into a fruit bowl. Dhewu unwittingly provided me with a unique opportunity to photograph him and his family in their home environment as I shared in their daily chores, always with a Hasselblad at my side. On returning home, complete with my fruit bowl, I tried to reward his generosity with gifts of clothes and the like for his family, but nothing could truly repay the kindness these 'poor' people had shown me. Dhewu and his family made me realize that it is not what you have got that counts, it is how you use it. I've never sold any of the pictures or used them commercially, gaining instead great pleasure in giving them away in the spirit that Dhewu gave them to me."

53

Tim Hall

Ron Haviv

Most of this American photojournalist's images are not intended for the coffee table. His incredible work has served as a horrifying pictorial record of death and misery from wars around the world, many in the former Yugoslavia during the 1990s.

Ron Haviv is not afraid to speak of his work: "My pictures are neither for voyeurs looking for war pornography, nor for the faint of heart. Many of the photographs are incredibly disturbing."

His pictures show the raw agony of a land torn apart by ethnic hatred: a Muslim captive pleading for mercy minutes before Serb gunmen threw him from a window; a Croatian child weeping at his father's funeral; a field of snow stained with blood.

While chronicling the long, painful break-up of Yugoslavia throughout the 1990s, Haviv's photograph of a Muslim in Bijelina begging for his life after capture by the much-feared Serb militant group, Arkan's Tigers, was one of the most striking images to come out of the Balkans.

"I was just trying to document what was happening," recalls Haviv. "It's a horrific thing to see someone killed in front of you. The first time it happened, I wasn't allowed to take a photo. I couldn't have saved him, but it made it worse that I couldn't tell the world about it. I made a promise to myself that if I was in that situation again, I would at least be able to take a photo."

Throughout his career as a photojournalist, Haviv has "confronted risk" in order to bring our attention to our less fortunate neighbors. In addition to the Balkans, he has covered conflict in Latin America and the Caribbean, crises in Africa, the Gulf War, and fighting in Russia. In the 21st century, he has documented the aftermath of September 11th, including the subsequent war in Afghanistan and the overthrow of Saddam Hussein in Iraq.

"It is a cliché," he admits, "but it's important that photojournalists are out there documenting what's happening and holding people accountable. And yes, the work does become evidence."

Haviv is a cofounder of the world-renowned VII photo agency in Paris and his work is widely published by magazines throughout the world including *Paris-Match*, *Time*, *Geo*, *Stern*, and the *New York Times Magazine*. His photographs have earned him several World Press, Picture of the Year, and Overseas Press Club Awards, and the prestigious Leica Medal of Excellence. Haviv's poignant shots have been exhibited at many museums and galleries, including the United Nations, the Louvre, and the Council on Foreign Relations. He has contributed to numerous books, and regularly lectures at universities and seminars. Published books include *Blood and Honey: A Balkan War Journal*, in which Haviv's unforgettable Balkan War photographs are documented, and *Afghanistan: On the Road to Kabul*.

Not surprisingly, his pictures have also led to Serb militant group Arkan's Tigers threatening to kill him: "Arkan was furious when that picture was published and put out a death warrant on me, stating publicly that he looked forward to drinking my blood."

Afghanistan, 2001
Northern Alliance soldiers tend to a dying commander during the assault on the Taliban stronghold of Maidenshar, overlooking the road to Kandahar. The Northern Alliance withdrew after sustaining heavy casualties and being outflanked by the Taliban.

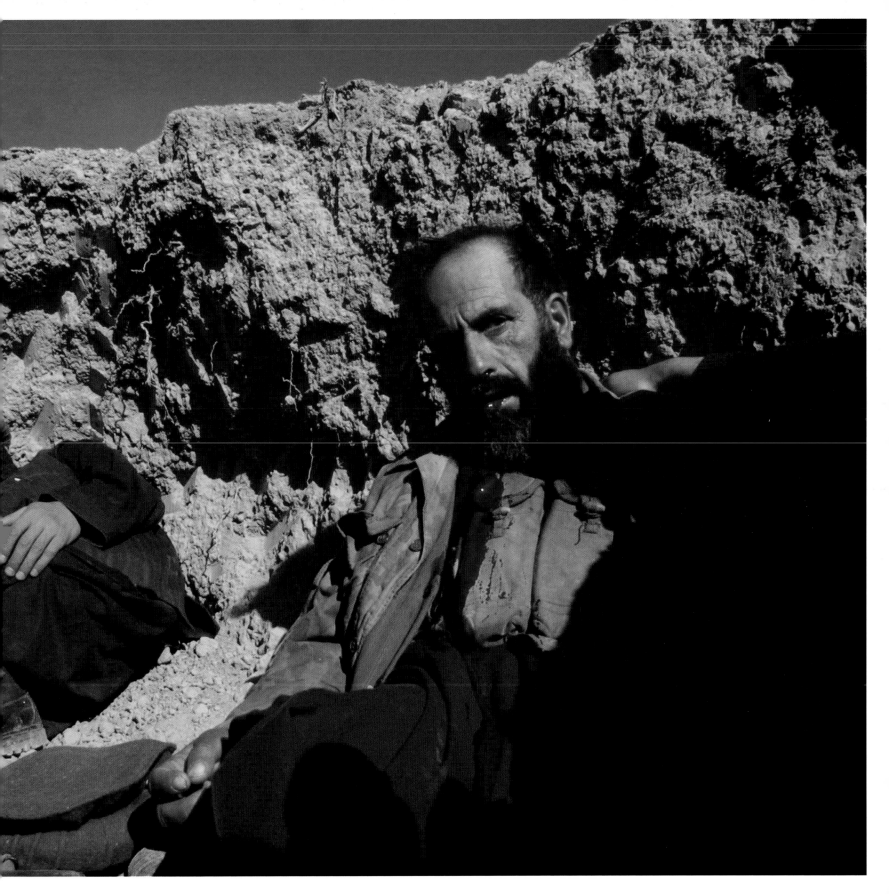

Ron Haviv

Bosnia, 1992
A Muslim in Bijelina begs for his life after capture by the much-feared Serb militant group, Arkan's Tigers.

But Haviv, who first went to the Balkans when he was just starting his career in 1991, sees his work as a necessity, "I never look at the things I do as courageous," he stresses. "I am just trying to document what is happening."

And Haviv still travels to the Balkans—he was in Macedonia for the start of the fighting in 2001, and was outside former Serb President Slobodan Milosevic's house when he was arrested. He believes his work in the Balkans has made a difference, and that is what he hopes to carry on doing.

"Journalists were showing more and more images from Bosnia and finally the politicians had to act," he says. "When it came to Kosovo, the politicians reacted much faster. I don't believe photojournalism alone can change anything, but I think the world would be a very different place without it."

Panama, 1989
A soldier looks on passively as newly elected Vice President Guillermo Ford is beaten by a paramilitary supporter of dictator General Manuel Noriega.

Ron Haviv

Tim A. Hetherington

Tim A. Hetherington has the demeanor of a modest member of London's professional elite, not someone who spends two-thirds of the year in some of west Africa's most dangerous countries.

With a base in London and a schedule that takes him to some of the most politically unstable places on earth, he is in an ideal position to record some of the political and humanitarian events that have characterized recent history.

"I'm able to visually communicate complex political ideas and events," says Hetherington. "Like any other job, there's a skill in shaping and developing the things that you are passionate about."

During the past six years, the self-confessed "experimenter and documentary photographer" has traveled throughout Asia, though in more recent times his work has been based in west Africa. His portfolio is dominated by pictures from Angola, Sierra Leone, the Ivory Coast, and Monrovia in Liberia, where he rents an apartment.

It's difficult to define exactly what Hetherington does, although he doesn't consider himself a typical member of the press, but instead as someone who uses it as a valid outlet for his photography. Although much of Hetherington's work is distributed by Panos Pictures and Reuters, he considers himself an independent operator.

"There are personal motives to what I do," he says. "There are issues around the world that the West is connected to and I think it's important we understand these political and humanitarian relationships. I use my photography to bring a face and name to these particular circumstances, and I want to bring them to the attention of the public because it is important they are conscious of what's going on. If you're led to believe that what's happening in these countries doesn't matter, or if you don't believe they're closely related to the West's economy, then you have been deluded."

A former children's book publisher, Hetherington's interest in politics has been the driving force behind his career change to photography. "I'm really curious about the world and I'm interested in the politics that dominate it. We live in a very visual place and photography is the easiest way to access the world of visual communication."

Travel aside, his passion for meeting people and exchanging ideas is also a big factor. "Meeting people is a great way to learn new skills and I really love the exchanges I have. Just as importantly, I love creating visually stimulating work."

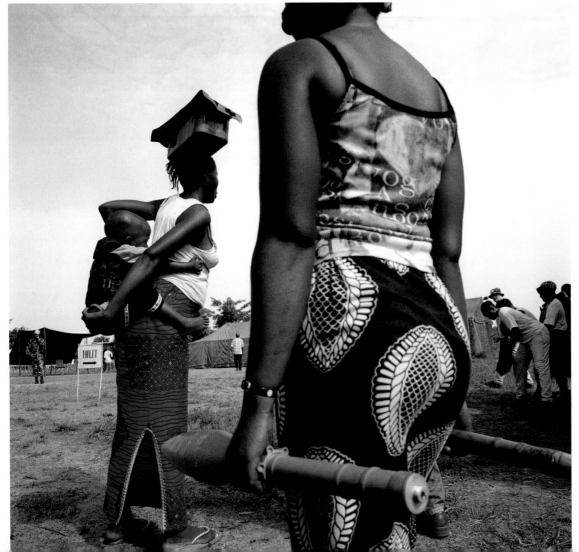

Tubmanberg, Liberia, April 2004

"I work a lot on self-initiated projects that allow me to engage with a subject for a longer amount of time than if I was working for someone else. This gives me time to distil my ideas and to develop an appropriate visual strategy. I worked on the Liberia project for over three years, and even ended up living there. I photographed the whole project in medium-format color, seeking to represent the details and textures of daily life. While I advocate trying to bring an awareness of tumultuous events that occur around the world, I am wary of the ways in which certain places have become abstractly represented by black and white images of poverty and suffering. I want people to engage with my work.

"There were key events in Liberia that contributed to structure the narrative of my work, like the arrival of the United Nations peacekeeping force, the presidential elections of 2005, and the process of disarming the rebel factions. This image was made during the disarmament in April 2004 in the old rebel town of Tubmanberg. The UN had enticed fighters to hand in their weapons and ammunition in exchange for money. It was a type of peace dividend for those who had conducted the war, and the rebel commanders had begun to distribute weapon stocks for their followers to hand in. Women form an integral part of a rebel force, some as fighters, but most simply as wives. They are expected to follow their husbands, to look after the children, and cook. War is inevitably intermingled with domesticity. Even during such a disarmament program, no one thought it strange that the women should be handling explosives and children at the same time."

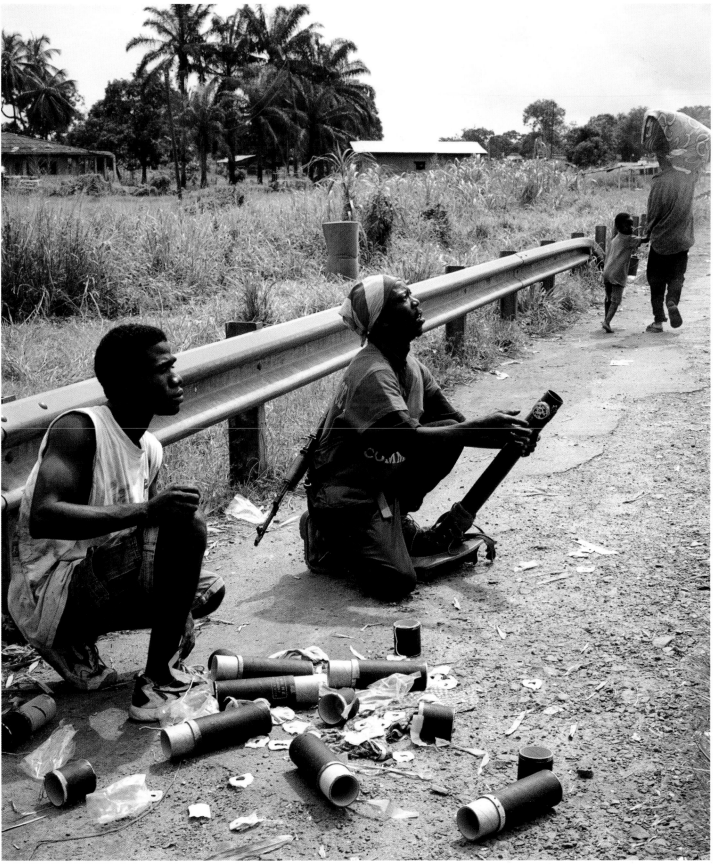

Monrovia, Liberia, June 2003

"During the recent Liberian civil war, I was the only photographer to live with the LURD Rebel Army that was attempting to remove President Charles Taylor from power. This is the only image that exists of the indiscriminate shelling of Monrovia by LURD forces during the siege of the Liberian capital in June 2003. The LURD had a very casual approach to the firing of mortars, and rounds were fired without any accurate triangulation, resulting in widespread civilian deaths. On one tragic occasion, several mortar rounds landed on the Greystone plantation, a US Embassy compound, where thousands of refugees were seeking sanctuary. Hundreds died and survivors carried the dead to the US Embassy, dumping them before the main gate to protest against perceived US inactivity in bringing the war to an end. Ironically, these mortar rounds supplied by the Guinean government to the LURD had originated from the US.

"Images like this remind me of the importance of photography as documentary 'witnessing.' Increasingly, it has become fashionable to rubbish photojournalism with subtle arguments centered on the ethics of representation. While I do appreciate such discussions, inevitably they can be a little impractical. I don't need to defend the making of an image like this. When the warring factions began to argue about who had fired the mortars on Monrovia, I knew I had this picture. During this time, I was also filming *Liberia: An Uncivil War* with my friend and TV colleague James Brabazon. I only saw the final edit when the film opened in New York at the Human Rights Watch film festival. The sequences of the mortar being fired had been cut with images of civilian deaths at Greystone, and when I saw the consequences of what we had been filming, it upset me deeply."

Tim A. Hetherington

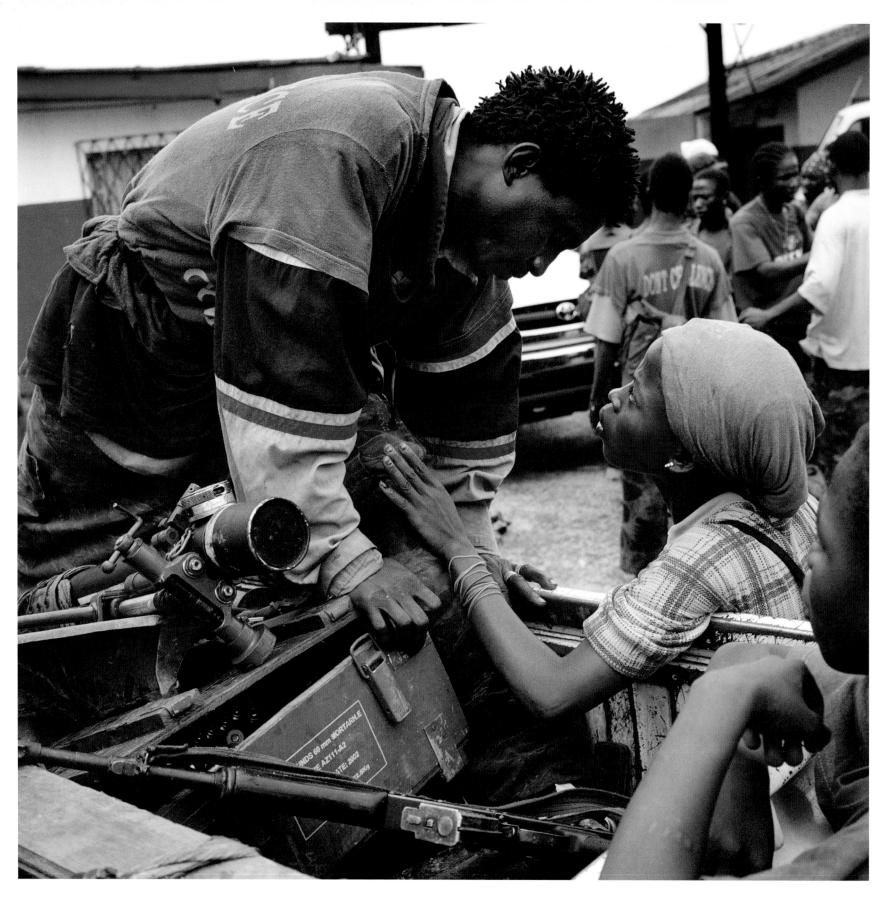

Monrovia, Liberia, June 2003 *(left)*
"The fighting to reach Monrovia had been pretty intense. I was with a second group of fighters, perhaps around 500 or so, who were trying to punch through the government lines to reach another group trapped in the city. When the two groups finally did link up, they established a base at an old warehouse, where I took this picture. It's one of my favorites because it's something so tender and human from a situation that we always seek to dehumanize. It's also a picture you don't often see in conflict photography where the focus tends to be on weapons, suffering, and death. The Liberian civil war has been stereotyped as an orgy of madness where drugged-up kids committed indescribable atrocities. While I accept that there is some truth in this view, I like this picture because it challenges that preconception. I don't know what these two lovers are saying, but he was on his way to the front, and I'd like to believe it's something tender and intimate. Even a fighter is someone's child or lover, or sister or father."

Banda Aceh, Indonesia, January 2005 *(right)*
"I spent most of my time in Banda Aceh wandering around the ruins. The scene was apocalyptic. There wasn't much I could compare it with, except perhaps images I'd seen from Chechnya, and the bombing of Dresden or Hiroshima. I developed an isolated routine and got into a fairly surreal state of mind, which I think is reflected in the set of images I produced during that time. Normally, sunset pictures tend to be a little too clichéd for my liking, but the light was incredible and I could feel the situation was something very strong. Later, some people suggested that the work was too esthetic for such a tragic event. I thought they'd missed the point, I find the work evokes the tragic precisely because of its beauty."

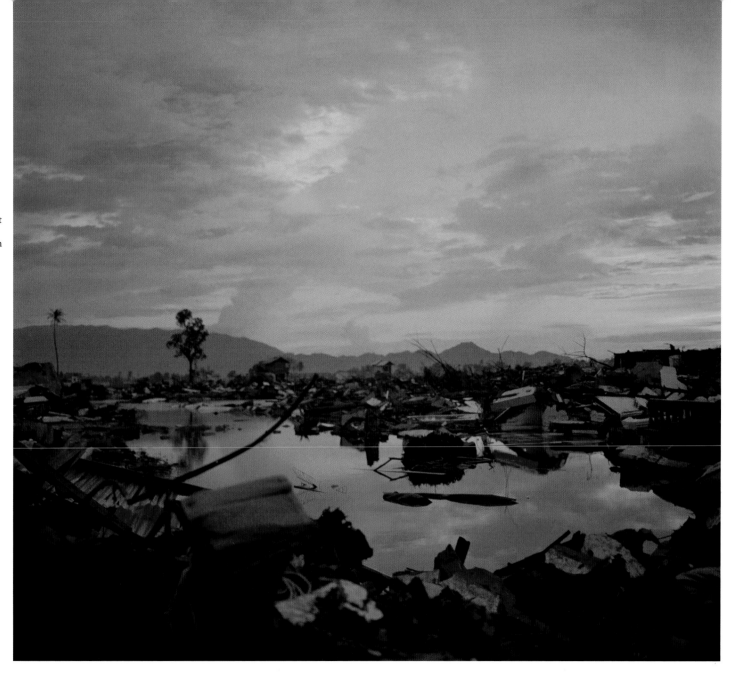

Surprisingly, for most of his travels, Hetherington prefers a Hasselblad 6x6 and 60mm lens, even though he owns a Canon EOS 35mm digital camera. One has to wonder why he chooses such cumbersome equipment, given that a 35mm kit would enable him to shoot faster and from further away, especially when there is a risk of being shot.

"I like frank images," he stresses. "There's something about framing in 6x6 that lends a structural clarity to the photograph; this format also gives the images a textural density which enhances impact. You're helping to give people a feel for what it's actually like to be in the picture. For a long time, photojournalism has been centered around Cartier-Bresson's 'decisive moment,' but I think medium-format brings in much more valuable clarity and detail."

Using medium-format means that film has to be used sparingly, as Hetherington points out: "When you're shooting on 6x6 with 80 rolls of 120 film, you'll run out sooner or later, so it's a good idea to be frugal. But sometimes there are great opportunities all around you, and you can't help but start shooting if you see something that makes for a strong image."

Hetherington also says his work is often physically and mentally demanding. "I work a lot in isolated places, and sometimes I get lonely and mentally I've had enough. Sometimes I am confronted with scenes that are difficult to take on board and it's hard to digest them. During the aftermath of the tsunami in 2004, I was working from the crack of dawn until the early evening and then sleeping on the floor of a house. I was absolutely exhausted."

Tim A. Hetherington

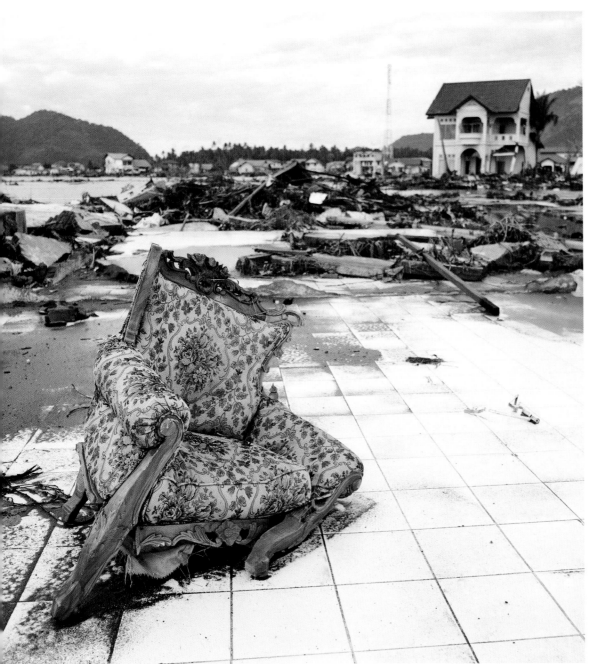

"Nine months after the tsunami, I was commissioned to make images for an exhibition to mark the anniversary of the disaster. I traveled with a writer to south India and Sri Lanka, looking at how far people had come in rebuilding their lives. I was interested in the relationship that people had with the sea and the ways in which the tsunami had affected this. Fishermen who hadn't previously questioned the predatory nature of their own work were now fully aware of the arbitrary power of the sea to give and take away life. People I met at the beaches in Colombo, the capital of Sri Lanka, told me that they'd stayed away from the sea for three months or so, afraid to venture back to something that had once been a source of pleasure. It was while walking along the seafront in Colombo that I made this picture of young schoolgirls enjoying themselves on a day out at the seaside. I thought, after everything I'd seen and photographed about the tsunami, that this picture was a fitting end-point."

Although passionate about his photography, Hetherington is keen to express video broadcast as an increasingly important part of his documentary work. "I'm trying to strengthen my broadcast side of things—I clearly recognize the limitations of photojournalism within the print industry," he says, "and I see broadcast as offering a solution to get visual documentary work to the eyes of the public. The world has gone digital and wireless broadcast is increasingly the technology of choice."

Hetherington says that his greatest photographic achievement has been his work with LURD (Liberians Reunited for Reconciliation and Democracy) rebels in Liberia. "I'm very proud of the fact that I was the only photographer to live alongside and to break the story of the LURD rebels overthrowing the government of Charles Taylor. Not only was it a world exclusive, it was an absolutely incredible experience."

But why west Africa? Are there not other environments that need media attention? "It's a central component to my work," says Hetherington, "to teach photography to people internationally, as a way for them to record their own history. It's important that communities learn to represent themselves rather than just being represented by others, and west Africa has been a great example of this."

Banda Aceh, Indonesia, January 2005 *(above)*

"On December 26, 2004, like most people around the world, I was sitting at home when news of the tsunami started to filter through. Initially, I hadn't thought about going to Indonesia. I'd been caught up in projects in Africa, and didn't feel sufficiently connected to the region to start working there. Then the phone rang and it was Adrian Evans from the agency Panos Pictures, telling me that an aid agency was looking for a photographer who could also make a short film. Since there aren't many photographers who can also produce TV, I felt it was a good enough reason to go. Two weeks later, I found myself standing in the ruins of Banda Aceh, in what was until two weeks previously an affluent city. After finishing the film and making digital stills, the aid agency suggested I fly back to their offices in Jakarta. Getting in and out of Aceh wasn't easy and I asked them to let me stay and carry on working. I'd brought 70 rolls of film with me and felt strongly about making a piece of work in my own time. Hesitant at first, my producer generously agreed and left me to it. While the news-bandwagon moved relentlessly onward in search of the next thing— Muslim uncertainty at US military involvement, a man lost at sea for five days, increased danger of kidnapped orphans— I remained dumbfounded by the sheer surreal nature of what had happened. That many people had been at home on the morning of the 26th seemed to me to be some kind of starting point. I began searching for those images that I felt someone a long way away might be able to identify with: homes that survived, family photo albums, the chair on which granddad would sit."

Tim A. Hetherington

David Høgsholt

David Høgsholt's charismatic black and white pictures, which follow the life of a young prostitute in Copenhagen, literally turned him into an overnight success.

"I hadn't actually been shooting for more than about a year-and-a-half when I became interested in photographing this particular girl," he remembers. "In the beginning, I didn't set out to be a photographer or a journalist, but rather to do something interesting and meaningful."

Høgsholt's body of work, which has defined the very best traditions of documentary photography, demonstrates the struggle faced by young drug addict Mia in the Nordvest district of Copenhagen, Denmark. It was deemed so good by industry experts that it earned him an Ian Parry Scholarship in 2004, the UK's most prestigious award for young international photographers (Ian Parry was a photojournalist who died on assignment for *The Sunday Times* during the Romanian revolution in 1989). He says: "I wanted to do the type of photography that tested my abilities as a person. I don't think being a good photographer necessarily just means you're good with a camera. Just as important is your ability to be good with people and strike a long-lasting rapport with them. These things will show in the pictures."

Demonstrating a skill shared by the very best, Høgsholt's photographic approach is unobtrusive, even in the most deep and intimate moments. Trust and commitment between photographer and subject can be seen in every shot, something that earned him third prize in the Contemporary Issues category during World Press Photo 2005.

"The life of Mia and her friends is a very private one and I feel privileged to have been given access to shoot them. I think good photojournalists are those who can gain this trust and exploit it through their images."

Clearly Høgsholt has stamped his own vision on a subject that could easily be over-sensationalized for all the wrong reasons. "There's no doubt that this is a very harrowing story about a drug addict," he says. "It shows her through all of the rituals of addiction. Fighting with herself, self-denial, self-examination, shooting-up, the love, the beatings… everything. It's a complete story. I spent a lot of time with her. But the editing job has been marvelous."

Born in Skælskør, Denmark, Høgsholt studied for four years at the Danish School of Journalism before "doing numerous other jobs as a bike courier and sail boat instructor." He shoots with a 35mm Canon EOS-1 SLR and loves black and white. He also likes medium-format for different photo projects and always shoots with a wide-angle lens. "I want to be close to people to feel accepted into their personal space."

Not surprisingly, letting his camera absorb the detail and emotion of his subjects is key to getting the best possible shots. "Unfortunately, older generations look at images because they like what they see. I want them to look at pictures that are more powerful, even if they're not what they want to see. Things will change because we have a generation growing up now that's used to seeing pictures that are sometimes ugly.

"I've never really been into commercial photography. For me, photographing real life is the only way I can fulfil my needs. And I won't do stories just for my own satisfaction. It's important to expose them to people who will listen. I never used to think about the widest possible communication for my work, but my viewpoint has changed and is changing."

Høgsholt says many photojournalists often have two different bodies of work: one for themselves and one for those they are trying to reach. "You're seldom going to get something published on a wide scale with an edit that is 100 percent to your satisfaction. But when I am able to walk in and out of places that I'm not supposed to, and I know others can sense the situation through my pictures, it makes it all worthwhile."

Neck shot, from "Mia–Living Life Trying, 2003–2005"
Mia getting a fix of cocaine at a dealer's place on the outskirts of Copenhagen. For the last six-and-a-half years, Mia had been smoking heroin and taking pills, but her addiction had worsened over the last couple of years and, instead of smoking heroin, she was now doing crack and shooting cocaine.

**The day after Ali died, from
"Mia–Living Life Trying,
2003–2005"**
Mia's boyfriend had died of an
overdose the day before. Mia
came home from working her
shift in a topless bar in the red-
light district, late in the night,
and found her boyfriend, Ali, in
the hallway. She was tired and
stoned. She thought that he was
sleeping. After getting him a
blanket she went to bed, only to
find him dead the next morning.

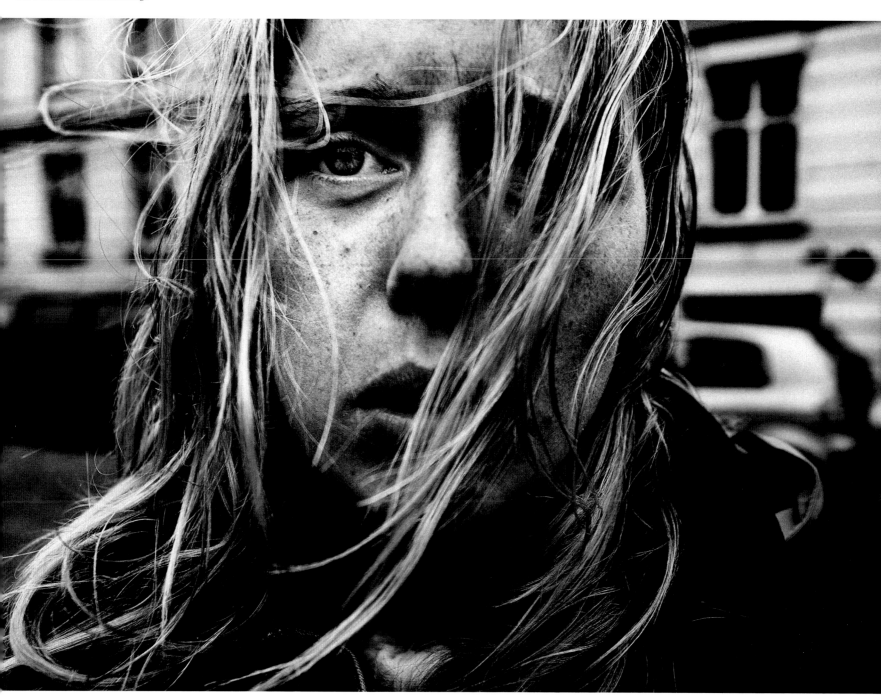

David Høgsholt

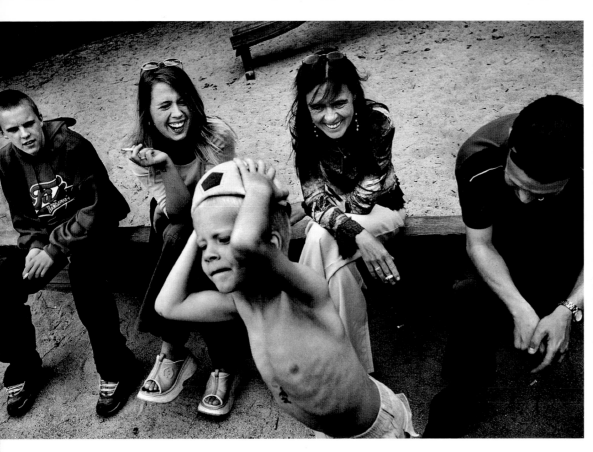

Family visit, from "Mia–Living Life Trying, 2003–2005"
Mia's mother, Kate, visits from Nakskov, a two-hour drive from Copenhagen. Kate took her boyfriend, Steen, and Mia's two younger siblings, Allan and Tim. Before going to a nearby playground, Mia had to go to the basement and smoke heroin to get well. Meanwhile, her brothers were play-fighting on the couch upstairs. She didn't smoke as much as she normally would, "Just so that I won't be sick. I want to have a clear head while my family is here," she said.

Customer, from "Mia–Living Life Trying, 2003–2005"
Mia with a customer. It's winter and Mia has taken him to a porn club a few blocks from Skelbækgade, a street in the red-light district in Copenhagen, because it's warm and couples do not have to pay the normal six dollar entrance fee.

On one side of the room is an old TV showing porn with the volume turned up all the way. From a room just next to Mia's, three male guests watched the act through a "false mirror."

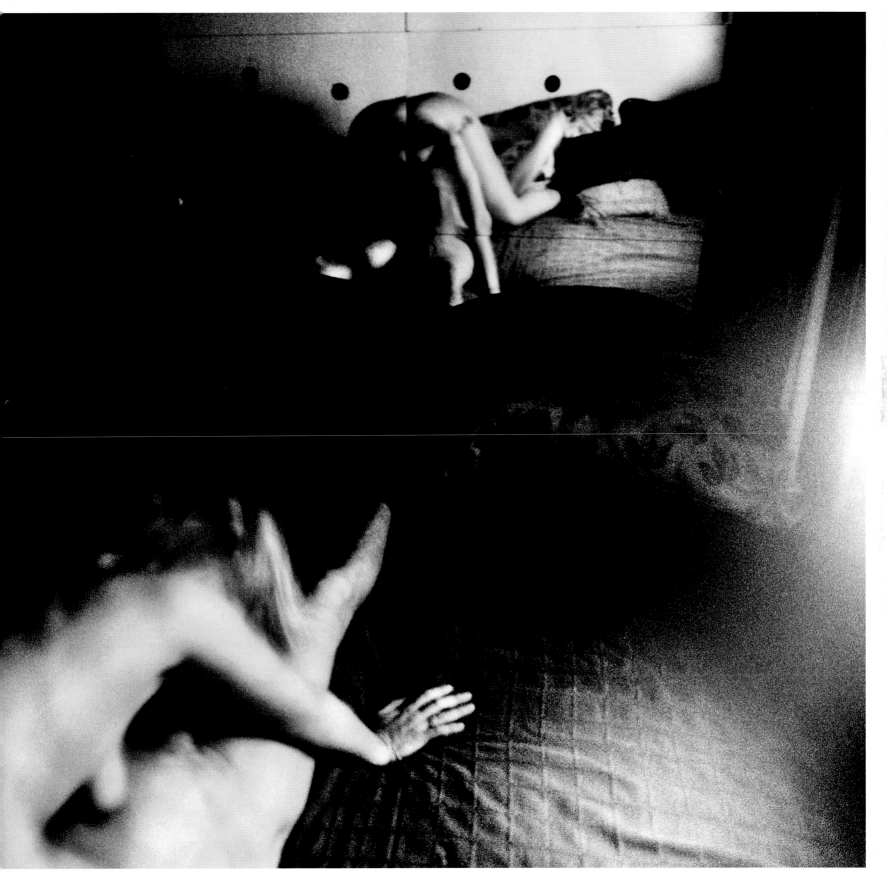

David Høgsholt

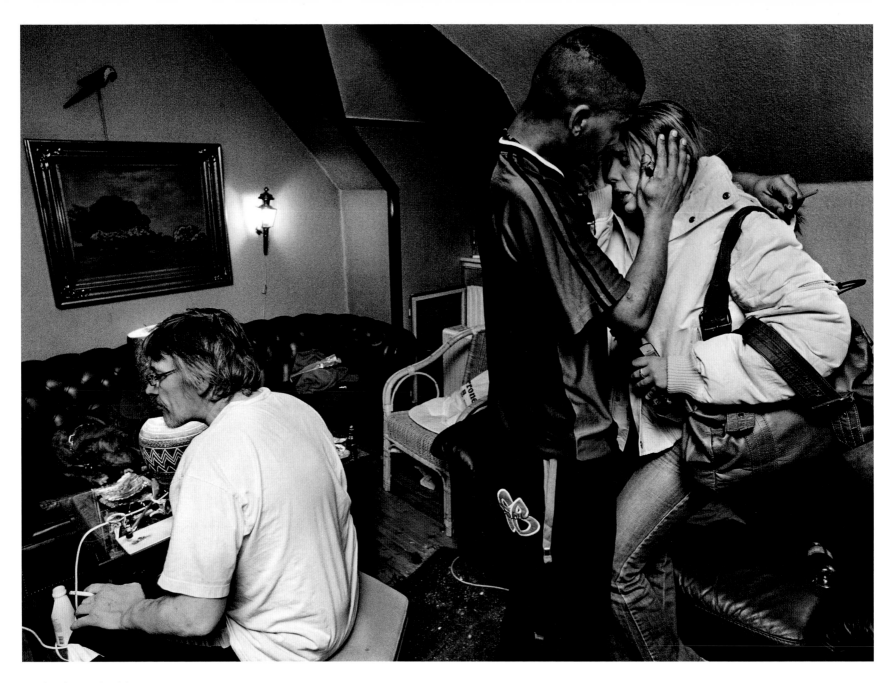

**Comfort, from "Mia–Living
Life Trying, 2003–2005"**
Mia's boyfriend Flemming
comforts her after she was
cheated out of some drugs by
a girl whom she thought was a
good friend.

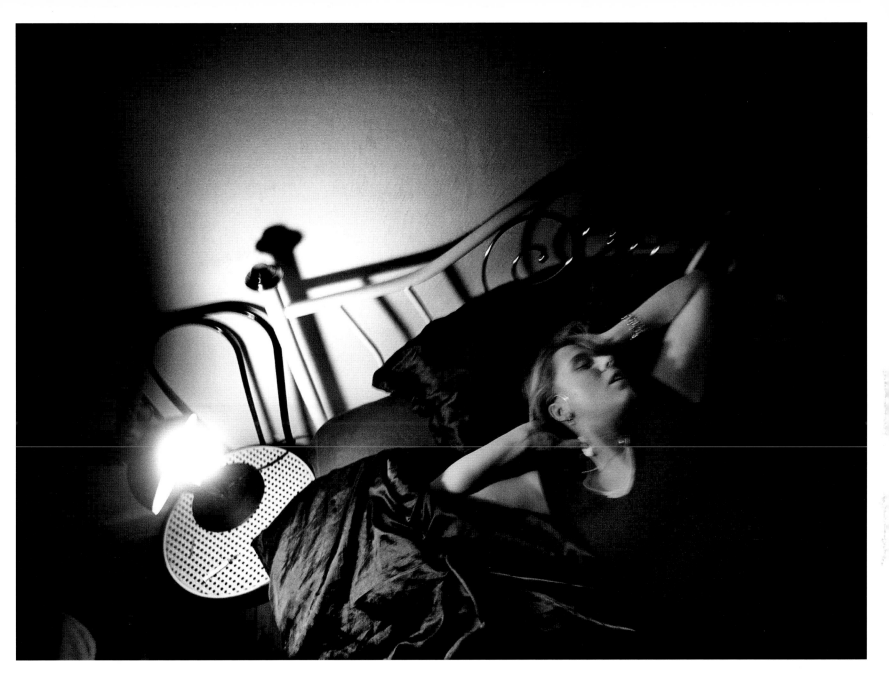

**High on crack, from "Mia–
Living Life Trying, 2003–2005"**
Mia at a pusher's place in her
neighborhood. She'd just had
a shot of cocaine in her neck.
She told the guy who helped her
shoot up not to be afraid if
she momentarily stopped
breathing—that was a normal
reaction for her when the dosage
was as high as she wanted it.

David Høgsholt

Chris Hondros

For American Getty Images photographer Chris Hondros, photojournalism is both a way to make a living and an important political tool. He uses the medium to highlight things that are happening in parts of the world that aren't necessarily understood by the masses. His images are not so much out-and-out documentary photography, but more news reportage that involves travel.

"My primary work is with areas of conflict and war and it's fair to say that my photography is based on conflict. For me, photojournalism and conflict often go hand in hand because it is critically important to understand the realities of war, and not to ignore these terrible things that are happening around the world," he says.

Hondros adds that he's "pretty much always been infatuated with photography," ever since his days at high school, and has been "hooked on the subject right from day one."

After he graduated from college—which, surprisingly, comprised a major in literature—Hondros took a job at the *Troy Daily News*, a small newspaper in Ohio. It was not until 1998, however, that Hondros started traveling and making a living through his photography: "My first overseas assignment was in Kosovo," he remembers. "It was during the late 1990s that I decided to move back to my native city [New York], where I started shooting for the international press."

After being supported financially by the United States Agency for National Development, which awarded him with a grant to fund his travels back to Kosovo, Hondros landed a full-time role with Getty Images. He has been working there since 1999. "Thankfully, Getty is very open-minded as to what types of pictures they require. Photographers are expected to be advanced enough in their thinking and good enough journalists to be able to understand what's important, and to get out there and record these things. Getty trusts my judgment and gives me the freedom to shoot in the manner I want."

Hondros says that it's vital not to get too caught up in one's own visual world, though, to help ensure that his photography appeals to the widest possible audience. "It's drastically important not to show too much of what is more important for you than for others," he stresses. "But I also think the photojournalism market likes to be led—a little bit at least— to help create compelling and innovative pictures that people will come to you for. It is this approach I look for the most."

Hondros is primarily based in Africa and Asia. It is Liberia, Sierra Leone, Nigeria, and Ghana where he undertakes the lion's share of his African work. In Asia, Pakistan and India are often his preferred locations, while in the conflict-saturated Middle East, Israel, Palestine, Syria, and Iraq are targets for his camera.

"For me, every country in the world is a place where people go about their daily business and I don't think one really has to fear one country more than another. Iraq, for example, is not a place where everyone is out to kill visiting journalists, as some of the international news depicts, but rather there are dangerous places within a country such as Iraq. I can't think of a single country in the world which suggests 'death upon arrival!'"

The people he encounters—often under very trying circumstances—have given Hondros a positive idea of the raw materials of human nature. "Part of my job as a photojournalist is that I get to see some pretty horrible things, things you almost wouldn't believe. I have seen people who are capable of some extremely brutal behavior. And I get lonely, too. But I have to take the rough with the smooth. Often I'm surrounded by tremendously strong and interesting people, as well as by some wonderful friends and colleagues."

Not surprisingly, there are some pictures that are very tdifficult to take. Hondros admits he finds it tough to press the shutter in situations where deep emotions, as a result of death or injury, are evident. "But on the other hand, if you feel that taking their picture is going to help the situation, broadly speaking, then that gives me confidence in my work. I don't feel intrusive because I believe that my photography is going to help these people."

Although reactive to certain events as they unfold, Hondros plans his photography carefully, working out where he can get good pictures and relying on his experience. An essential skill for a photojournalist is to be a good communicator with the local

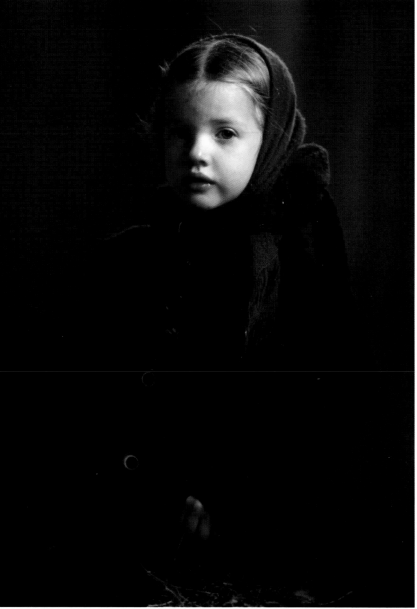

An Amish girl sits on a haystack, October 22, 2003, Wakefield, Pennsylvania, US
The Amish—traditionalist farmers who spurn machinery and other modern conveniences—live off the land, much as they have for centuries, in various communities throughout rural Pennsylvania and Ohio, although many now live side by side with modern Americans. Amish children start work on the farm early, often milling about the barn almost as soon as they can walk.

people, while not encroaching on their culture. "I like to think my photography has a realistic style. I like to create photos that simulate the experience of being in these places. Unlike some other genres of photography, I think a little bit too much artifice or style can put distance between a photographer and their subject."

Like most of his colleagues who follow conflict, especially those seeking speed, Hondros has fully embraced digital technology. Getty Images supplies its photographers with Canon equipment, specifically the super-fast EOS 1Ds Mark II. With two bodies of the same camera, Hondros adopts a 16–35mm and 80–200mm: "Which is in place to cover almost any eventuality," he says. "And, generally, I like to work without flash using available light."

Hondros says he doesn't think of his camera as being intrusive toward his subjects. "We in the West see the power of photography and are quite aware of our own visual reality, so we see a camera as an intrusive object. In most other cultures throughout the world, they're not quite as tuned in to that, and they don't see it as being as intrusive."

Hondros is aware of the need to constantly reassess his working methods if he is to remain on top. "It's important for me to keep improving my photography and always try to offer a fresh angle or approach. The best photographers are the ones who consistently evaluate the strengths and weaknesses of their images."

Tal Afar, Iraq, 2005
Samar Hassan, five, screams after her parents were killed by US soldiers serving with the 25th Infantry Division in a shooting on January 18, 2005, in Tal Afar, Iraq. The troops fired on the Hassan family car when it unwittingly approached them during a dusk patrol in the tense northern Iraqi town. Parents Hussein and Camila Hassan were killed instantly, and son Racan, 11, was seriously wounded in the abdomen. Racan, paralyzed from the waist down, was later treated in the US.

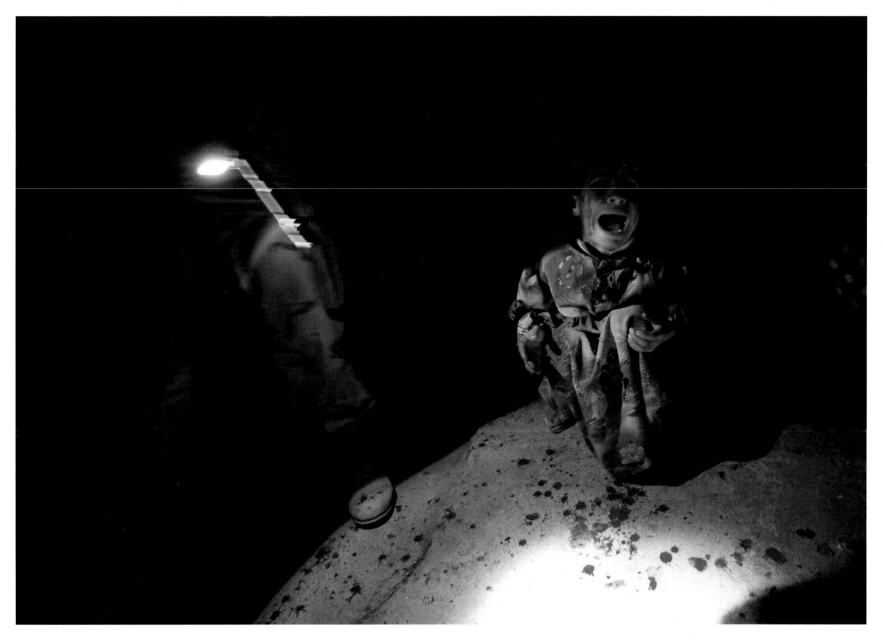

Chris Hondros

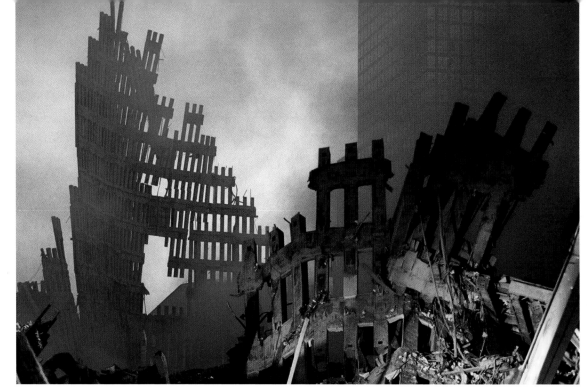

**New York, US,
September 13, 2001** (*left*)
Early morning light hits the
smoke and wreckage of the
World Trade Center, September
13, 2001, in New York. This
shot was taken just two days
after the twin towers were
destroyed after being hit by
two hijacked passenger jets.

**Peshawar, Pakistan,
2001** (*right*)
Muslims pray in a designated
praying area of an office
building, October 1, 2001, in
Peshawar, Pakistan. Peshawar
has a population of nearly two
million and is one of the largest
cities in Pakistan.

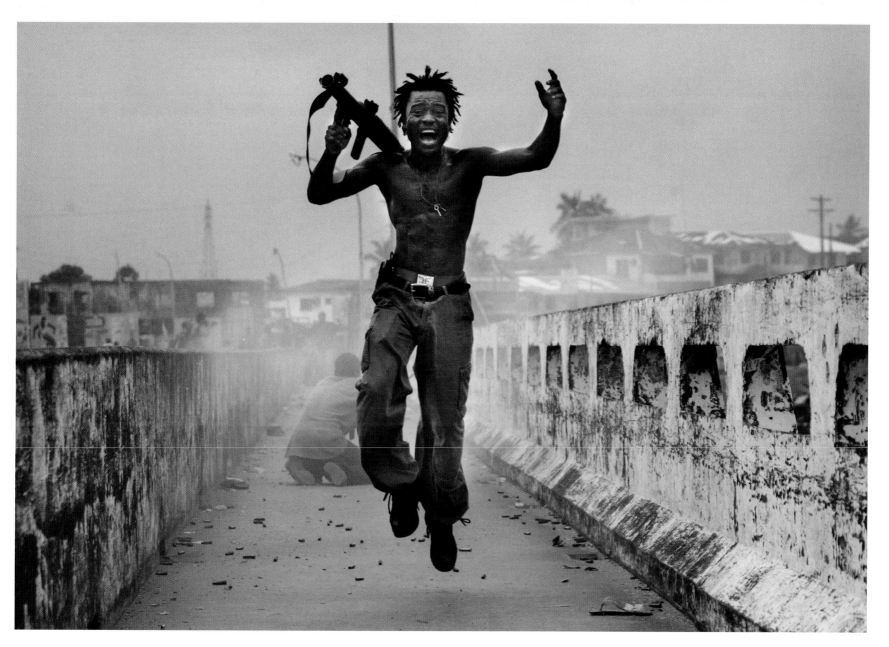

Monrovia, Liberia, 2003
Joseph Duo, a Liberian militia
commander loyal to the
government, exults after firing
a rocket-propelled grenade at
rebel forces at a key strategic
bridge, July 20, 2003, in
Monrovia, Liberia. Government
forces succeeded in forcing back
the rebels in fierce fighting on the
edge of Monrovia's city center.

Chris Hondros

Philip Jones Griffiths

South China Sea, 1971
As part of the techno-war concept, the idea of an automated battlefield was widely touted during the war in Indo-China. Aircraft carriers—known as "floating air–strips for secure attack"—would respond to requests for bombing from inland troops. The pilots and launch crews never saw the faces of those they killed and maimed. US authorities considered it important to protect the men on board from sights that could produce emotional reactions.

Philip Jones Griffiths is most famed for his poignant frontline coverage of the Vietnam War in the late 1960s and early 1970s.

"I'm not someone who gets off on violence, I hate it," he concedes. "But in war situations, you need to keep a cool head and distinguish between reality and fear. If you don't, you're much more likely to die."

For more than 40 years, Jones Griffiths' pictures have appeared in such esteemed magazines as *Time* and *Newsweek*. In 1971, his book *Vietnam Inc.* helped turn the tide of public opinion against the war in southeast Asia and is now regarded as a classic of photojournalism. Perhaps the defining quality of his work is the stark and often grotesque contrasts he makes between the human and the militaristic. He says: "I wanted to show that the Vietnamese were people the Americans should be emulating, rather than destroying."

Griffiths' bravery during his time in desperate war conditions was astonishing. "In Vietnam, I discovered that when a lot of crap was flying about, I was able to keep my cool. I've had a hood put over my head and been taken out to be shot. When my executioners cocked their rifles and fired, they missed. Obviously I was scared, but I kept thinking this was a more dignified way to go than dying in a car crash."

Born in Rhuddlan, Wales, in 1936, Jones Griffiths studied pharmacy in Liverpool and practiced in London while photographing part-time for *The Manchester Guardian*. In 1961, he became a full-time freelancer for *The Observer*. He covered the Algerian War in 1962 and later became based in central Africa, before moving to southeast Asia and then Vietnam.

Jones Griffiths' camera captured the resourcefulness of the Vietnamese and the incongruity of the US Army in their midst. "As television had taken over the task of day-to-day news transmission, and because I was one of the very few bona fide photographers with his own agenda, I was able to concentrate on conditions behind the headlines," he remembers.

Although he sympathized with Vietnam's indigenous forces, his argument has always been with the dehumanizing powers of technology and its bureaucratic apologists. "America is never punished for anything—it's always disregarded the Geneva Conventions. Realistically, and if it had the slightest interest in receiving world approval, America would at least compensate the victims."

An associate member of Magnum Photos since 1967, Jones Griffiths became a member in 1971. In 1973, he covered the Yom Kippur War and then worked in Cambodia, from 1973 to 1975. In 1977, he was based in Thailand, covering Asia. He then moved to New York in 1980 to assume the presidency of Magnum, a post which he held for a record five years.

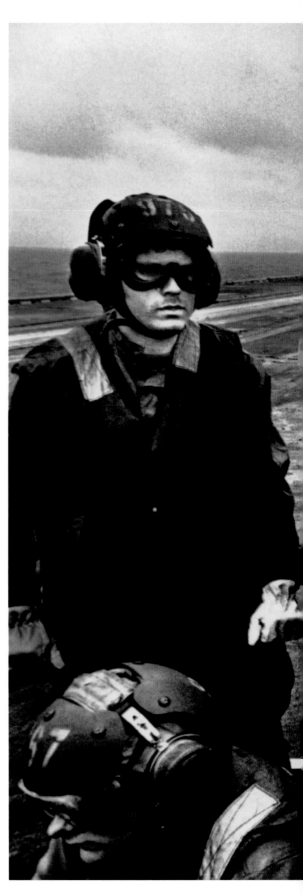

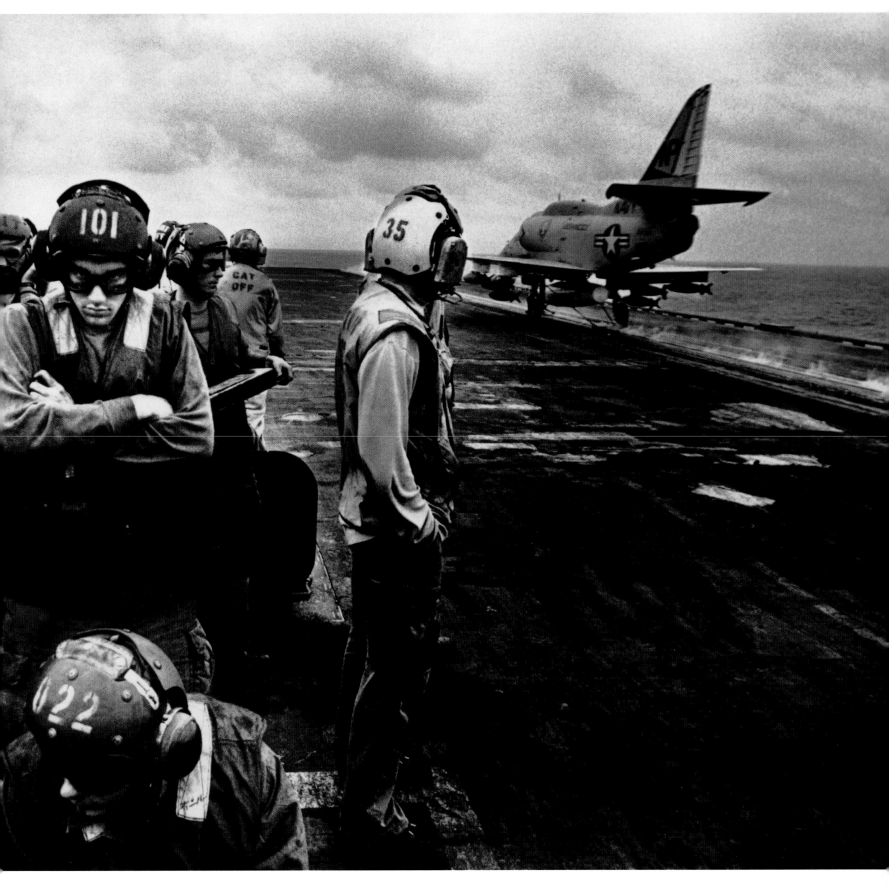

Philip Jones Griffiths

Jones Griffiths' photographs have appeared in every major magazine in the world, and his assignments, often self-generated, have led him to over 120 countries on all five continents. He has also exhibited widely in the US and Europe and continues to work for *LIFE* and *Geo* on such stories as Buddhism in Cambodia, drought in India, poverty in Texas, the reconstruction of Vietnam, and the legacy of the war in Kuwait.

He says the biggest influence on his own photography has come through the lens of Henri Cartier-Bresson. "The first picture of his I ever saw was during a lecture at the Rhyl camera club. I was 16 and the speaker deliberately projected the picture upside down, to disregard the subject matter to reveal the composition. It's a lesson I have never forgotten."

Like most leading photojournalists, he thinks the skill lies in the photographer rather than the equipment. "There is no perfect camera. Some have great bodies but lousy lenses and vice-versa. All my life, I've had this recurrent dream of discovering the perfect camera in some backstreet shop in Bangkok. Poets can scribble with charcoal on bits of paper, but we, alas, are forced to fret over the deficiencies of our equipment."

Through his photographs, Jones Griffiths continues to reflect on the unequal relationship between technology and humanity. His life's work is summed up in the book *Dark Odyssey*. His idea is that we, or at least some of us, once lived in harmony with our surroundings, later destroying ourselves with a thirst for greed and power.

Human stupidity always catches Jones Griffiths' eye, but, faithful to the ethics of photojournalism, he still believes in human dignity and in the capacity for improvement.

Saigon, South Vietnam, 1968
The battle for Saigon takes its toll on civilian life when a boy is killed. He was killed by US military gunfire while on his way to a Catholic church whose members were avid supporters of the pro-American government. The result was a disillusioned urban population, reluctant to believe in or support their discredited leaders.

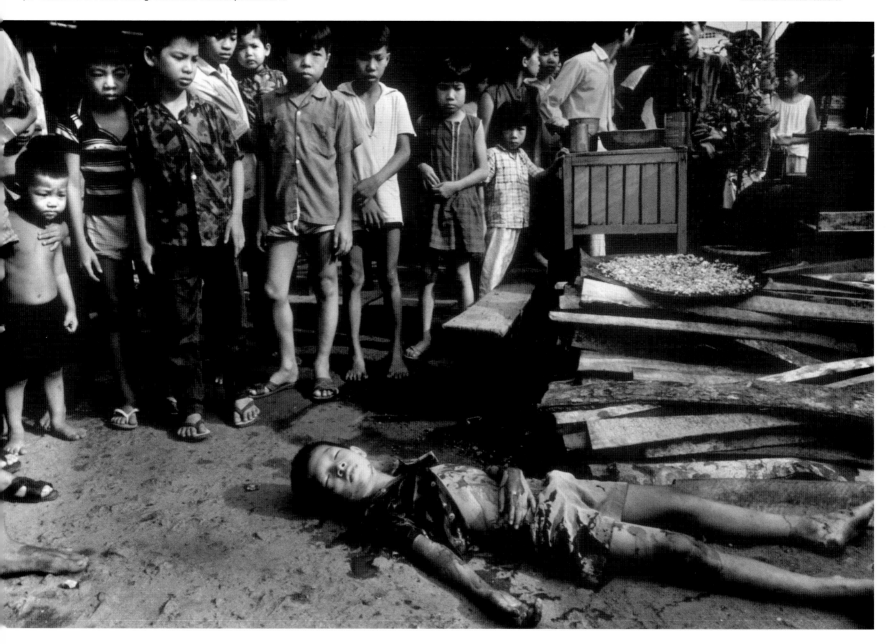

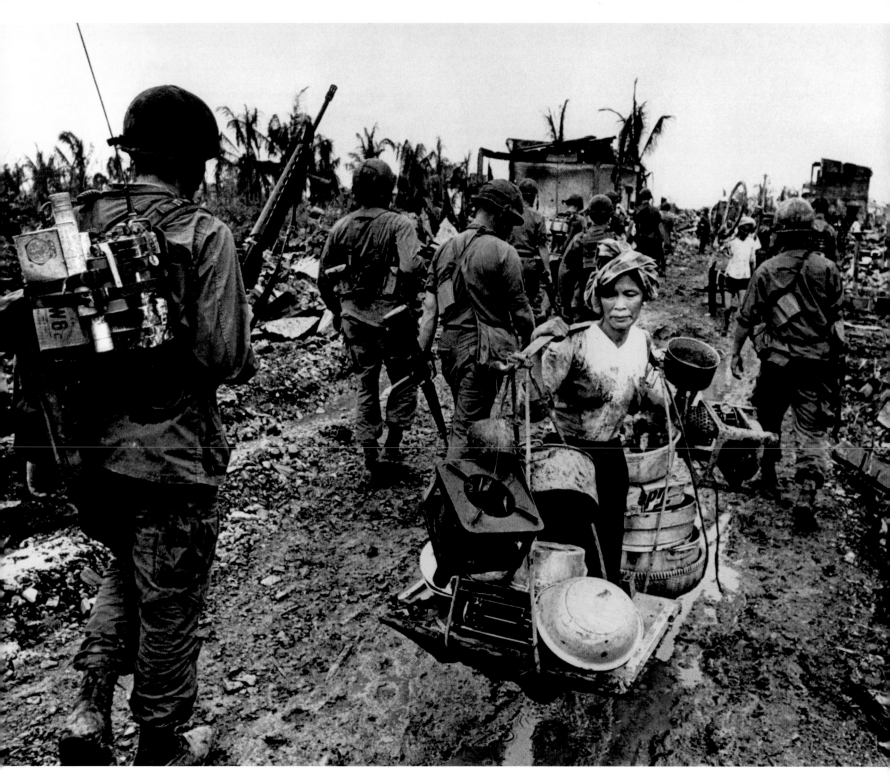

Saigon, South Vietnam, 1968
A refugee walks around in a confused state following US bombing. The area in the picture had previously been a "showcase" district of Saigon, where Catholics who had fled from North Vietnam were relocated. It was reduced to rubble by US firepower trying to "flush out" Viet Cong snipers. Casualties were enormous: unlike people living in the countryside, urban dwellers had never needed to build bunkers.

Philip Jones Griffiths

Karim Ben Khelifa

Karim Ben Khelifa is one of those photographers who chooses to tell the stories he believes in, using a format that feels appropriate to him, be it 35mm film, digital, color, black and white, or a combination of these and any other elements.

"I like to work with a wide-angle lens and most of my photography is color, although I also sometimes shoot black and white. I was not comfortable at first working with color, but now I feel completely at ease. It's just so vital for me to get up close to my subjects and bring out the best in them. I have to be close to the people I photograph because it makes it easier for me to understand them and to be accepted into their way of life. I hate working with a long lens, it's so impersonal!"

Strong words from a strong-minded individual, whose professional accolades include a World Press Photo Foundation in 2000, a Fujifilm Young Reporter Award in 2004, and a nomination for the prestigious French-based Le Prix Bayeux for War Correspondents, also in 2004.

But these accolades and his current status as one of the world's leading Middle Eastern documentary photographers were hard-fought for after working on very different jobs during his twenties. "I've had all kinds of mundane, meaningless jobs," he says. "I've worked in a gas station, I've worked as a waiter and, wait for it, I've even worked in McDonald's!

"I became involved with photojournalism by accident. I bought a camera before traveling to Nepal in 1990. When I came back, I showed the photos to a friend and she said they were really unique and that I should follow this career path. I became inspired to pick up my camera."

Armed with a Nikon FM2, Khelifa spent many years working and traveling before others began to recognize the quality of his work, often continuing with worthless jobs to supplement his photographic interest. "1998 was a turning point for me. I approached a couple of French-Swiss newspapers—*De Morgen*, *Le Matin*, and *Le Temps*—and asked if they would each give me a quarter page to photograph the soccer World Cup as it unfolded. They all agreed."

Nowadays, Khelifa, who was born in Brussels, Belgium, and has a base in Paris, frequents the countries in the Middle East that many Westerners would think twice about traveling to, including Sanaa, the capital of Yemen, Beirut in Lebanon, Oman in Jordan, numerous locations throughout Saudi Arabia, and Baghdad in Iraq.

"It is important for the West to understand the Muslim world and, at the moment, I am trying to fill this huge gap," he says passionately. "These are the places I want to go to, to report on the things that are happening and the culture. But I also document Muslim communities throughout Europe because I have the ability to help link the West and Middle East with my images. There is also a lot of misunderstanding in the Muslim community about the West and, importantly, I have enough experience to photograph a situation with the respect it needs, and to help translate it to another direction where it can be understood."

Magazines such as *Time* and *Newsweek* are the types of publications seeking fresh ideas and angles from photojournalists like Khelifa, who likes to record events that perhaps have not been covered by journalists as much as they should.

Kerbala, Iraq, March 2004
"For only the second time since the fall of Saddam Hussein, Shia Muslims were able once again to celebrate the traditional Ashura ceremony. More than one million pilgrims from all over the world had converged on the holy city of Kerbala. In the early hours of the seventh day of Ashura, men carrying traditional swords had been waiting for the sun to rise. At first light, they started beating themselves across their skulls. The light conditions were awful, but the atmosphere was incredible, with people chanting and screaming. I work mostly with a Nikon 20mm and an old F3, meaning that I have to be very close to the subject. That morning, with swords lashing out in all directions, and all the men and boys in a religious trance, I had to try and transfer the intensity of what these people were experiencing, while trying not to get cut."

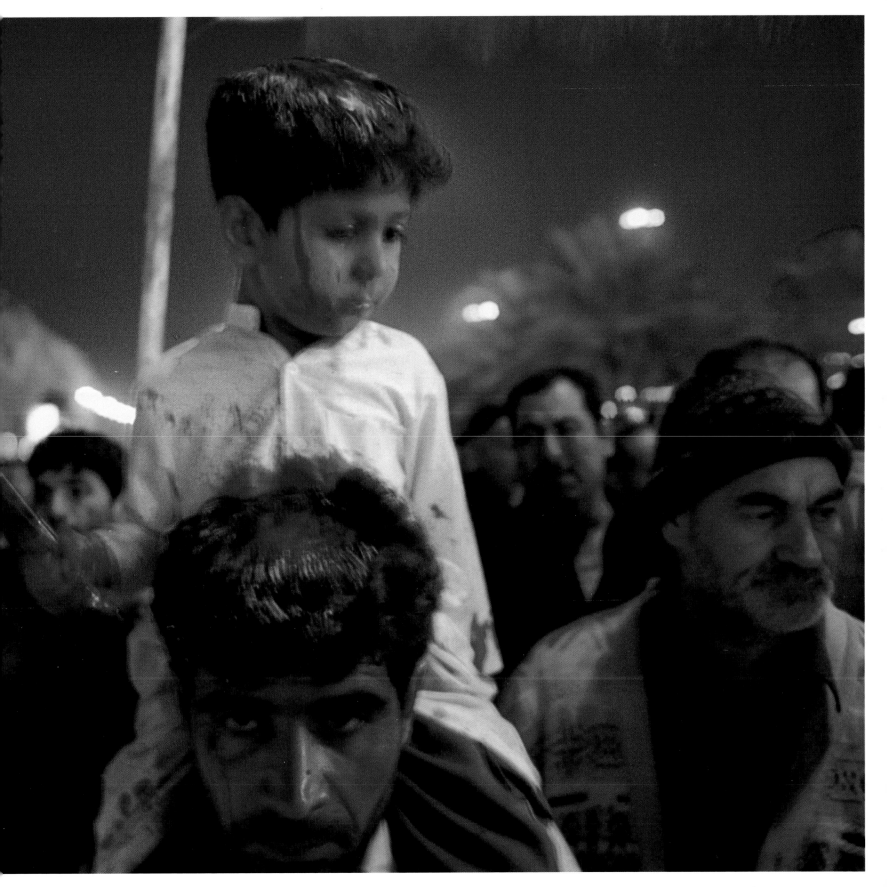

Karim Ben Khelifa

Biara, Iraq, March 2003
"In Biara, in the mountains in between Iraq and Iran, a day after the Peshmergas, with the aid of US special forces, took over the village. Almost every house and mosque in the area had been destroyed by the air strikes of the previous two days. I tried to depict the idea of a totally destoyed area in a single photograph by shooting an out-of-focus portrait of a Peshmerga fighter in the midst of the ruins."

Sadr City, Iraq, June 2004
"The Friday prayer in Sadr City, the huge Shia slum on the outskirts of Baghdad. At the time, daily clashes occurred here between the US army and members of Moqtada al-Sadr's Mehdi army. The Friday prayer is where the believers get direct recommendations from Moqtada al-Sadr. His representatives are surrounded by bodyguards—protection against both the US military and surprise suicide attacks. Because of the security concerns, the bodyguards usually don't allow anyone to get close. I managed to shoot this picture by staying no more than 15 seconds. I saw one of the bodyguards coming from the left, and took three steps back to get the angle I wanted. Once I had shot the photo, I left the scene immediately and went on to shoot from the rooftop of a nearby building."

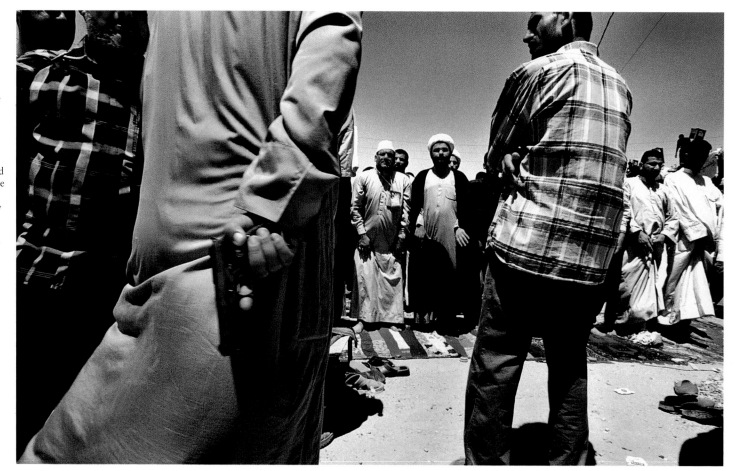

Biara, Iraq, March 2004

"A group calling itself Ansar al-Islam had been hiding out in the mountains of Iraqi Kurdistan on the border with Iran. The village of Biara was like a little Kabul, with a strict Sunnite version of Islam being forced on the population. US Secretary of State Colin Powell mentioned this area during his speech at the United Nations in February 2003. He made it the missing link to Al Qaeda and the regime of Saddam Hussein (even though it was in an area of Iraq not under the control of Baghdad). After US special forces and the local Kurdish fighters, the Peshmergas, supported by US air strikes, flattened the area, some men belonging to Ansar-Al-Islam fled the mountains and tried to blend in with the population of the Kurdish villages below. Many were found out and killed at Kurdish checkpoints. This man was killed a few hours earlier on a mountain road, by Peshmerga fighters who thought he might be carrying a suicide belt; they didn't bother to check first. The Peshmerga stopped a group of Westerners at one of the checkpoints and took them to the body."

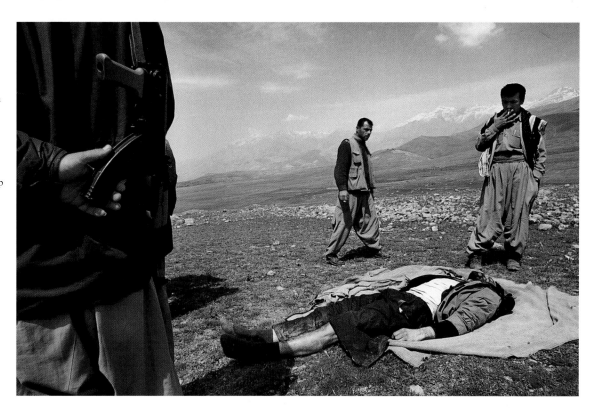

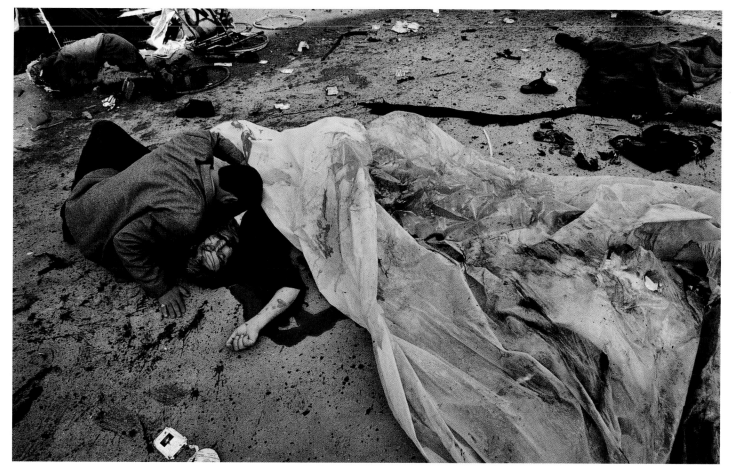

Kerbala, Iraq, March 2004

"Later that same day, around nine a.m., six bombs exploded all over the city, creating an unbelievable panic. The dead were lying side by side with the wounded, blood, glass, and shrapnel covering the ground. People were running for cover, while others were helping the wounded. Everybody was screaming, crying, and imploring Allah. In all, 106 people died in two coordinated attacks in Kerbala and Kadhimiya, a Shia area of Baghdad. In this photo, a man has just found his brother dead, lying in the middle of a street, covered by a plastic sheet."

Karim Ben Khelifa

Khelifa's tools are a Nikon F3 35mm film camera from the 1970s, while he uses just two lenses—20mm and 105mm Nikon-mount attachments—both reflecting a person who works with short focal lengths for close-up shots. "I also have a Canon 1Ds Mark II, which I use for my really fast assignments, but I still prefer the look and feel of film."

In recent times, Iraq has been the most geographically important for Khelifa, not just for the attention his work has received, but also for the love and commitment he has for the people there. He says the worst thing a photojournalist could ever do is only to photograph a situation that the public at large wants to hear and believe.

"If you want fame, then your best chance is going for a job as a fashion photographer. Or you could do a job that makes you lots of money. I'm pessimistic about what is going on in the world right now, but I'm optimistic that my photography can make a big difference.

"I often find myself in a situation I didn't expect to be in and I'm always having to develop new skills to cope with changing circumstances. For me, that's the most exciting part of all."

Kufa, Iraq, March 2004
"Halfway between Baghdad and Najaf is the city of Kufa. It is one of the holy sites of Shia Islam, and at the time it was also the stronghold of the rebel forces of the Shia leader Moqtada al-Sadr, which had been doing battle with coalition forces in Iraq. Busloads of Iranian pilgrims had made the journey to Kufa and Najaf in order to visit the holy shrines there. I hadn't seen the women coming from my right at first; they just appeared in front of my camera on their way to the mosque. I knew I wouldn't be able to shoot more than one frame before they noticed me, so I waited for a quarter of a second until the bus and the women were perfectly aligned. I rarely feel that I've got a great shot, but that day I had the feeling that this one would work out nicely."

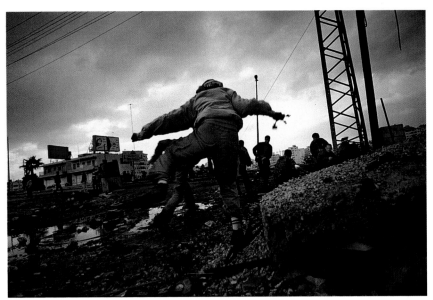

Ramallah, Palestine, November 2000 *(left and below)*
"The second Intifada had just started and I had no assignment at that time. I decided to go to the West Bank anyway. This is a hard conflict to photograph in the sense that there are already so many pictures of young Palestinian boys throwing stones at Israeli armored vehicles. Luckily, it had rained that morning, so I was able to work with the reflection on the large puddles of water that had formed in the streets. The photos were taken in the late afternoon. After a day of Palestinian boys versus Israeli military, the place was emptying out and the last angry youths were throwing the last stones of the day."

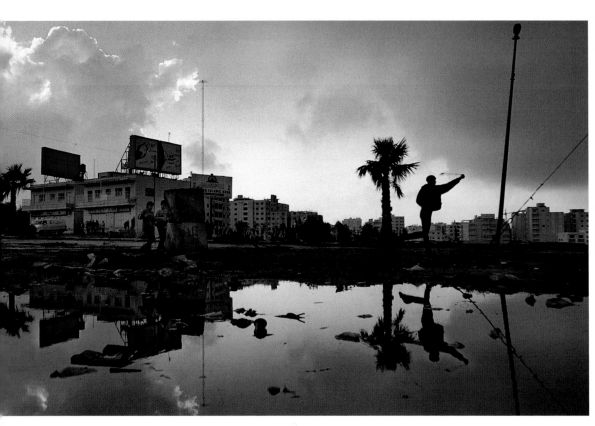

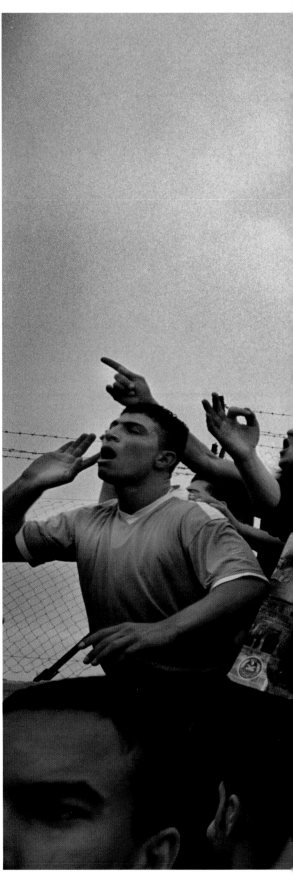

The funeral of Palestinan president Yasser Arafat in Ramallah, Palestine, November 2004 *(right)*
Young Palestinians are chanting anti-Israeli slogans and singing pro-Arafat songs. When you're shooting with a 20mm lens, you have to get close to the action.

So I decided to be in the middle of the crowd, looking for the best angle to depict the scene and its intensity. Posters of the late president were moving in between the Palestinians—hands, faces, and the poster of Arafat were blended and made that photo possible."

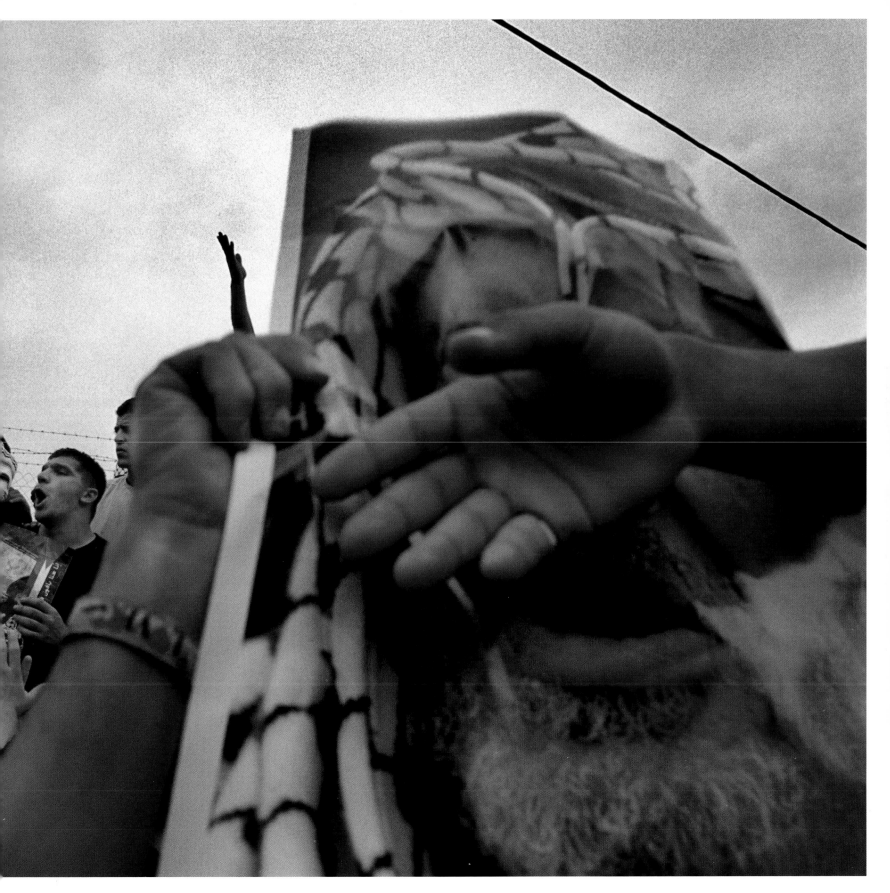

Karim Ben Khelifa

Edwin Marcow

Most people don't choose their profession, they stumble into it. The same, however, cannot be said of Edwin Marcow, who, since the age of 15, has dedicated his career to documenting the plight of the Great White shark and its habitat.

"The Great White—*Carcharodon carcharias*—is my favorite subject," enthuses the Cape Town-born Briton, "because it's the most beautiful and graceful animal in all the natural world. Unfortunately, it is also the most misunderstood."

A typical day for Marcow might involve getting up at dawn, traveling out to sea, and attempting to push a Great White away with the waterproof housing of his Nikon F100 35mm film camera. It's simply not a job description many can lay claim to.

"Prior to picking up my camera, I'll first spend time studying the shark's behavior from the safety of the boat," continues Marcow. "This gives me a better understanding of its mood and enables me to capture the essence and peak of the action when it finally happens."

This practiced method springs no surprises: he's got much less chance of being bitten or even eaten if the shark has already sated its appetite. "It's actually due to a number of factors," Marcow stresses. "Essentially, if a Great White has already eaten, then there's less chance of it seeing me as a source of food. Experience of working with the beasts also tells me when

to get in the water—if a shark's pectoral fins are flexed and the body rigid, or the mouth is open and gaping, it's a clear indication that it's in predatory mode and wants to eat something."

Underwater photography requires a lot of patience. It is often a case of waiting for the subject to come into view. "When I'm composing a shot underwater, it is important to have the basics under control, freeing you up to think about the fine-tuning. I love taking pictures using natural light and try to work with it and just fill in the missing color with flash," says Marcow. "Unless you're in the first three meters [10ft] of depth, where you get the most beautiful dappled light, common with sunrise and sunset, I'll often need to add to it.

"My flash is always almost set to -⅓ stop with the right depth. I find, with this method, most subjects are correctly exposed with no overexposed burn on critical parts of the subject. If I'm trying to match foreground and background light levels, but just need to add that kiss of light, I'll shoot the flash as much as -0.7 of a stop."

It's essential for Marcow to get the shots he wants quickly because being a marine photojournalist isn't cheap. And when it comes to taking pictures that people are interested in, Marcow says you have to bear in mind where the shots will be published. He prefers wide-angle shots that show the whole scene and diving conditions, rather than abstract close-ups.

Gansbaai, South Africa, July 2004 *(left)*
"We had been beset by poor weather and I had spent the last few days either watching the rain trickle down the windows, or obsessively watching any and every weather report. Then, as it can in Gansbaai, the sun broke through at about ten o'clock and we raced out to sea. Great White sharks are the only known sharks to "spy hop," to look out of the water to see what is there. The shark wranglers kneel on a metal ridge between the two outboard engines and try to entice the shark to the boat with shark liver or "chum" [a blend of fish juices and parts]. Once they have a shark, they will try and keep it close to the vessel with the bait. The shark will often circle the boat, and when the shark passes the wrangler and bait, a well-placed hand on the shark's nose will stimulate it to open its jaws to display its fearsome armoury of enamel. This natural reaction is hardwired into the shark's brain and is part of the biting and feeding action. This has occurred time after time with no injury to either the wrangler or, more importantly, to the shark."

Gansbaai, South Africa, July 2002 *(above)*
"On July 25, 2002 I became one of the first people in the world in South African waters to photograph a Great White from the sea floor."

Edwin Marcow

"On land, a 50mm lens is the standard, but underwater it's 35mm. An 18–35mm lens gives me tremendous flexibility to frame the image I want. I like using short zoom lenses because they give me the freedom to have a better relationship with my subjects—when a Great White won't let you enter its comfort zone, having a zoom option is a big help!"

Given his expertise, it is no surprise that Marcow was awarded Gold and Silver in different categories in the prestigious 2004 Austrian Super Circuit competition, for an image of a Great White swimming with its mouth open, directly toward the camera. His amazing shots, which "help to tell the world about this wonderful species," have also earned him a second place in the renowned *Sport Diver* magazine PADI competition, and a Highly Commended accolade in the International Photo Art competition.

"Very few people can take the type of images that I do; it's a specialist market, which allows me to have some flexibility when I negotiate the placement of my pictures. The market isn't very big, but there are opportunities if you're good enough with the shots."

Marcow says that being one of only two people in the world to photograph Great Whites in South African waters from the sea floor without the use of a protective cage is his greatest achievement to date.

"I was on assignment to shoot an advert for a scuba-diving equipment company with the simple brief: to photograph a diver wearing scuba gear alongside a Great White. Instead of one shark, we had three, the largest measuring four-and-a-half meters [14¾ ft]! Our guide, Andre Hartman, called us to descend to the sea floor from our position on the surface. My descent was slow because of the conditions, which brought me into the path of the largest shark. He slowed his pace and edged

Gansbaai, South Africa
"A Great White breached the surface of the ocean and lunged past the two outboard engines, as it charged down the well-placed shark liver floating in the swell. Shark liver—a particular delicacy to Great Whites—can stimulate this type of behavior. At the time, I was sitting on the starboard outboard engine barefoot, feet dangling on the

surface of the water, with a deck hand holding on to my waist so I didn't fall in. As the shark approached, I was sure that I was going to be in the way and get hurt or might worse still, be bitten. I managed to fire off this shot as the shark pulled on the bait with such force that I fell backward onto my safety supervisor!"

closer until he was right in front of me. His black, motionless eyes fixed on me and I felt as if time stood still. Finally, he broke and maneuvered directly beneath me. In a reflex reaction, I raised my knees and tucked them into my chest to prevent making contact. Once out of direct confrontation, I surveyed the scene and decided to make for the seabed as quickly as I could. But, to my surprise, this massive shark was now turning his huge body to swim back toward me again.

"Realizing he was not going to break his run this time, I had to act immediately. I swam toward him and pushed my camera into his nose until he eventually broke and banked away. I then swam directly over the shark with inches between us. I did a half tumble-turn and, as he banked, followed him, swimming side-by-side while maintaining eye contact. With this second moment of reprieve, I dived down and, as I hit the sea floor, turned, and shot the photograph [see page 87]."

Although it's been extremely dangerous, Marcow looks back at his career with fond memories, and says he would encourage anyone with a love of sharks and photography to pursue it as a career. "When you've spent hours waiting for a Great White to appear and for something to happen, and it does happen and you capture it on film, it's the best feeling in the world."

Gansbaai, South Africa, August 2000
" I was flying to Gansbaai, South Africa, to assist in the production of a documentary for *National Geographic*. My in-flight magazine had an excellent article about Great White sharks, abalone farming, and the abalone poachers. I read it through twice, closed my eyes, and prayed that I should be so lucky to capture what I had just perused. We touched down in Cape Town, and after a two-hour wait due to a logistical problem, I jumped in my ride to Gansbaai, a further two-hour ride to base.

"Once at base, I only had time for a quick coffee and to wash my face before racing to port to catch the boat, which was casting off. I jumped on board as we slipped our moorings and headed out to sea. Then, [I got] seasickness, brought on from extreme fatigue. Ashen-faced, I recomposed myself, suited up, and rolled into the shark cage. I looked up to see this very large Great White charge at the bait, I fired off my camera and took this shot. My prayers had been answered; I got what I was looking for and more."

Edwin Marcow

Great White shark's teeth, South Africa

"Whenever I see shark teeth and jaws for sale, I am always filled with sadness and anger. You can log onto the Web and buy sharks' teeth necklaces and assorted jewelry. I have even seen a single Great White's tooth marked for sale at £2.20 [$4 US]. How sad it is to see such a magnificent and perfectly evolved animal, that was swimming in the oceans when dinosaurs walked the earth, belittled to some kind of novelty item. The protection of all sharks throughout the oceans is imperative to safeguard the health and ecosystem of the seas, and the very future of all marine life.

"South Africa, the first country in the world to protect the Great White, has seen tourism in towns like Gansbaai rocket, and a whole shark cage-diving industry has evolved, with hotels and bars to service and look after the eco-tourists. I believe a live shark has far more worth to mankind than a dead one sold for jewelry."

Sea kelp forest, South Africa
"Thick underwater forests of sea kelp (*Ecklonia maxima*) dot the topography of the ocean floor, from Dyer Island to Holsbaai, near Pearly Beach in South Africa. These forests are so thick that not only do they act as a nursery and sanctuary for the juvenile Cape Fur seals, but also for abalone poachers, too.

"Dyer Island is named after its first resident, Sampson Dyer, an African-American slave. In 1806, his American employers left him there to run a seal-culling operation. Dyer Island and its sister island, Geyser Rock, lie side by side some 3.5 nautical miles out to sea.

"Separated by a channel of water affectionately called "Shark Alley," these islands are famous for three things: a very large colony of sea birds, thousands upon thousands of seals, and Great White sharks that are ready to pick off any stragglers left behind. For any juvenile seal not skilled in the art of defensive swimming back to the islands, his best bet is the safety of the sea kelp forests—so thick and dense, sharks will not swim into them, as they could get stuck. Sharks cannot swim backward, only forward, so it could mean death."

Edwin Marcow

Don McCullin

Don McCullin is arguably one of the greatest conflict photographers of our time. His amazing career has covered much of the latter part of the 20th century, a relentlessly photographed period steeped in political friction and cataclysmic events.

Over the last four decades, his illustrious lens has seen the world's most troubled areas and recorded the most harrowing scenes of death and destruction. He has found almost unbearable tragedy throughout his travels, but also examples of people rising above the pain and misery of their situation.

Importantly—and it's fair to say, more so than any other individual—it is McCullin's inspirational photojournalism that has been the catalyst for others to follow intrepidly in his footsteps.

Perhaps best known for his stunning and shocking war images of Cyprus, Vietnam, Biafra, and the Lebanon, McCullin's photographs have hitherto revealed a ravaged northern England, riots in Northern Ireland's Derry, and famine and disease in Bangladesh and Africa. All have been photographed with unswerving courage and compassion that have left others full of respect.

One could argue that it is McCullin's working-class background and tough upbringing that has enabled him to empathize with, and to some extent tolerate, his surroundings. Born into a poor family in a tough neighborhood near Finsbury Park in London, McCullin went into a dead-end job when he left school. At 18, he was called up for National Service and volunteered for photo-reconnaissance in the Royal Air Force (RAF). It was here that he learned to use a camera.

"My photographic career was an accident. I was brought up in Finsbury Park, and that was the greatest university I could have attended—it galvanized me for the world I was to see."

When McCullin left the RAF, he returned home, taking with him a Rolleicord Twin Lens Reflex camera he had bought while on service in Kenya. One Sunday in 1958, he got some of his friends to pose in the skeleton of a burned-out house. A few weeks later, some of this gang were suspects in the murder of a policeman. He took the photo to show the picture editor of *The Observer* newspaper, who asked him to go and take some more of his friends, and three were published.

McCullin got offers of work from other papers and went out and bought himself a 35mm Pentax SLR and became a photographer.

In 1964, *The Observer* asked him if he would cover the civil war in Cyprus for them. It was his first experience of war and produced some of his finest and most famous pictures, winning him the World Press Photo Prize and the Warsaw Gold Medal.

After this came many other wars: the Congo, Vietnam, Biafra… McCullin hated war, but was determined to show the grief and tragedy it caused to both soldiers and civilians. In Biafra, he photographed the effects of the terrible famine—subjects with painfully spindly limbs, empty breasts, protruding ribs—but often found a great nobility in those close to death.

He has twice been Photographer of the Year, and has won two gold awards and one silver from the Designers and Art Directors' Association.

After documenting the troubles in Northern Ireland, McCullin had become weary of war and decided to spend time documenting the homeless down-and-outs on the streets of London.

The Bogside area of Londonderry, Northern Ireland, 1970
A street resident cowers away when the British Army's Anglia regiment counterattacks stone-throwers. McCullin's war photography had proved so painful and memorable by 1982 that he was forbidden to cover the Falklands War by Prime Minister Margaret Thatcher's British government.
 "There are aren't many places in this earth I haven't been. I have traveled extensively, more than anyone I've ever known. The thing about me is I'm not financially rich, but I am incredibly wealthy as a human being."

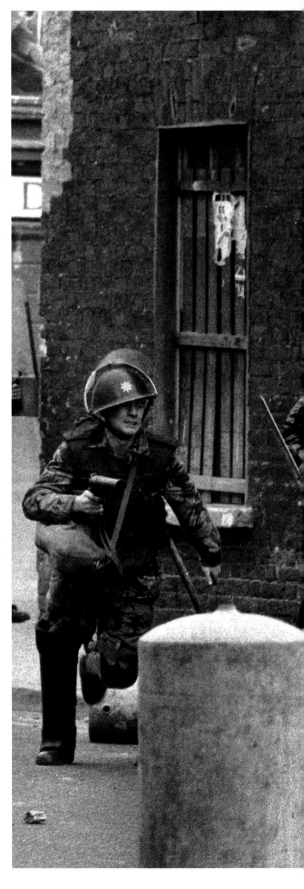

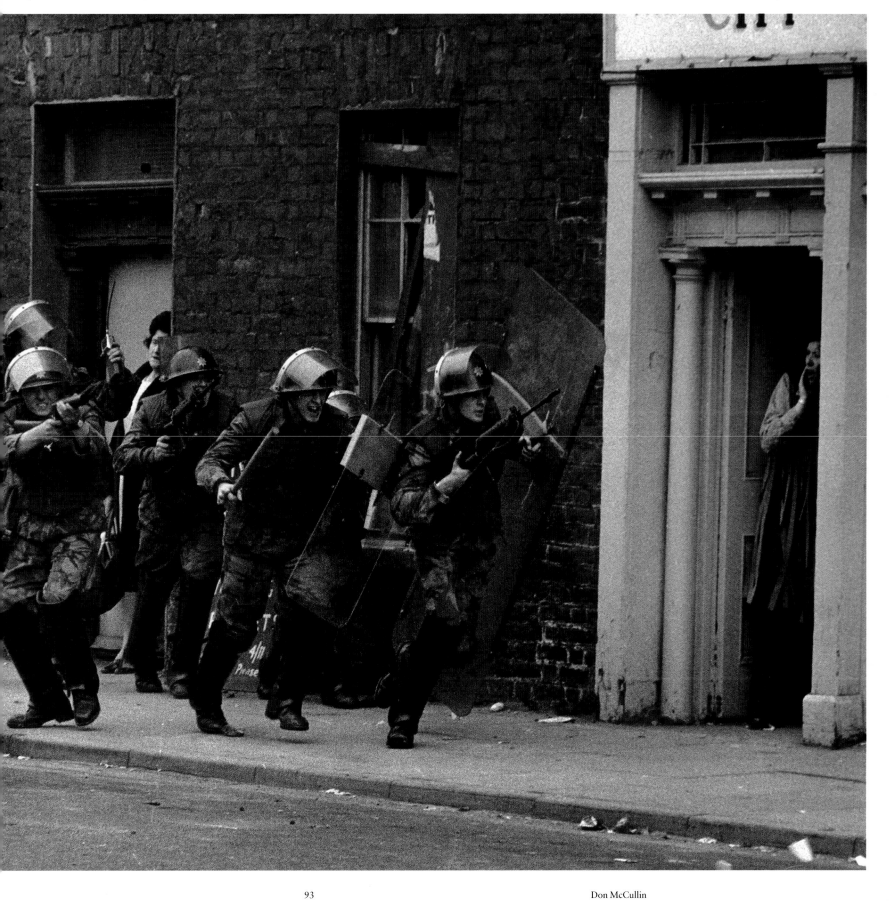

Don McCullin

More recently, McCullin has photographed the English countryside and worked in Africa, in 2001 for Christian Aid, and from 2003 to 2004 in Ethiopia, recording the changing culture of a number of local tribes—the topic of his book *McCullin in Africa*.

He said of his travels there: "Unless we address the root causes of poverty by canceling the overwhelming debt owed by these countries to the wealthy nations, and change the trade rules which blatantly favor rich countries, it will be even more difficult. These photographs should strengthen our determination to end these injustices."

McCullin acknowledges that he has become, in his own words, damaged. "I'm not a person who wants to go stealing images of other people's grief. I am Mr. Guilt himself, I'm the hod-carrier of guilt, you know. I don't sleep well… I wake up and think about things. I can still remember the day I saw a man shot in cold blood in front of me.

"It's not always convenient, but these memories come back at the most terrible times: sometimes at night, sometimes on a sunny day when I'm sitting in my garden, or walking through woodland. Photography has been very, very generous to me, but at the same time it's damaged me, really."

Naturally, words are no substitute for images, and some of McCullin's most memorable images need little captioning to accompany them. However, his comments are a perfectly healthy reaction for any intelligent being who has experienced situations others seldom dare to imagine.

Collectively, McCullin's photographs constitute one of the great documents of human conflict and its attendant grief, expressed with a visual lyricism that allows us to glimpse the unbearable.

Beirut, Lebanon, 1976
McCullin was ordered, under threat of death, to leave the area when he came across the Young Christians beside the body of a teenage Palestinian girl.

He says: "I can read a book and forget all about it within the hour. But I can remember hundreds and hundreds of pictures."

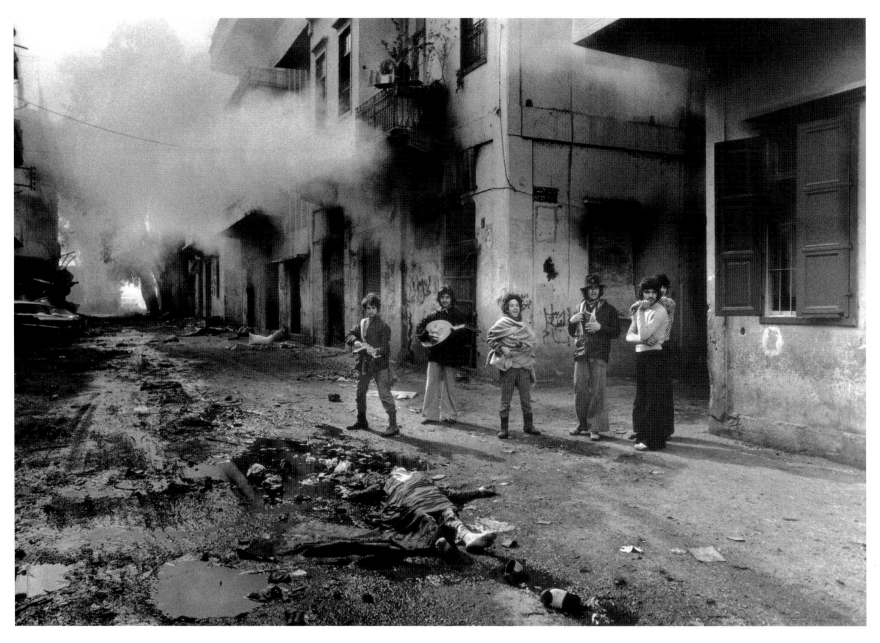

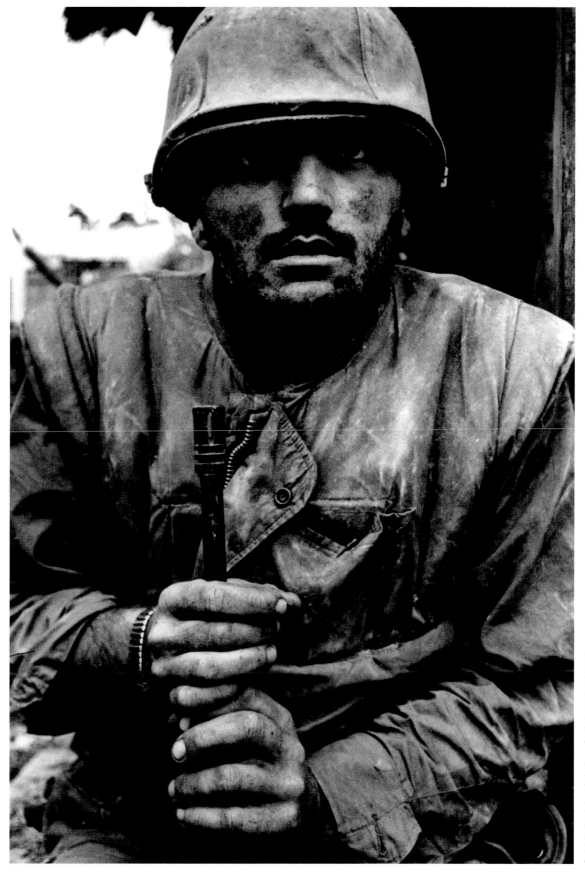

Vietnam, 1968
A close-up of a shell-shocked US marine, portraying a dramatic moment of supreme human emotion under maximum distress, captured with McCullin's incredible compassion and empathy.

"I got into a big battle with the Fifth US Marines at Hue, the biggest battle of the Vietnam War. Two weeks of living there and seeing dead bodies just yards from where you were sleeping at night, I came home a bit mental, actually. But I did have the best set of pictures I'd ever taken."

Don McCullin

Jeff Mitchell

When the British Prime Minister's former chief press secretary, Alastair Campbell, presented the Fujifilm Photographer of the Year Award to Jeff Mitchell during the prestigious Picture Editors' Awards in London's Guildhall in 2003, it came as little surprise to many within the industry.

The leading news photographer and Getty Images staffer had already demonstrated his picture-taking skills and versatility, with a string of awards throughout the late 1990s and early millennium, spanning a diverse range of genres.

Mitchell won Young Photographer of the Year in 1996, Royal Photographer of the Year in 1999, and Business and Industry Photographer of the Year in 2000. In 2001, he received first prize in the Nature and Environment category at the World Press Photo Awards in Amsterdam, and in 2003, as well as receiving the Fujifilm award, picked up the Sports Photographer of the Year Award.

Like many of today's leading photojournalists, Mitchell started young, but had no formal photographic training. "I didn't study at college," he remembers. "Both my father and brother worked in the photographic industry, so I learned quite a few techniques from them at a very young age."

In the late 1980s, at the age of 19, Mitchell took up his first post with a local newspaper, the *Helensburgh Advertiser*, based about 25 miles (40km) from Glasgow, Scotland. He stayed here for about two years before moving to the *Edinburgh Evening News*, which turned out to be something of a lucky break.

"This was the turning point for me," he recalls fondly, "because I was placed among experienced photographers like Ian Rutherford, which gave me the chance to watch and learn. I was encouraged by the picture editor, Rod Sibbald, who had a big influence on my work."

As a young press photographer in Scotland, working for *The Herald* was something to aim for and, after several stints with smaller publishers, Mitchell joined the newspaper in 1993. It was a big step up, and he was soon covering major events as they unfolded, including the Dunblane massacre in 1996.

"My photography was more influenced by people and events than anywhere else I'd been before. I worked alongside an experienced picture desk and a team of very seasoned, award-winning press photographers," he says.

Donald Dewar's funeral, Glasgow, Scotland, October 2000
"You could say that this is one of my strongest photographs, of [politician] Donald Dewar's funeral, taken quite early in the morning, about nine-thirty a.m. I managed to get into pole position before the other photographers arrived... I went in and I didn't just start shooting—it was a bit more respectful than that. I think I had three or four minutes to get the shot, which I took using natural light with no flash. The rose and the shape of the coffin made for a good picture; I think it's a really symbolic image, especially fitting for a Labour MP with the red rose."

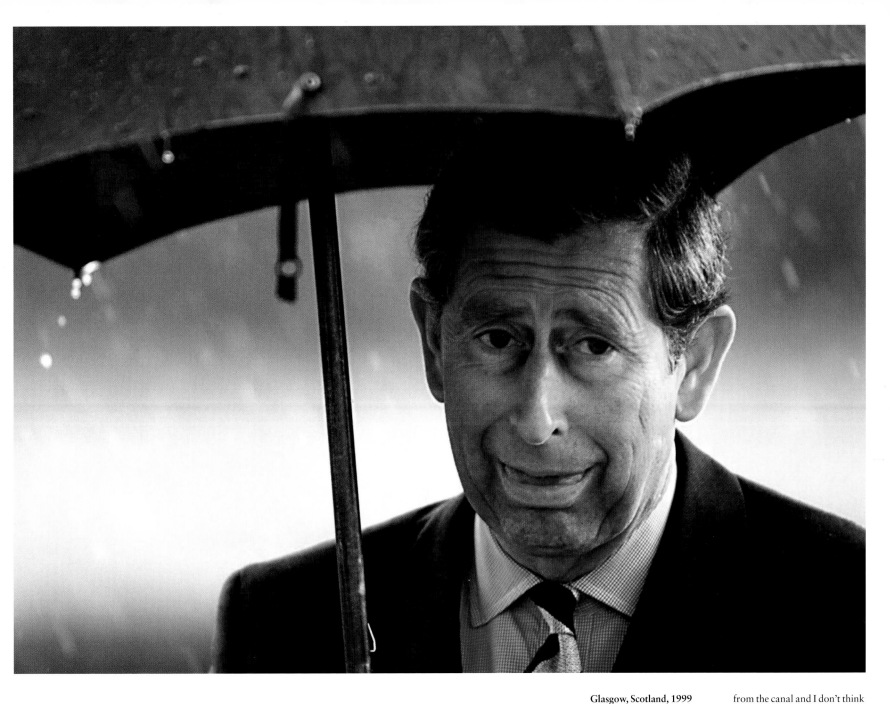

Glasgow, Scotland, 1999
"The Forth and Clyde canal had been having major restoration work, so it could be opened and used to link Edinburgh and Glasgow. Prince Charles was with the Prince's Trust to promote the event. I was in town doing a general shoot in the Mary Hill area of Glasgow, which wasn't far away; it was one of those typically Scottish days— sunshine one minute and showers the next. Charlie just happened to walk off the boat from the canal and I don't think he was conscious that he was pulling such a bizarre face. I used a 300mm lens, so he was a little bit away from me, and I remember there being quite a few photographers in front of me. I didn't know I'd captured his funny expression, and it was only when I got back to edit the pictures that a colleague said to me 'That image is an absolute cracker!' I ended up winning the Royal category in the 1999 Picture Editors' Awards in London's Guildhall."

Jeff Mitchell

Netherplace Farm, Lockerbie, Scotland, March 2001
"This was taken very early, just as the light was breaking. It was ironic that something like this was happening in a place that had already had its share of disaster. I remember using a 400mm lens with 2x converter—so it was equivalent to 800mm in focal length. I went to the edge of this field in the farm and saw these huge carcasses just burning everywhere, with no effort made to hide them from view. It was one of a series of almost 'biblical-type' pictures that were taken during the foot and mouth crisis that year. At the time, I was concentrating on getting the picture, even though it was extremely sad and the farmer's business was literally going up in smoke."

Glasgow, Scotland, 2004
"Three Iranian Kurd asylum seekers were about to get deported because they had failed to get their refugee status. All of them stitched up their mouths, but this particular guy, Fariborz Gravindi, characterized the whole episode for me.

The desperation to starve yourself and make that kind of statement by sewing up your mouth must have meant he felt so passionate about not going back to his own country. He wanted me to photograph him; as soon as I took the shot, I knew it would work."

Jeff Mitchell

Mitchell remained at *The Herald* for three years before Ian Waldie, who at the time worked for Reuters as its Scottish stringer, approached him. "Ian was leaving Scotland for London and asked me if I wanted the post—which I accepted."

He stayed with Reuters until 2006. Shooting for such a well-known and respected agency enabled him to document major news stories such as the foot and mouth crisis in 2001, as well as some of the world's most prominent sporting events, including the soccer World Cup and the Winter Olympics.

It's the type of photojournalism that calls for an all-round technical ability, and Mitchell has certainly risen to the challenge. "Sports photography wasn't always my strong point, though with time and practice it has become easier," he says.

Mitchell reckons he now feels happy with all areas of his work. "Although there is always room for improvement!" he underlines. "At Getty, I have to cover all aspects of photography, so I can't place myself in any one area of photojournalism. I have to be flexible enough to cover anything and to create pictures which can be published in tabloids as well as [serious] broadsheet newspapers."

So, does he have a secret technique that sets his work apart from other photographers? "I never go on a shoot with preconceived ideas. You can never predict what the situation will be, and your photography can often be limited by bureaucracy and security. You have to remain flexible and be innovative when opportunities are restricted."

Not surprisingly, film is a thing of the past for Mitchell. "Working for a fast-moving news agency, film simply doesn't fit into my timescale," he says. "I am happy with digital and I have no intention of using film again."

A pair of Canon EOS 1DS bodies form the basis of his kit, together with 16–35mm, 70–200mm, and 400mm lenses, and two flashguns.

But Mitchell is quick to point out that shooting digitally has not altered the integrity of press photography, at least as far as Getty Images is concerned. "Absolutely no manipulation is permitted at Getty—we are only allowed to enhance an image as you would in a darkroom, but nothing else. It is a serious offence to tamper with a picture."

So, having won the UK's most prestigious photojournalism awards, what might the future hold for Mitchell? "I haven't got a crystal ball. But I do know that I want to continue keeping up the standard and getting involved with all the world's major events as they take place. In this line of work, you can never stand still thinking you're great, so you must always analyze your day-to-day pictures and continue to work on improving. If you give up trying, you may as well hang up your camera."

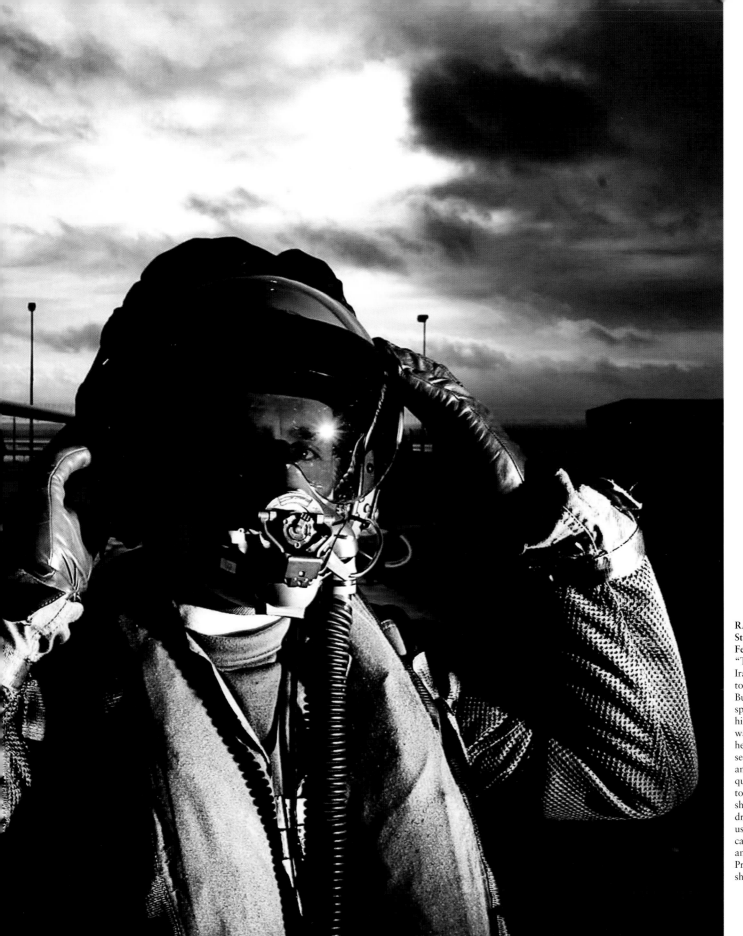

**RAF Leuchars, near
St. Andrews, Scotland,
February 7, 2003**
"The guys were going off to
Iraq, so I asked for permission
to shoot Squadron Leader Tim
Bullement, who looks like a
spaceman standing in front of
his Tornado fighter. I think he
was one of the first people to
head out to the Gulf before the
second conflict started. I used
an off-cable flash because it was
quite dark; I thought I would try
to massively underexpose the
shot, which made for quite a
dramatic backdrop. If you can
use flash off-camera, you
can really get the right effect
and bring the picture to life.
Probably one in every 100
shots turn out as good as this."

Inge Morath

Inge Morath was a subtle but evocative photographer who used her camera as a means of celebrating what she respected and valued: civilization, artistic achievement, and the significance of place.

"I am especially interested in photographing in countries where a new tradition emerges from an ancient one. In my work, I am more attracted to the human element than to the abstract," she once said.

Born in 1923 in Graz, Austria, Morath had parents who were scientists and took her on their many European assignments. Like millions of others in the Germanic region during the 1940s, she became displaced during WWII, but through her wanderings in a torn-up Europe, she unexpectedly found escape through photography.

In Paris after the war, Morath met and joined an eclectic group of young photographers. A friend of Ernst Haas, Morath wrote articles to accompany his photographs, and, together, they were invited to Paris by Robert Capa to join the newly founded Magnum Photos agency.

Using her no-nonsense approach to writing and news reporting, she started her career as an editor, but soon afterward surprised her colleagues with a set of photographs taken in Spain during her travels in the 1950s.

After this, Morath began to use the camera as a tool for exploring her passions, producing strong photographs in 1951 and assisting the great Henri Cartier-Bresson as a researcher from 1953 to 1954.

As the years rolled by, Morath traveled extensively throughout Europe, North Africa, and the Middle East. Her special interest in photography found expression through essays published by a number of leading magazines.

After marrying the playwright Arthur Miller in 1962, Morath settled in New York and Connecticut in the US. In 1965, she made her first trip to the USSR, and in 1978, after studying Mandarin for five years, she made the first of many photographic trips to China.

Throughout the 1980s and 1990s, Morath continued to develop her taste for independent projects as well as commissioned work from international magazines such as *LIFE*, *Paris Match*, and *Vogue*. She won numerous awards, including being presented with a Doctor Honoris Causa by the University of Connecticut, the Austrian State Prize for Photography, the Gold Medal of the National Art Club, and the Medal of Honor in Gold of the City of Vienna.

Even though Morath's greatest achievements are in portraiture and taking posed images of celebrities, she is probably most respected by those from within the industry for taking fleeting images of anonymous passersby.

Shortly before her death in 2002, she embarked on a special journey through the borderland between southern Austria and Slovenia, which became a personal trip through time on a number of different levels—geographical, autobiographical, historical, and cultural—with the multifaceted photographer herself as the linking element. For the globe-trotter Morath, the "Border Areas" project was also a trip through her own past to the home of her ancestors.

Morath, one of the world's legendary reportage photographers, will always be respected for her varied photographic work. Said one colleague of her: "Morath always tried to capture human aspects and everyday life, rather than spectacular events like everyone else."

Andre Charles, Houston Street, New York, US, 1998
Morath demonstrates her abilities as a multifaceted photographer by befriending and photographing graffiti artist Andre Charles on New York's illustrious Houston Street.

**Rockefeller Center,
New York, US, 1958**
Female visitors enjoy the view.
The majority of America's Art
Deco complex of commercial
buildings was built between
1929 and 1934.

Inge Morath

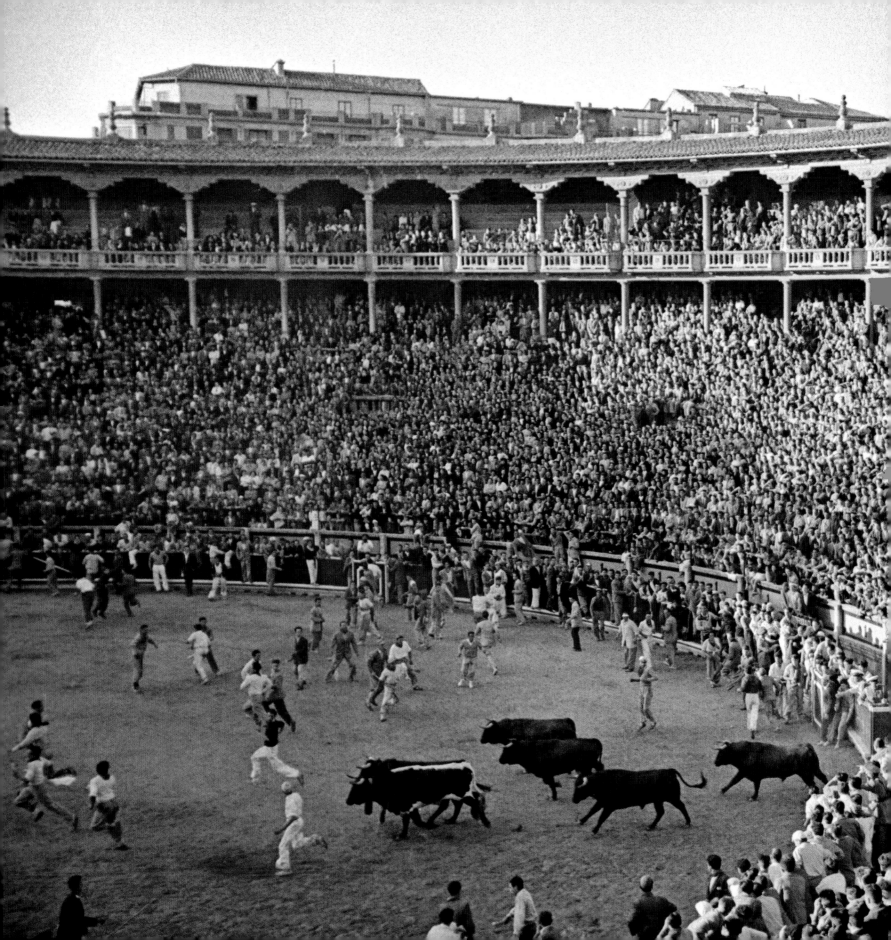

St. Fermines Festival, Navarre, Pamplona, Spain, 1954
Morath had spent much of the 1950s traveling in Spain. Here, she records one of the country's most famous bullfights.

Zed Nelson

Zed Nelson does not shy away from conflict or controversy. After a decade working as a photojournalist in some of the most lawless places on earth, he has, by his own admission, had more opportunity than most to "witness some of the world's most difficult situations."

In a similar manner to other media workers with a strong sense of justice, Nelson shares the same crusading spirit and the belief that it is a reportage photographer's duty to expose wrongdoings and ask the questions most would prefer to leave alone.

He says: "Photography can trigger a debate and make people question a situation. It is this I try to achieve because I am interested in documenting the things around me, and I want to motivate others to have opinions about them."

Born in Uganda in 1966, Nelson's first career-defining piece of work came as a result of covering London's Poll Tax riots during the end of Margaret Thatcher's reign as Prime Minister. "I actually went as a sort of anti-tax demonstrator with my camera, but I ended up being right in the thick of it," he recalls. "It was the first relevant thing I had photographed and it felt really historical and important. I didn't expect it to turn into a crescendo of violence so I only went with one camera, one lens, and just a couple of rolls of film. I ended up [borrowing] more film from other photographers because I'd used mine up too quickly."

Having found his vocation in life, Nelson's next big project was in Somalia in 1992. "I'd heard about this growing famine on the radio, but it was hardly in the news at all. It struck a chord with me and I literally hopped on a flight the next day. I was shocked to arrive in a country with no government, no police force, and no infrastructure, as well as seeing all these starving people. When I arrived, I was the only photographer working there at the time and I became very upset and involved with the whole project. There was this unbelievable shortage of food and I just had to tell the world about it."

Even at the age of 26, Nelson remembers becoming increasingly frustrated by how difficult it was to get the Western media interested in the issues he felt passionate about. "The politics of Somalia were more complicated than I could have possibly imagined. Quite a lot of Third World countries were being armed by Russia and America during the Cold War, to fight on their respective sides, and the situation in Somalia was a direct result of this."

Nelson said he has never considered the financial implications of avoiding the more well-paid avenues of photography, such as fashion or commercial work. "You could say I am politically motivated. I've always wanted to play a part in the world as it unfolds and I have never been interested in taking pretty pictures. I'm more interested in communicating a message through my photographs."

During one occasion, Nelson's motivation to take the most inspiring pictures nearly cost him his life. In 1995, while working in Afghanistan, the car he was traveling in was ambushed. Even though Nelson came out unscathed, a colleague was shot in both arms and his interpreter was shot in the neck. "This incident made me realize that most of these guns were actually manufactured in America, outside of the world's main conflict zones," he says.

Feeling drawn to the US, Nelson spent over three years there on a personal, self-funded photographic mission. "I began my study of American gun culture in the wake of the gun massacre in Dunblane, Scotland, where these schoolkids and their teacher were shot. The incident prompted a fierce backlash against guns in the UK, and calls for a ban on privately owned firearms."

While gun-control measures were being debated in Britain, Nelson turned his focus on the US, a nation where a centuries-old gun culture was clashing with the realities of modern life. "In all my time in western Africa and other places, it was obvious that guns were a constant presence," he explains, "But in

Church sign outside the town of Justice, West Virgina, from "Hillbilly Heroin" *(opposite)*
This church was fighting a losing battle against the effects of OxyContin, the brand name for the synthetic opiate, oxycodone. The drug is highly addictive, and a prescription can sell for over $1,000 on the street. In the tiny mountain towns of West Virginia, they call it "hillbilly heroin." In recent years, it has caused scores of deaths in the region in the form of overdoses, suicides, and car wrecks. In the words of one prosecutor trying in vain to combat its influence: "The bodies are stacking up like cordwood." It is no accident that the epidemic took root in the Appalachians, traditionally one of the poorest regions in the US.

Preparation for rhinoplasty (nose job), Iran *(right)*
There have reportedly been more nose jobs in Iran in recent years than in any other country in the world. Many of the 100 or so registered plastic surgeons operating in the country became adept at reconstructing faces damaged during the Iran–Iraq War.

Today, with the war behind them, Iranians are finding time to worry about their looks instead. For more than 20 years, strict social rules have required modest dress and covered hair for women. Laws forbid women to publicly sing, dance, or wear makeup. But today, frustrated with their lack of freedom, Iranian women are redefining what it means to live in an Islamic fundamentalist society.

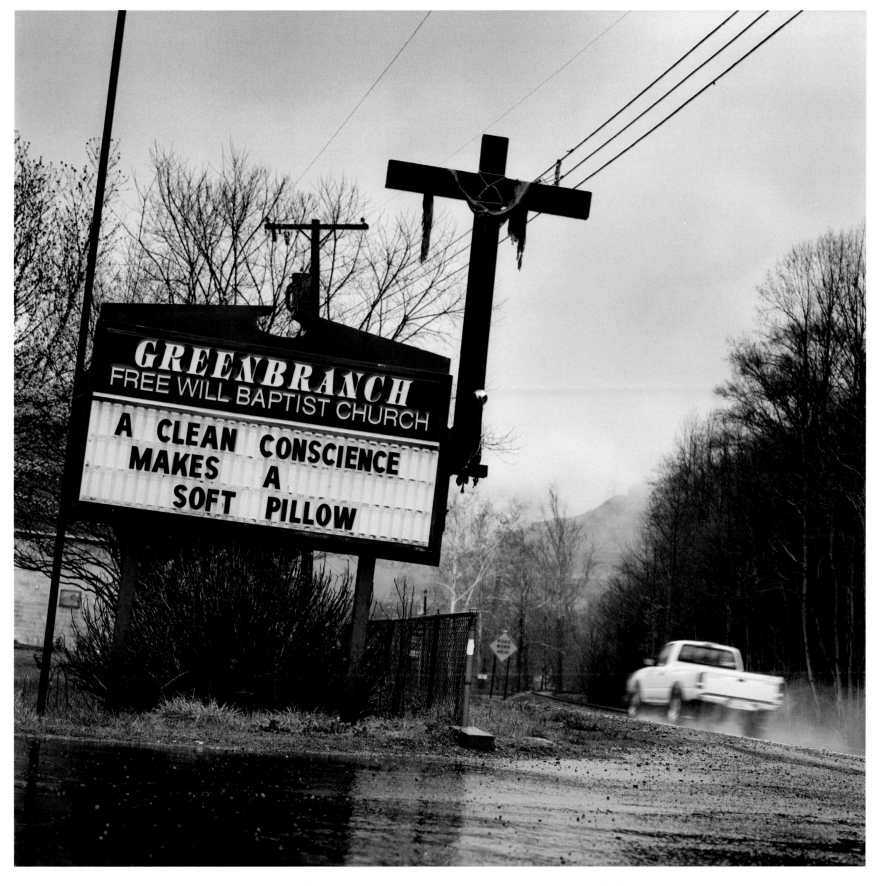

GREENBRANCH
FREE WILL BAPTIST CHURCH
A CLEAN CONSCIENCE
MAKES A
SOFT PILLOW

Zed Nelson

Ms. Olympia contestants prepare before the final competition, 2001
(Left to right) Betty Pariso, Brenda Raganot, Angela Debatin. The granite physiques of those who compete so fiercely in the Ms. Olympia competition are carved from grueling training schedules and determination bordering on obsession. The sport of female bodybuilding is overshadowed by the suggestion of steroid abuse and psychological disorder. Anabolic steroids, the drugs most commonly taken by bodybuilders, basically mimic the bodybuilding traits of the male hormone testosterone. "You'd have to be a fool to go up on stage without steroids," says one observer, who asked to remain anonymous.

America, something like 25,000 people a year are killed by guns, so I spent months in Memphis and elsewhere visiting gun rallies and spending time recording gun culture."

Soon after came Nelson's best-known piece of work to date: his book *Gun Nation*. It was shot using a combination of 35mm and medium-format film.

"People in the US and the UK like to see pictures shot in color, and there is this obsession with celebrity. It's trivial. I wanted to turn this manner of doing things on its head, so I decided to record this obsession with firearms in black and white."

Since then, Nelson's lens has recorded all manner of issues from around the globe, including fox-hunting, old age, plastic surgery, the Ku Klux Klan, OxyContin drug-taking hillbillies in West Virginia, the death of traditional industry, and obesity.

Nowadays, he is planning his next trip, although he doesn't care to disclose where that will be. "It's a battle to get people interested in the things I think are the most important," he underlines. "But I love the fact I can steer myself toward what I am interested in. And I love the fact I can be so involved in life and that I am free to get on a plane and go almost anywhere in the world."

Fairytale Fantasy Dinner Dance, National Association of Fat Acceptance (NAAFA) annual convention, San Diego, US
"Often when we're out in the world, we don't see many people our own size. I knew when I was growing up that I would never go to the prom, never wear that fancy dress, never be picked for the team. Here, it's different, you can wear that dress you always wanted," says this party-goer.

The size acceptance movement is framed as a civil rights battle, a fight for the right to exist, in the words of NAAFA, "Without guilt, without shame, and without the humiliation meted out by a fat-fearing public and a thin-obsessed media."

Zed Nelson

Mike and baby, from "Gun Nation"

Over a period of three years, Nelson documented America's gun culture. In "Gun Nation," he avoids the stereotypical groups that are often conveniently portrayed as "the problem." There are, significantly, no images of gang members posturing with their weapons, and no fringe-element extremists in camouflage fatigues. Instead, Nelson focused on so-called "ordinary, law-abiding citizens," at gun shops and NRA conventions, in living rooms, emergency rooms, and schoolyards. "I wanted to show how guns pervade all areas of society," says Nelson.

These compelling images explore the paradox of why America's most potent symbol of freedom is also one of its greatest killers, resulting in an annual death toll of over 25,000 American citizens.

Gun Nation won five major photojournalism awards and is regarded by many as the definitive body of work on the subject.

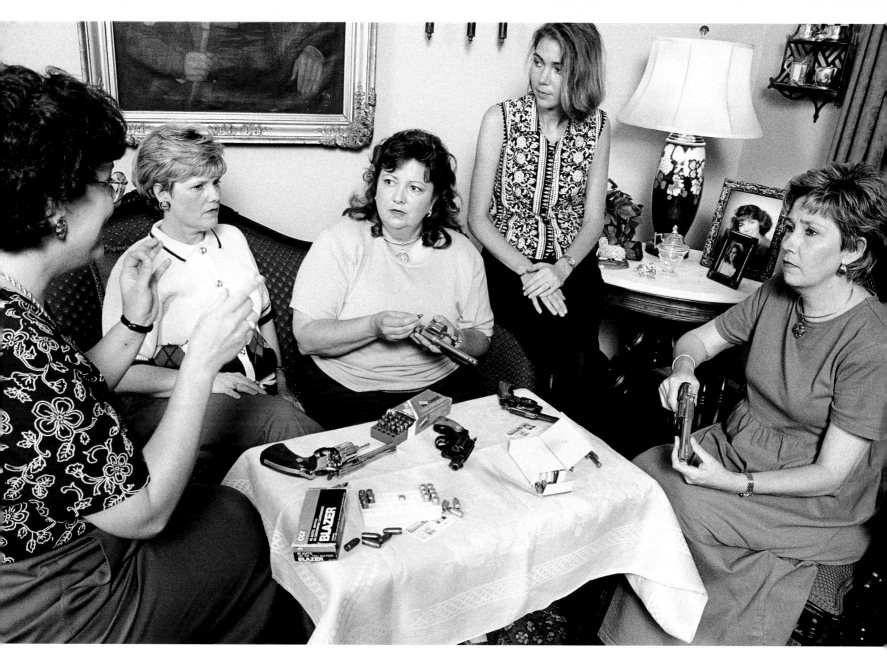

Memphis, US, from "Gun Nation"
Memphis housewives meet and compare recently purchased weapons.

"Sure I would unload my gun on someone; not because I want to hurt them, but because I'm goin' to make sure they're down. And if it takes nine bullets...well, that's what it takes. That's what the course teaches you; to empty the clip."

Elizabeth Strong, 28

"I'm going to be carrying a 9mm semi-automatic from now on. Things are getting dangerous out there. I hope and pray that the person I shoot doesn't die, but I'm goin' to shoot so that I don't die."

Susan Wilson, 44

"I have a gun because I refuse to be a victim. I will not succumb to the scum that is out there. "

Vicky Sykes, 40

"If someone was breaking into my house, I would probably shoot them. Passing more gun-control laws just makes it harder for us, law-abiding people, to own guns."

Melva French, 46

Zed Nelson

Martin Parr

Martin Parr is renowned for his innovative images, which have revitalized social documentary photography, making him one of the most influential figures in the industry.

"I like to be called a documentary photographer," he says. "For me, the fun about my photography is that it is intuitive. I'm trying to take pictures that deal with a modern world without confronting issues head-on—I deal with them in a sideways manner. The main theme in my pictures is about [mocking] the wealth of the Western world, particularly Britain."

Seagulls gobbling fries on the promenade, dozing matrons squeezed into groaning garden chairs, the greasy delights of a hotdog stand… Parr's wryly affectionate images capture a world and a way of life that millions of people in the UK would recognize instantly, but which is rarely celebrated.

However, Parr's work is not confined to Britain. South America—Argentina and Uruguay in particular—is also a place that he frequently visits. "I just like to go places to document the world. The great thing is that, nowadays, globalization means I can go almost anywhere and start taking pictures. My favorite place abroad to go and photograph things—anything—is North Korea. It's just so remarkable. It's like a surreal film set and it's just an amazing place to look at. But I can't go as often as I'd like because it's very difficult to get access to."

Although it is a well-known fact, it is still surprising that Parr's photo books are his main obsession. "I've literally traveled the world to track some of them down. The photographic book is a great teacher," Parr elaborates, "not least because it's where photographers learn about photography."

Parr's resume has an unnerving serendipity to it: he has rarely failed to put himself in the right place at the right time. Encouraged in part by childhood visits to his grandfather in Yorkshire, he became fascinated by approaching the north of England with a southerner's eye. In his undergraduate pictures—of tank-topped couples kissing in shopping precincts, and posed families in their living rooms—Parr's sense of the world around him has always been razor-sharp.

"I think it's important to think of one's photography as a vocation, rather than just a way of making a living. The fact that I've been successful with my photography is something I am very happy about, but the enjoyment of taking pictures is the overriding factor. When people say photography is an art form, they are right; a photojournalist, just as an artist, wants to be creative because they enjoy being original and have something to say about the world. It had never occurred to me to be a fashion or commercial photographer."

Parr likes to keep his photography simple. And, though well traveled from his many international commissions, as well as the worldwide projects he embarks on "at least once a year," it is Britain and British culture he likes to exploit most, always with a sense of irony.

Epsom, England, 1972
Having documented Englishness for more than 30 years, Parr's surrealistic and sarcastic style of documentary photography is more reminiscent of American photographers Garry Winogrand and William Eggleston, or filmmaker David Lynch. "A photojournalist, just as an artist, wants to be creative because they enjoy being original and have something to say about the world," says Parr.

Chewstoke, England, 1992 from "Chew Stoke: a Year in the Life of an English Village"
Parr has been accused by some of trading warmth for wit and turning British people into laboratory rats under microscopic inspection. Featuring oozing rainswept resorts, roadside picnics, and quintessential village life, his photography is unmistakably sarcastic.

Martin Parr

Benidorm, Spain, 1997
Parr manages to define Englishness through the nation's subjects abroad. He says: "When the British travel to other countries for their annual two weeks in the sun, many often join this imaginary white tribe, developing a terrifyingly insular, racist outlook toward our European neighbors. I always try to capture the funny side of it."

Weymouth, England, 1999
Shown as part of the BBC's *Modern Times* series, Martin Parr's "Think of England" documents and exposes the eccentricities and casual bigotry of England's white "moral majority," creating a unique form of photojournalism.

He says: "The piece of work that opened me up to an international audience, more than any other, was 'The Last Resort,' which I shot in 1986. Suddenly, my work was seen in so many more places, especially in Japan and in America. The Japanese still, to some extent, haven't yet fully grasped the sense of irony in my work!"

Parr says that most people employ him for the work he's most renowned for doing, because they know what they'll be getting. He is not keen on scripts. "For me, the most enjoyable bits are when I go in and ad-lib it, when I don't know what's going to happen next."

Aside from his unique photography, Parr is busy with other, solo projects. "Even though I love what I do, I'm going to be doing much more editing and curating in future. I curated an entire festival in 2004 and [will be] curating some very big exhibitions [in the future]. There are lots of other things I want to do apart from my own work."

New Brighton, England, 1986
In this image, "The Last
Resort," Parr uses photography
to transform Britain's national
identity into a powerful
metaphor for a falsely proud
and isolated island. "Britain
continues to be united under a

Union Jack and a permanently
gray sky," says Parr, "which I
find most amusing, even when
the sun shines. Today there's still
this 'we won two world wars
and one [soccer] world cup'
attitude, which I love to exploit
through photography."

Martin Parr

Carsten Peter

The word fear is one seldom used by nature and documentary photojournalist Carsten Peter, who specializes in making the most of situations others wouldn't dream of involving themselves in.

"The guys in the car were screaming at me: 'Carsten, Carsten, we have to get out!' Yeah, I thought, maybe another image, then maybe another. When they cried so loud I couldn't ignore them, I jumped into the car and we sped out like hell."

He is referring to one of many trips to the US where he has spent the better part of three successive spring seasons crisscrossing the Midwest and Great Plains in search of tornadoes.

"Chasing tornadoes requires skilled forecasts, plenty of stamina and, most importantly, the ability to get out of the way quickly!" he says. "If a tornado is heading straight for you, often the smartest thing to do is run or, even better, jump back into your car."

Tornadoes number among the earth's most naturally violent phenomena, yet no one fully understands how they work. Peter has captured pictures of a tornado from closer to its fatal spout than any other previous photographer, a feat that garnered him the 2004 World Press Photo first prize, one of photojournalism's most prestigious awards.

He also photographs active volcanoes, and, in the process, has shot what may be the most dramatic pictures ever taken of molten magma in action. "They take a while to come down," he says. "So you watch them. If you see a [lava] bomb falling toward you, step aside. It will impact into the earth right beside you. Of course, if the bomb comes out at a flat angle, it can bump in front of you and split into many different pieces. That can be quite dangerous. There is never a security package with a volcano."

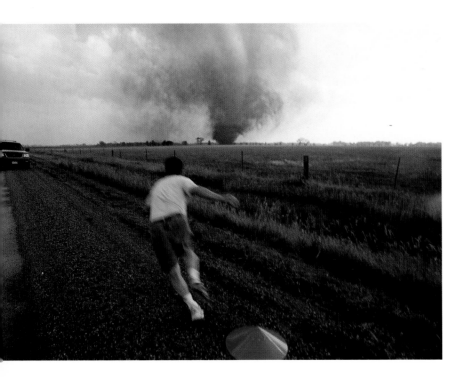

Woonsocket, South Dakota, US, 2003 *(left)*
Peter photographs intrepid scientist Tim Samaras deploying instruments designed to measure forces inside a tornado. Samaras runs away from one to escape with his car—and his life.

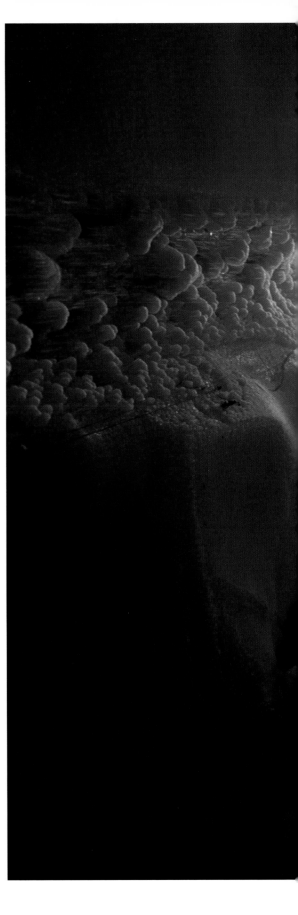

Inlandsis, Greenland, 1995 *(right)*
Peter's amazing 558 feet (170m) descent into the deepest ice shaft on the planet: the Inlandsis in Greenland.

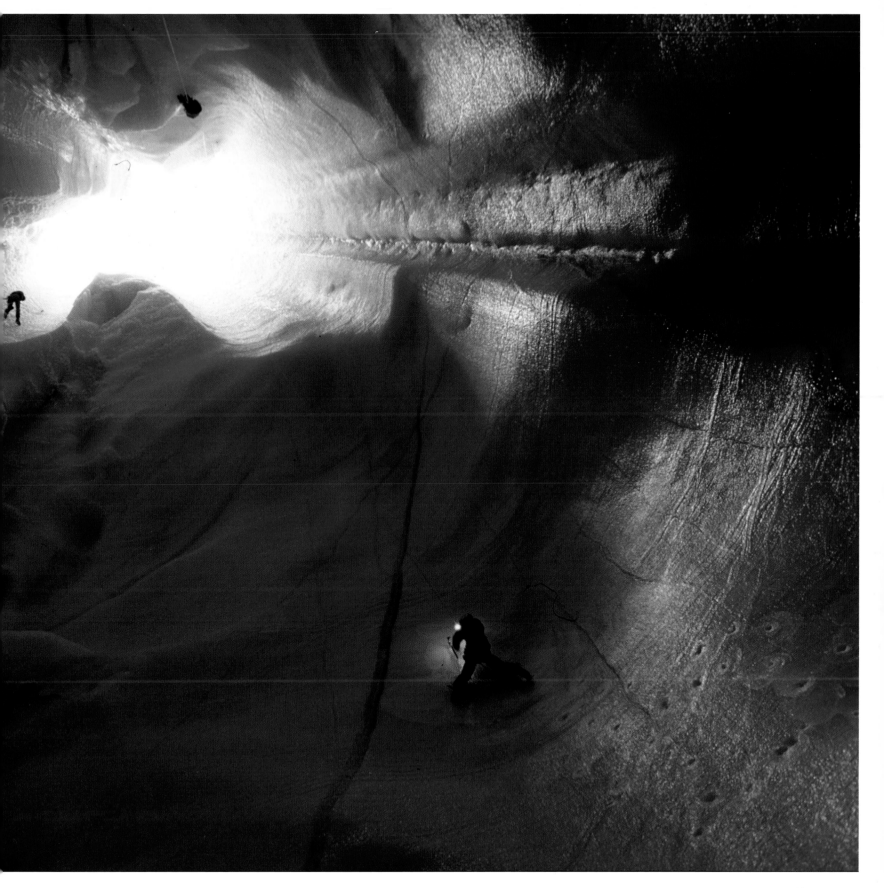

Carsten Peter

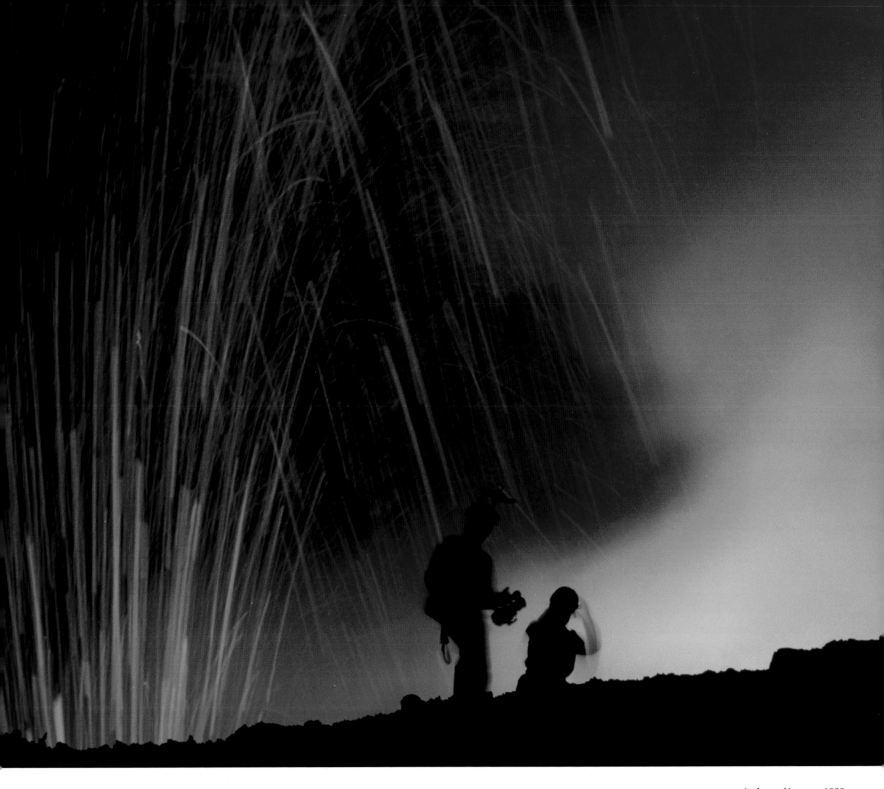

Ambrym, Vanuatu, 1999
Photographing close to the vents
of an active volcano after a
hazardous descent down an
almost vertical, fragile 1,476
feet (450m) deep crater.

If there is a common thread to the kinds of assignments Peter seeks out, it is his own fascination with and surrender to nature at her most chaotic and unpredictable.

Peter grew up in Pullach, Germany, a diminutive Bavarian town south of Munich that is little more than a stop-off point en route to the big city. He was restless from the start: "When I was young," he recalls, "I always wanted to emigrate."

Peter got his first dose of a volcano at close range at the age of 15, on a family visit to Sicily's 10,876 feet (3,315m) Mount Etna. Two years later, he and a friend set up their tripods on the crater rim of Stromboli, an active volcano that has created its own tiny island in the Tyrrhenian Sea, north of Sicily.

Suddenly, Stromboli erupted. "We left our cameras and just ran," he remembers. "That's how I learned how stupid it is to run. When we stopped, I asked my friend, 'Did you get a picture?' and he replied, 'No, did you?'"

Such is Peter's passion for his job that he has compromised much to finance his photography throughout his career. He has run the gamut of what he calls "pointless jobs:" by turns, he was a woodcutter, office cleaner, vendor of motorcycle parts, and a math and physics tutor. And for about 10 years he worked really hard without any money. All the money he did have was invested in photo equipment that would break and have to be replaced.

After witnessing a staggering variety of the world's natural wonders, Peter now professes to love nature in all her guises. "I think," he says, "there is no place on earth that I'm not interested in."

In the process of his career, he's also developed a passion for glaciers. With tornadoes and volcanoes in mind, one may think glaciers would be Peter's most predictable subjects. Wrong. "They are alive… melting and changing each year; they are the chameleons of caves!" he enthuses.

Normally a minimalist, Peter over-packs for glacier trips, bringing dry suits and inflatable rafts just in case he encounters a new glacial river or lake. Formed by eons of running water, limestone caves are damp; a hazard to equipment but hardly a deterrent for Peter. "I use all types of photographic equipment—including waterproof—to cover any event," he says.

Worrying about his gear could cost him his life, so he has learned to treat all cameras, no matter how pricey, as disposable. "If I'm in nature, I'm fine. It is in the city with lots of other people that I feel at my most vulnerable."

Erruption of Loki, Iceland, 1996 *(top right)*
The volcano's heat was so intense it melted through the 1,968 feet (600m) deep ice cover of the Vatnajökull, Europe's biggest glacier.

Ol Doinyo Lengai, Tanzania, 2001 *(right)*
This volcano has mystery in its lava. Called "cool lava," which, at 1,000°F (500°C), is about half the heat of other volcanoes. Peter exposed his film for about three minutes on a moonlit night.

Carsten Peter

Marc Riboud

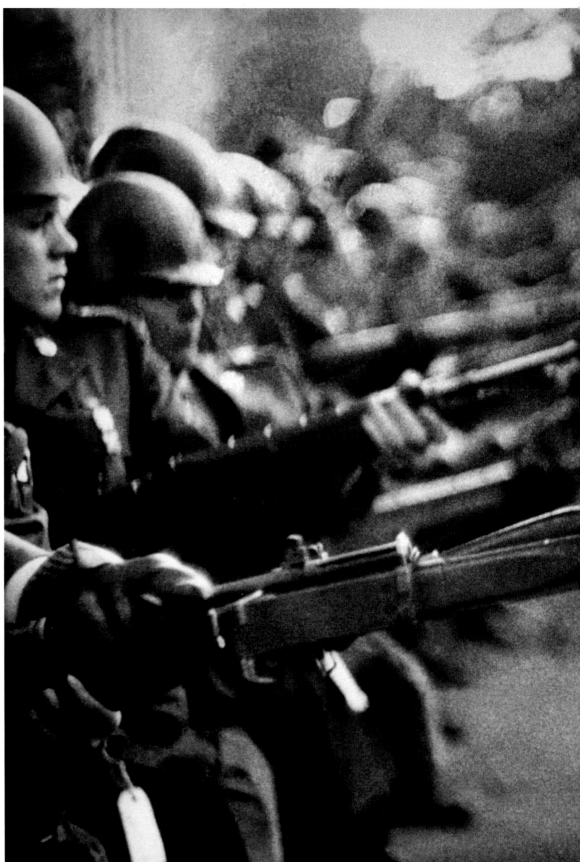

Washington DC, US, 1967
National Guards demonstrate their authority when confronted by young American girl, Jan Rose Kasmir, outside the Pentagon during the 1967 anti-Vietnam War march. The march helped to turn public opinion against US involvement throughout Indo-China, showing just how large the tidal wave of anti-war sentiment in America was. About two million people took part in activities all over the country, with 250,000 demonstrators filling the streets of Washington DC.

One of the greatest names from the Magnum Photos agency, Marc Riboud is best known for his extensive reports on the East: "The Three Banners of China" (1966), "Face of North Vietnam" (1970), "Visions of China" (1981), and his more recent "In China" (1996).

Riboud values authenticity above all, and thinks of the photographer as an existential traveler. Remarkable for their spontaneity and harmony, his Eastern documentaries are rich in encounters and portraits of citizens who pause long enough to give a strong account of themselves, while his color photography gives sweeping views of untouched nature as well as chaotic urban life.

Born in Lyon, France, in 1923, Riboud went to high school there and produced his first photograph in 1937. He was active in the French Resistance in Lyon from 1943 to 1945 and, after coming out of the German occupation of France unscathed, studied engineering at the École Centrale in Lyon, from 1945 to 1948.

Until 1951, Riboud worked as an engineer in Lyon-based factories before trying his hand as a freelance photographer, moving to Paris in 1952. Invited to join Magnum as an associate that same year by Henri Cartier-Bresson, Riboud also became a friend of George Rodger, whom he later joined in the Middle East.

In 1955, Riboud became a full member of Magnum. The next year he made a long trip to India. In 1957, he was one of the first European photographers to go to China and he returned for a lengthy stay in 1965 with writer K.S. Karol. Riboud served as president of Magnum from 1975 to 1976.

In 1968, 1972, and 1976, Riboud made several reportages on North Vietnam and later traveled all over the world, but mostly in Asia, Africa, the US, and Japan.

Riboud's photographs have appeared in numerous magazines, including *LIFE*, *Geo*, *National Geographic*, *Paris Match*, and *Stern*. He twice won the Overseas Press Club Award (1966 and 1970), and has had major retrospective exhibitions at the Musée d'Art Moderne de la Ville de Paris (1985) and the International Center of Photography, New York (1988 and 1997).

He became a Magnum contributor in 1980. In recent years, he has shot his stories mainly in black and white and on his own initiative. His most recent work was completed in Turkey.

Marc Riboud

Tehran, Iran, 1979
Women supporters of Ayatollah Khomeini stand in front of his picture. The political system created by Khomeini after the revolution of 1979 is unique, first and foremost, because of the role he carved out for himself. He established himself at the top of the political pyramid as the faqih, or supreme leader, although many in the West saw the institution of faqih as a cloak for dictatorship.

Paris, France, 1953
Riboud's famous photograph
captures a workman merrily
painting the Eiffel Tower. This
picture is regarded as one of the
definitive Parisian images, and
yet, amazingly, Marc Riboud
took it near the beginning of
his career. When published in
LIFE magazine in 1953, the
photograph became an instant
sensation. "That painter was
joyful, singing as he worked,"
said Riboud. "I think
photographers should behave
like him—free and carrying
little equipment."

Sebastião Salgado

Sebastião Salgado is the name most synonymous with the world of international photojournalism. Having discovered photography almost by accident while working as an economist for the World Bank, he is now one of the world's most famous photographers, with a reputation and portfolio that will surely place him firmly among the all-time greats.

Sebastião Ribeiro Salgado was born in 1944 in the small town of Aimorés in the state of Minas Gerais, in Brazil. During the 1940s, over 70 percent of this region was still covered by rainforest, known then as one of the world's 25 environmental hot-spots. At that time, this coastal Brazilian forest was twice as big as all of France; today it has been reduced to just seven percent of its original size, while in Salgado's birthplace, the forest is even more sparse, at just 0.3 percent of its initial size. These facts, naturally, make Salgado one of the world's leading campaigners for environmental conservation and, more positively, one of the most influential to help affect change through his photography.

Salgado is a UNICEF Goodwill Ambassador and an honorary member of the Academy of Arts and Sciences in the US. He has received numerous prizes, including several honorary doctorates and many other accolades for his photographic work.

"My parents moved to London in 1971," he remembers. "I worked as an economist for the International Coffee Organization and I often traveled to Africa on missions affiliated with the World Bank."

It was then that he first began taking photographs. On his return to London, these images began to preoccupy him and he abandoned his career as an economist. At the beginning of 1973, he and his wife moved to Paris so that he could begin his life as a photojournalist.

"I worked freelance and joined the Sygma photographic agency in 1974. During my time at Sygma, I got to cover stories in Portugal, Angola, and Mozambique, after which I decided to shoot for the Gamma photographic agency the following year. Here I worked on many stories throughout Africa, Europe, and Latin America. It was only later, toward the end of the 1970s, that I began my long photographic essay on the Indians and peasants of Latin America."

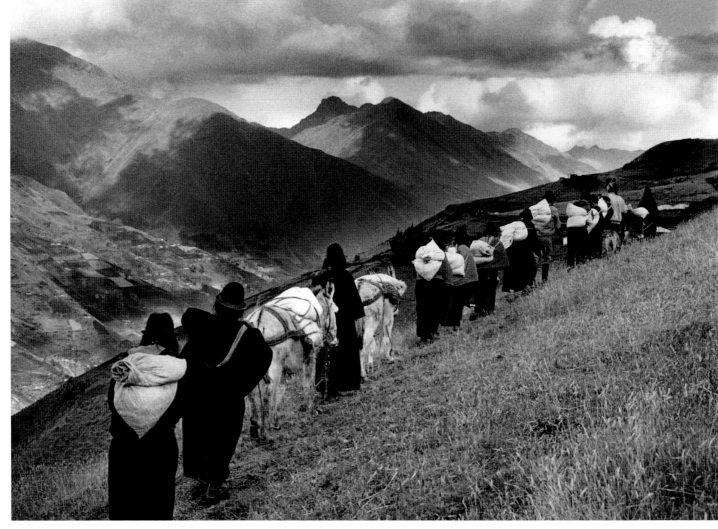

Chimborazo, Cañar, and Azuay provinces, Ecuador, 1998
Men migrating from the countryside, leaving only women, children, and the elderly behind in the villages. A study of the upper lands of Ecuador from 1990–1997 has revealed around 15 percent of the population (mainly men) has migrated to the large urban centers of Ecuador and, in some cases, to foreign countries. One of the main reasons for abandonment is the extreme poverty in which the families live.

In 1979, Salgado left Gamma and joined Magnum Photos, where he would stay for 15 years. By the time the 1990s had arrived, the illustrious Salgado had already traveled to 23 countries, creating a series of photographs that challenged the West's narrow-minded perception of the developing world. In 1993, he published the book *Workers: An Archeology of the Industrial Age*. More than 100,000 copies of the book were printed, and a large exhibition has been circulating throughout the world to more than 60 museums ever since.

Salgado's burning ambitions saw him and friend Lélia Deluiz Wanick form Amazonas Images in 1994, the year Salgado left Magnum. Amazonas Images is one of the smallest press photo agencies in the world, representing only one photographer.

Building a strong team, Salgado and Wanick have also worked together since 1991 on restoring a small part of the Atlantic Forest in Brazil to its natural state. In 1998, they succeeded in making this land a nature reserve and created Instituto Terra, which includes an educational center for the environment. More than 500,000 trees have been planted, and the project is at the heart of a much larger community effort focusing on sustainable development in the Rio Doce valley.

Clearly, Salgado's success has not daunted his passion for the thing he believes in. It is the eyes of his camera that have produced some of the most haunting and inspirational photographs of all time, not just in books and photo agencies, but also in leading newspapers, magazines, and throughout almost every publication in the world.

"Sometimes photography is not enough," he admits with sadness, "but I can take great heart from the fight we are putting up to make the world a better place."

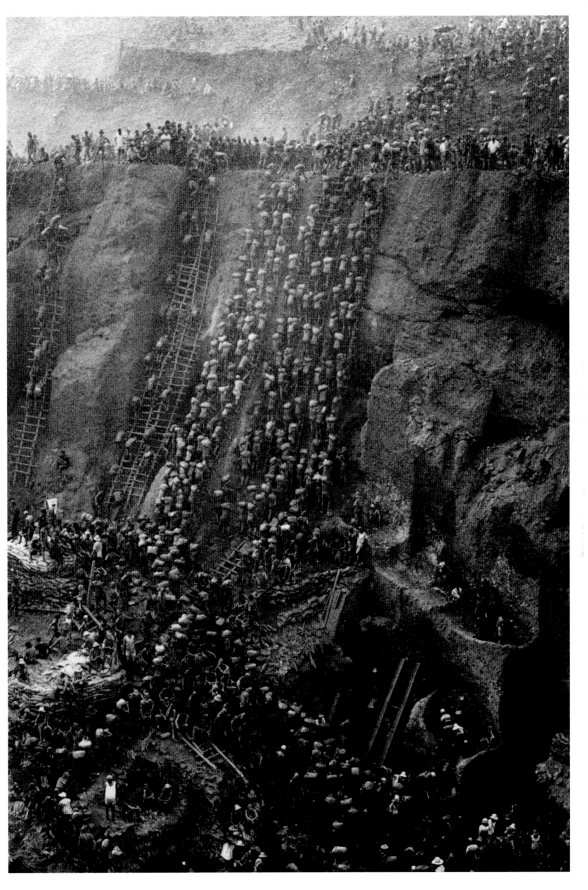

Serra Pelada, Brazil, 1986
Every day 50,000 "garimperos," otherwise called gold diggers, descend open-top mines, each the size of a football field, in the state of Para. Controlled by the State giving concessions of 65 square feet (19.8m²) of vertical land wells, each owner must dig downward. Each well has 10 people working on it (diggers, carriers, and supervisors), and the carrier hauls sacks of 65– 130 pounds (29.5–59kg) of soil for just ¢20 (US), bringing massive social inequality.

The 50,000 men struggle up ladders to reach the upper edge, where they receive a "slip" for their sackload. The mine is only open during the dry season (September to January) and the terrain makes it impossible for machines to do the work.

Sebastião Salgado

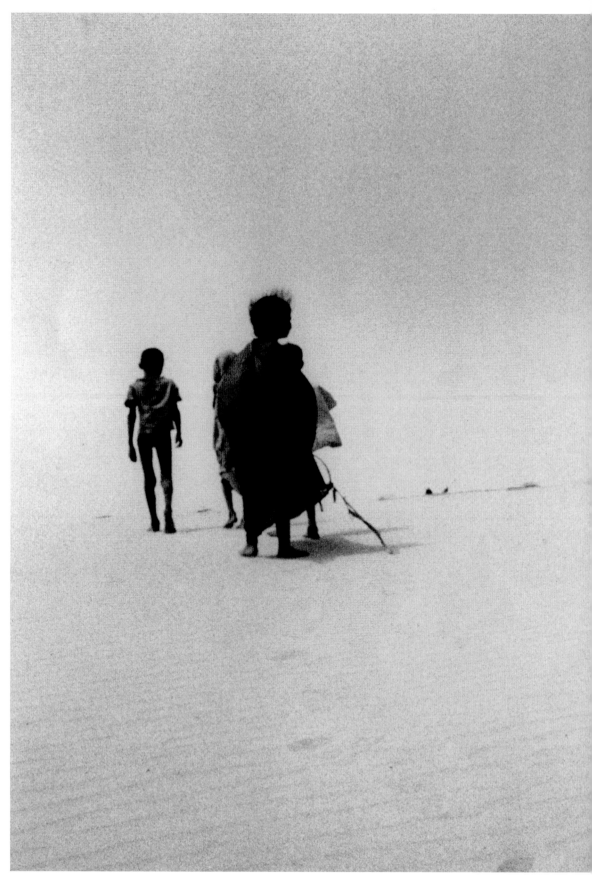

Mali, 1985
Nearly one million people are threatened by the continuing drought in Mali, in a country that once prospered from the majestic Niger river and its exports of fish to the African continent. Seventy percent of the livestock has died and thousands have deserted their villages and formed shantytowns around already crowded cities. There has been no harvest for the past five years, sandstorms are slowly covering villages, and lakes have become completely dehydrated.

126

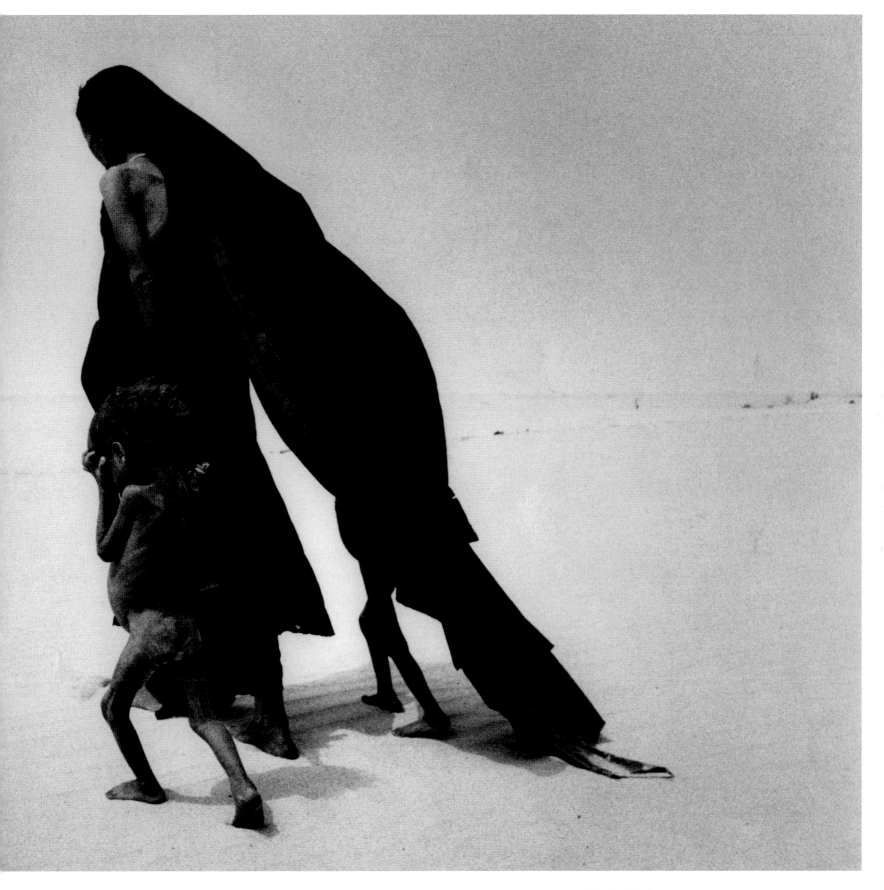

Sebastião Salgado

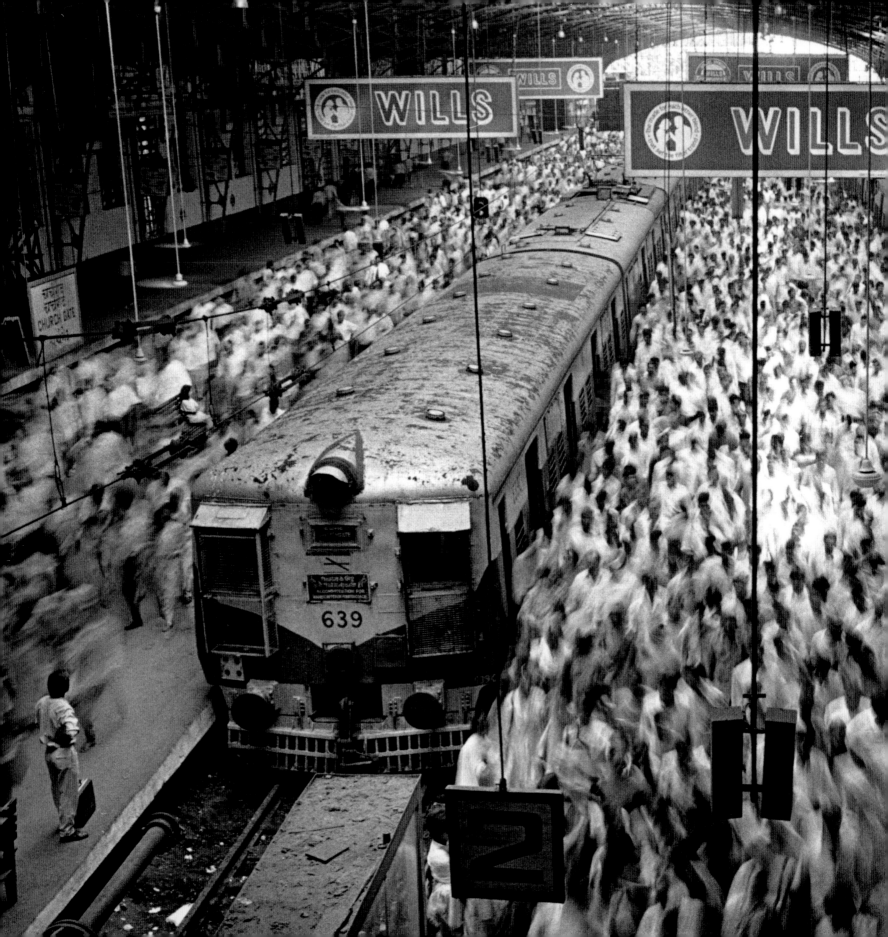

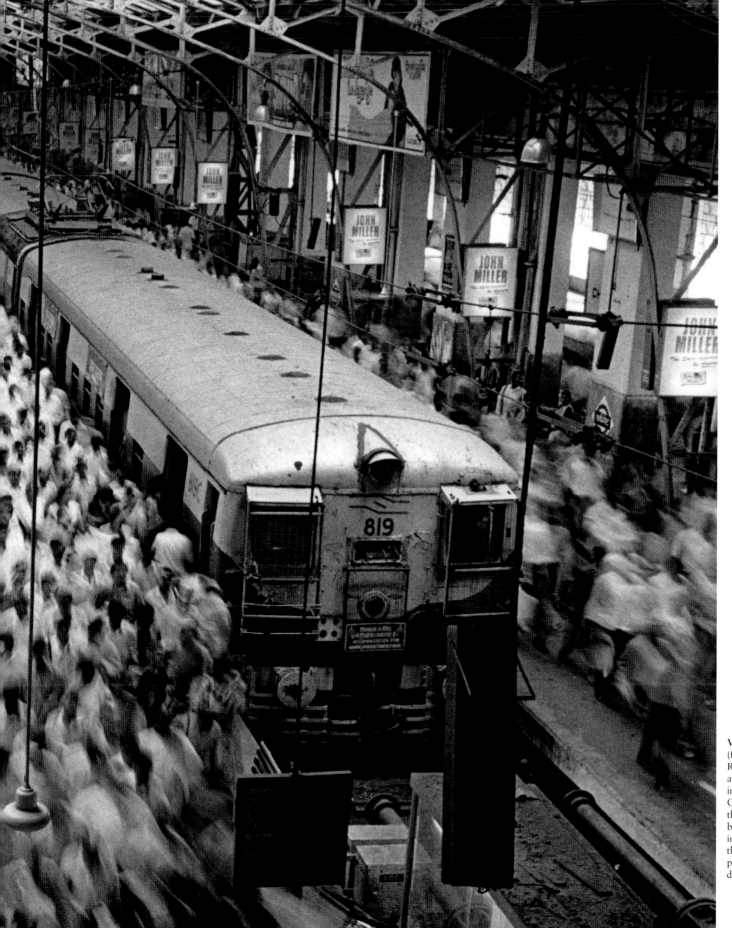

Victoria Station, Mumbai (formerly Bombay), India, 1995
Rush hour brings a frenzy of activity among those working in India's second largest city. Church Gate terminal—built by the British over 100 years ago—brings 2.7 million commuters into Mumbai each day. Such is the population growth in this part of India that the trains are dangerously overcrowded.

Daniel
Silva Yoshisato

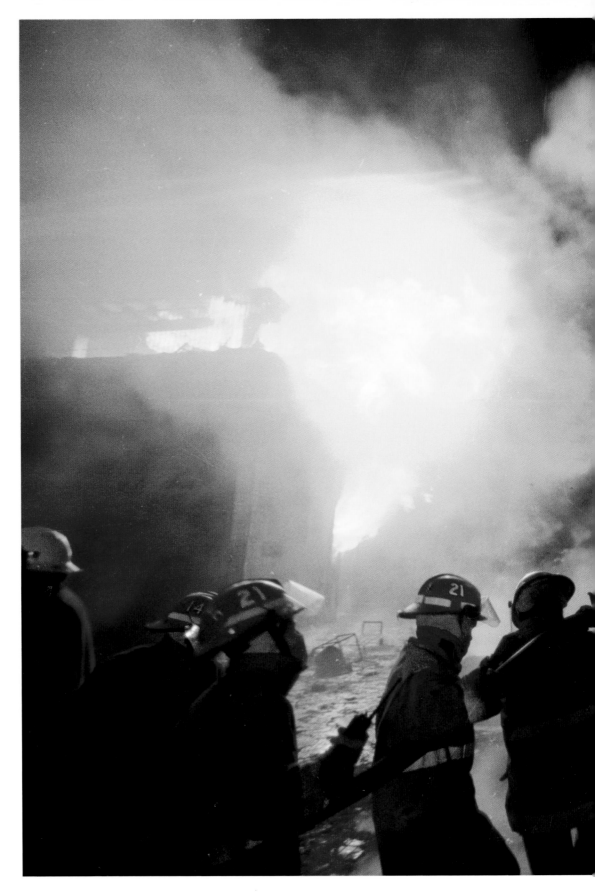

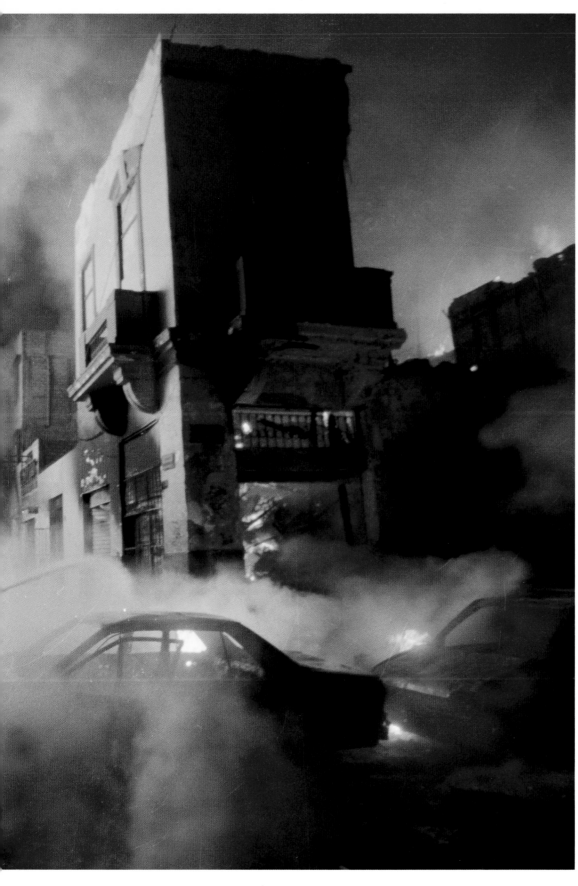

Like many at the top of their game, Peruvian photographer Daniel Silva Yoshisato "fell into photography," rather than aiming squarely at a photojournalism career from the outset.

Lima-born Silva worked as a bona-fide journalist before becoming a freelance photographer in 2004. After graduating in Communications from the University San Martín de Porres, he worked for the Peruvian newspaper *El Comercio* and for various Peruvian magazines.

"I began as a writer on a little newspaper called *Perú Shimpo*, the only Japanese-speaking paper with a base in Peru. I was 24. There were no photographers, which meant the writers had to take their own pictures. By chance, I found photography—or maybe photography found me," he says.

Since those early days, Silva's career has evolved strongly and his work is recognized throughout South America and the rest of the world. He has received several awards, including the 2004 Daily Press Visa d'Or for his reportage story entitled "Women's Soccer in the Andes of Peru," as well as a first prize in the Sports Features Stories category in the prestigious World Press Photo Contest 2005, for his documentary story called "Churubamba Women's Football Team."

He currently freelances for industry giant Reuters and Agence France Presse, and his work has been published in leading publications *Paris Match*, *L'Equipe*, and *Der Spiegel*.

Unlike many photographers with a thirst for money in the fashion or commercial sector—he admits his "studio photography could be improved"—Silva feels at ease with the prospect of recording daily lives and events with his camera. "I feel comfortable with daily life," he says. "Especially with breaking news and the social problems that affect the world. Documenting these things with my camera is important to me.

"Some years ago, I made a story about a family that lived in the middle of a street. Their house was made out of paper and wood. A few days after my photographs were published, a rich man gave this family a nice house. I cannot describe the satisfaction I felt."

Even though Silva needs to work fast and practices his trade with ultra-modern Canon D1 and D20 digital cameras, he still appreciates the character that film can portray in an image. "I love film because it creates this romantic feeling, especially when you see the physical, step-by-step development of a picture. But digital cameras are faster, the photos are cheaper to produce, and, importantly, I enjoy the technology aspect."

Lima, Peru, December 2001
Approximately 350 people died
in the center of Lima during the
greatest fire in Peru's history.

Daniel Silva Yoshisato

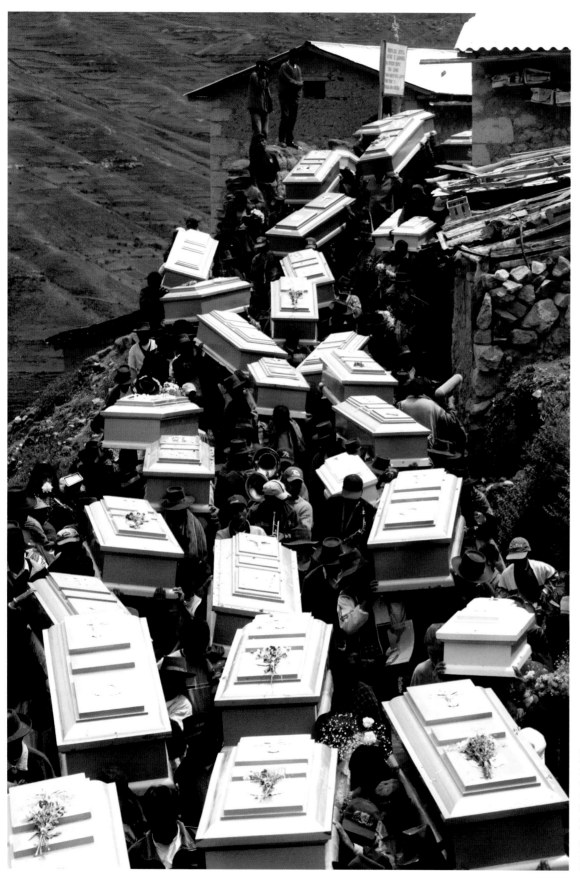

Silva usually takes three lenses on his travels to cover focal lengths from 20–200mm, preferring to get close to subjects and seldom shooting beyond 50mm. "My favorite lenses are 28mm, 35mm, 40mm, and 50mm. You might say my work is fast and simple. I try to do everything from a personal point of view; I like to discover and create pictures in the middle of chaos."

But Silva does not believe photojournalism and war go hand in hand: "I've never taken pictures of war, but I imagine that that kind of work is the most difficult to deal with, because of the daily stress and the dangers one faces. You have to take pictures and also take care of your life. I am sure war involves many feelings I have not experienced. My view is personal, but I think war photography could make a prisoner of you and your emotions."

Silva's motivations instead lie in the Andes and the Amazon jungle because, among other reasons, "there are a lot of beautiful colors."

He concludes: "Watching nature unfold and watching pictures from all over the world makes me think about my own work. All I want to do is to travel and to try and understand the world around me. What more could a photographer want to achieve?"

Ayacucho, Peru, 2002
In 2002, the bodies of 62 citizens from the Lucanamarca village in the city of Ayacucho, Peru, were finally buried after 20 years in a symbolic act organized by "The Commission of the Truth." The feared terrorist group called Sendero Luminoso (or Shining Path) killed many throughout the 1980s and 1990s.

Gold Lake, Pacaya Samiria, Peru
The paiche is the biggest fish in the Amazon River and is in danger of extinction. A census 12 years ago found just a few paiche but, thanks to the work of the Yacutayta community, numbers are believed to have risen to around 700.

Daniel Silva Yoshisato

Churubamba, Peru

Churubamba is a farming village situated 2.4 miles (3,850m) above sea level, approximately five hours from Cusco city in the Andahuaylillas district of Peru. Soccer is big here, and the women of Churubamba play a competitive game in the village square. At the time of these photographs, they were the Andahuaylillas district champions.

Daniel Silva Yoshisato

W. Eugene Smith

In a relatively short lifetime, W. Eugene Smith became one of photojournalism's legendary figures and is best known for his intrepid coverage of the American–Japanese conflict during WWII.

Born in Kansas in 1918, the American was, in the opinion of many, the world's greatest ever war photographer. The legacy of his amazing pictures ensures his status will remain this way.

Importantly, Smith was a man who stood up for what he believed in, ensuring the power remained in his photographs, and not in the hands of those who published them.

Smith was often regarded by editors as troublesome because of his steadfast refusal to allow his pictures, their layout, and often the text that accompanied them to be molded by the policy of the magazine or anything else other than his personal vision.

But if Smith endured personal hardships for the sake of his work, he always had the satisfaction of being true to himself. He has probably, more than any other photojournalist before or since, raised the art of the "photographic essay" to unequalled heights.

He took his first photographs at 14 and began to sell them to newspapers shortly after. After studying at the New York Institute of Photography, in 1937, Smith started working for leading magazine *Newsweek*. He left after a year and struck a deal with the respected Black Star agency, later joining *LIFE* magazine (1939 to 1942), and *Parade* magazine thereafter.

Smith's defining moments were spent in the South Pacific during WWII: first for *Flying* magazine (1943 to 1944) and a year later for *LIFE* magazine.

Poignantly known as the photographer who would take almost any chance if it meant getting the right shot, Smith's luck deserted him on May 23, 1945.

While on the east coast of Okinawa photographing an essay entitled "A Day in the Life of a Front Line Soldier," he was seriously wounded by a Japanese shell fragment. The missile hit him in the head, cutting both cheeks, damaging his tongue, and knocking out several teeth. Characteristically, he was taking pictures at the time and the fragment passed through his left hand before entering his cheek, just below the eye and near the nose. His comment in the hospital later was: "I forgot to duck, but I got a wonderful shot of those who did. My policy of standing up when others are sitting down finally caught up with me."

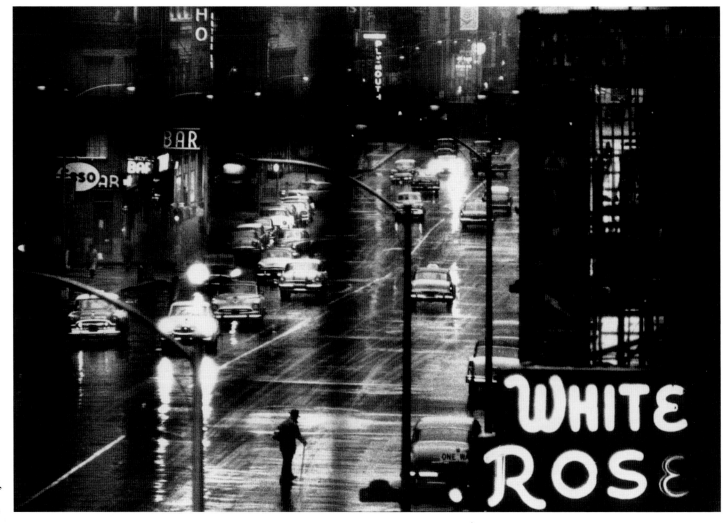

New York, US, 1958
Smith's charismatic shot of the neon lights on New York's Sixth Avenue stimulated much interest in Europe. By far the most populous city in the world, New York was soon to become the most cosmopolitan city, too.

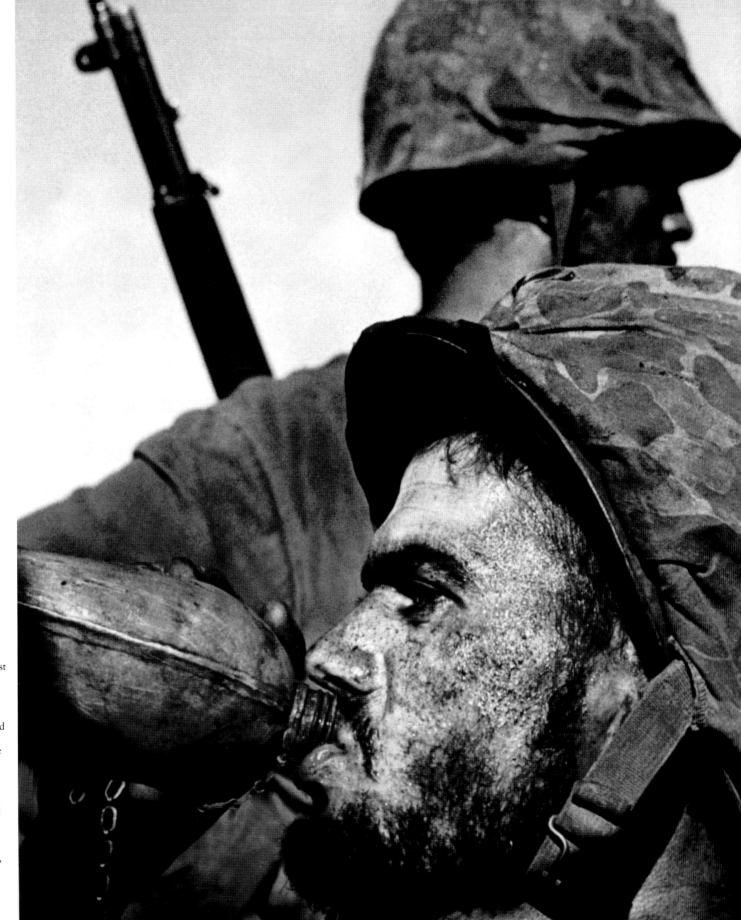

Pacific War, 1944
A US marine pauses for a drink during the torrid battle with Japanese forces for Saipan Island. The assault began almost a week after the invasion of Europe, with a huge armada of 535 ships, carrying 127,570 US military personnel (a single supply ship carried enough food to feed 90,000 troops for one month). Victory was to give the US control in the region and helped to bring about a premature end to WWII. The strength of the Japanese forces was, however, overlooked, and the Americans suffered heavy losses even though they were the victors. "The Japanese fought to the last man, woman, and child," said one witness.

Ernie Pyle, another war correspondent, who worked in the Pacific with Smith, said of him: "Smith is an idealist, trying to do great good with his work, but it will either break him or kill him."

Indeed, Smith's war wounds cost him two painful years of hospitalization and plastic surgery. During this time, he took no pictures and whether he would ever be able to return to photography was doubtful. Then one day, during his long recovery, Smith took a walk with his two children and, although it was intensely painful for him to operate a camera, came back with one of the most famous photographs of all time: "The Walk to Paradise Garden."

Over the years, Smith came to use any camera, from a diminutive Minox to a 4x5 press camera. In most of his work, however, he used 35mm cameras, famed for having as many as six or seven around his neck and slung over his shoulders at one time.

Following his recuperation, Smith worked for *LIFE* magazine again from 1947 to 1955, before resigning to join the world-famous Magnum Photos as an associate. With the support of two Guggenheim fellowships, he began a project in 1956 to photograph Pittsburgh, US, producing color photographs for the American Institute of Architects Centennial Exhibition, at the National Gallery of Art, in Washington DC.

Smith resigned from Magnum in 1959, changing his status to a contributing photographer and, from 1961 to 1962, he photographed the Japanese industrial firm Hitachi Ltd., even though there was much anti-Japanese feeling in the US.

In 1970, a retrospective exhibition, "Let Truth be the Prejudice," opened at the Jewish Museum in New York. The following year, he moved to Minamata in Japan to document the aftermath of industrial pollution with his wife, Aileen Mioko Smith.

After moving back to Tucson, US, to teach at the University of Arizona, Smith died from a stroke in 1978. His archives are kept at the Center for Creative Photography in Tucson, Arizona.

Of himself he once said: "I am an idealist. I often feel I would like to be an artist in an ivory tower. Yet it is imperative that I speak to people, so I must desert that ivory tower. To do this, I am a journalist—a photojournalist. But I'm always torn between the attitude of the journalist, who is a recorder of facts, and the artist, who is often necessarily at odds with the facts. My principal concern is for honesty, above all honesty with myself."

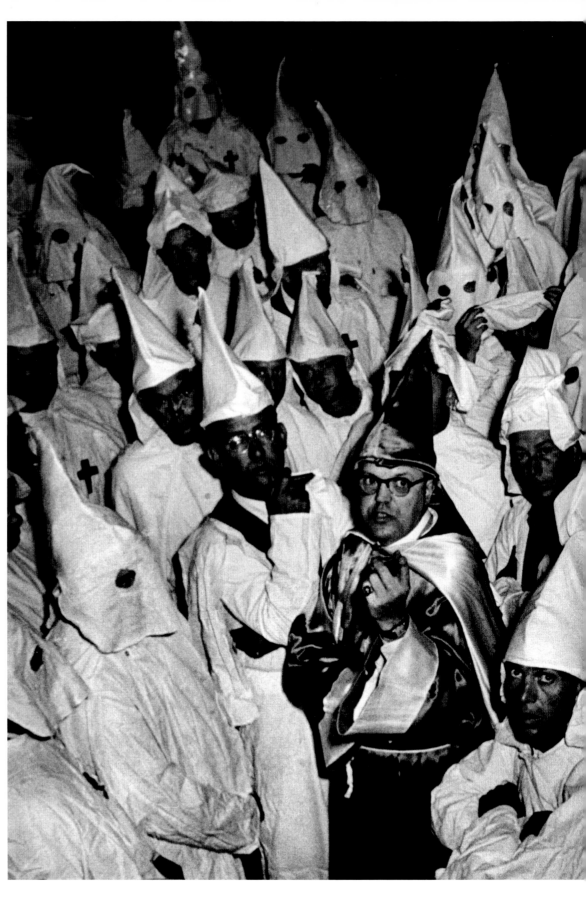

South Carolina, US, 1955
Racism in southeast regions of the US was widespread throughout the 1950s, with large-scale Ku Klux Klan (KKK) meetings commonplace. It was not until 1954 that racial segregation in schools became deconstitutionalized. Smith's photographs helped document the start of campaigning of civil disobedience to secure civil rights for Americans of African descent.

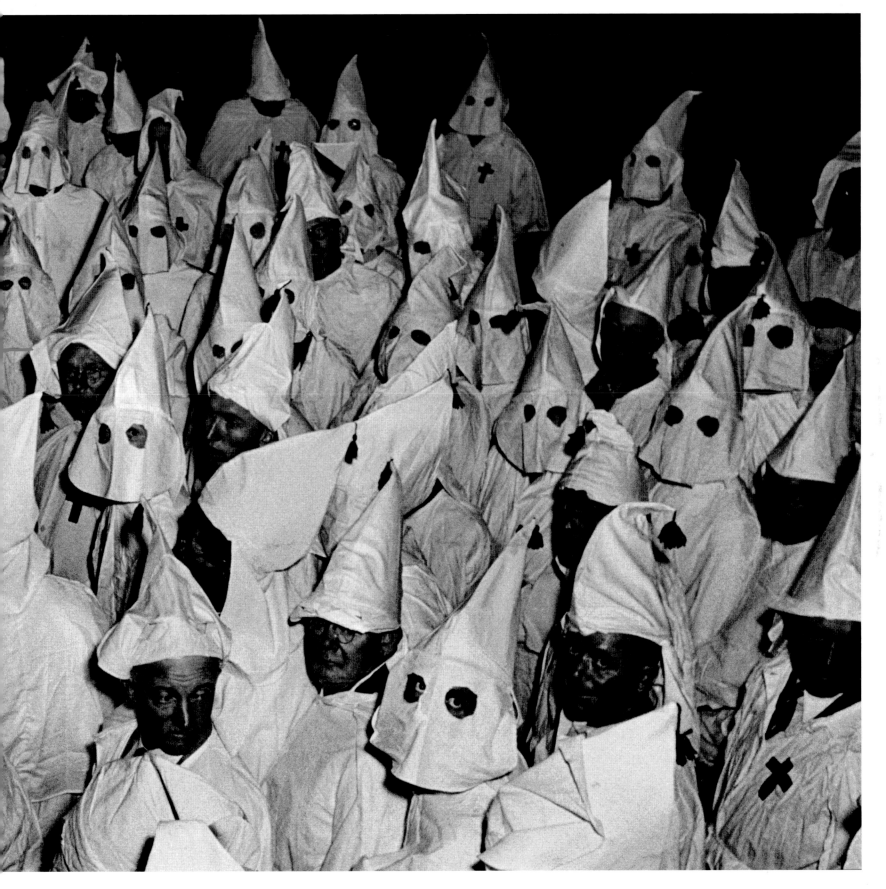

W. Eugene Smith

Bruno Stevens

Bruno Stevens was born in 1959 in Brussels, Belgium. After 20 years of working as a sound engineer, he became a photojournalist in 1998.

He explains: "I worked in the music business for a long time. But I didn't feel like I was achieving anything useful. It was just a paid job like any other. I'd always loved to travel and take pictures, as well as having a healthy taste for history and, to some extent, politics. So I decided to put all these elements together."

Stevens' first reportage assignment was on the Zapatistas in Mexico, documenting the plight of an indigenous people's stand against the authorities. Since then his illustrious career has taken him around the world. "I have worked in Mexico, Haiti, the former Yugoslavia, Chechnya, Afghanistan, Pakistan, India, Israel, Palestine, Iraq, and most recently Darfur, Libya, Sri Lanka, Nepal, Uganda, Kenya, and Somalia," he says.

"From the outset I have wanted to tell the world about these places and what is happening in them. I am a journalist whose camera is his pen, rather than a photographer who does things in the name of art. That is not what I am about."

Stevens concentrates his efforts on the fate of civilian populations in places of great social tension and war zones. As one of the world's most respected photojournalists his work is regularly published in *Stern*, *Liberation*, *The Sunday Times Magazine*, *Time*, *Newsweek,* and *Paris Match*, among numerous others.

Stevens explains: "I think of my photographs as a form of protest against violence, and I want to share my feelings and emotions through black and white imagery. Pictures that are witnesses of life in a zone of conflict. Having strong international contacts and using them to tell a story is the most important thing. I can go to almost any remote place in the world and—even if I cannot speak the language—I can establish a rapport."

Stevens says he always follows what he wants and seldom lets picture editors of magazines and newspapers influence his decision making. "I only work on stories that interest me and I only take pictures of situations I feel empathy for. I choose my path for very simple reasons; whether I shoot color or black and white, film or digital, or medium or large format depends on the way I want to tell the story, not what the publishers think is best. I would otherwise become the journalist who changed his grammar and vocabulary to suit each and every person he worked for."

Going against the mill of publishing opinion, Stevens still prefers the look and feel of film. He owns more cameras than most: two medium-format Hasselblads; one Hasselblad XPan; for 35mm work he has a Leica M7 and M2, while, for digital, he shoots with two Canon 5D bodies. Stevens also owns two Mamiya 7s and an exclusive large format Swiss Alpa which takes 220 roll film, in addition to a rare panoramic Russian Horizont. "With each camera I always carry two lenses to cover any eventuality."

Baghdad, Iraq, December 2003 *(right)*
The reflection of a car dominates the window of coffee house Al Zahawi, in Rashid Street. The coffee house is named after a celebrated Iraqi poet and musician.

Ramallah, Palestine, May 2002 *(opposite)*
After nearly five months of house arrest by Israeli forces the Palestine Liberation Organization's leader, Yasser Arafat, is more isolated than ever in his Mukhata office.

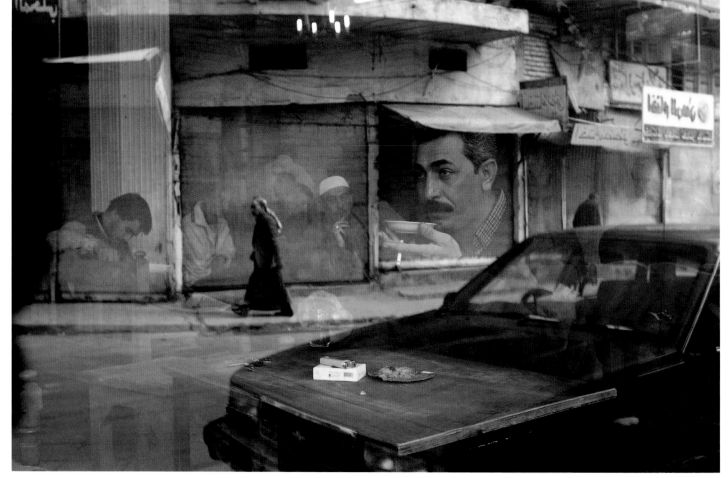

Bruno Stevens

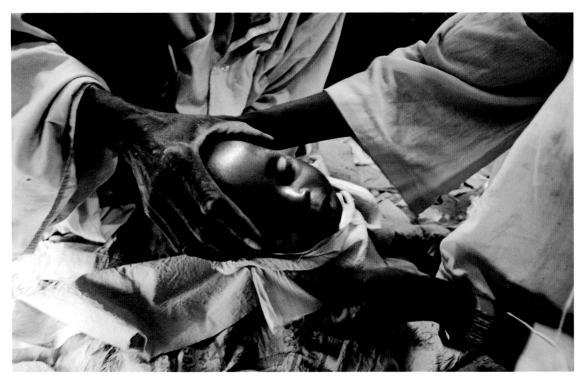

Farchana refugee camp, Chad, June 2004 *(left)*
Men prepare for burial the body of Hafiz Malik Yaya, a 9-month-old baby, who died from severe malnutrition. More than 13,000 Sudanese refugees from Darfur stay in this camp, forced to live in very harsh conditions.

Muzaffarabad, Kashmir, December 2005 *(right)*
Normal life slowly returns to the martyr city following one of modern history's worst-ever earthquakes; customers sit in a hairdressers' salon that has reopened for business.

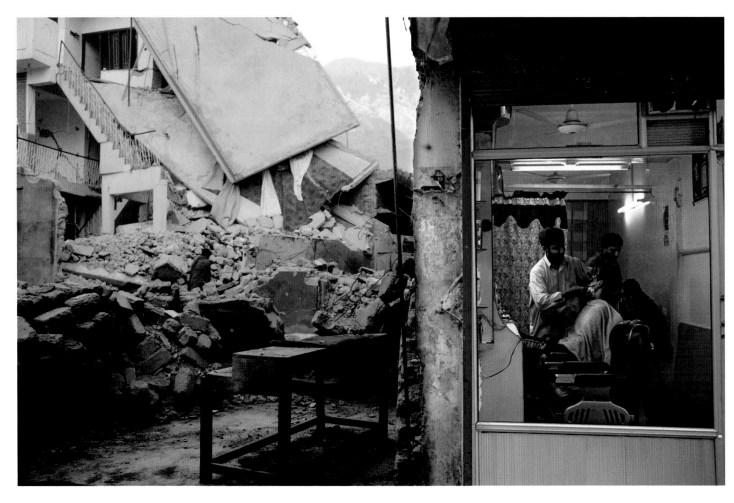

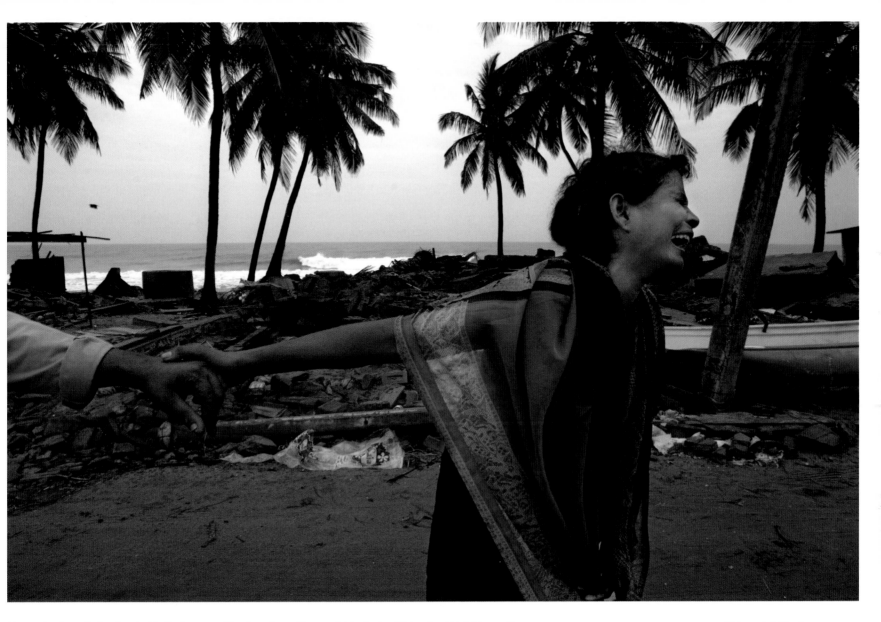

He says he doesn't often fear for his life, however, Chechnya in the former Soviet Union is an exception. The armed conflict in Chechnya began in September 1999. Despite repeated pledges by authorities in Moscow that they would do their best to improve human rights in the region, the atrocities continue, apparently unabated.

He says: "I went to Chechnya in December 1999, which was right in the middle of the Russian offensive. It was almost impossible to get there, which meant very few pictures of what the Russians were doing were getting seen in the West. It was the might of the Russian army against these little pockets of civilian resistance. I just had to go there and document it. It is the most dangerous place I have ever been. There is no security whatsoever. Corruption, kidnapping, gunfighting—it's one hell of a tricky place, you know."

Stevens thinks the best thing about his job is meeting and learning from the many people he encounters. "I meet thousands of people from all over the world and it's just so incredibly enriching, whether they're a Somalian farmer, Indian guru, or intellectual from Palestine. It's fascination with first-hand travel. And it's immensely fulfilling to know that if something interests me I can react and book an air flight almost immediately.

"No matter how small just one of my images may be, I like to think of it as a little piece of sand in the machine which prevents a story from not being known."

Kalmenai, Sri Lanka, January 2005
A mother comes back to the place where her 15-year-old son was killed during the Asian tsunami.

Bruno Stevens

Ian Teh

What immediately strikes you about Ian Teh's pictures is the grainy, vibrant, and instantaneous style. "I usually shoot purely on intuition, although I sometimes discuss with magazine and newspaper editors what type of pictures they require before embarking on my travels," says Teh. "For personal work, I often do self-assigned projects; this gives me the freedom to build a photo essay on my own terms. I then come back and place the pictures I've taken."

Malaysian-born Teh has exhibited his work around the world, and his picture credits include *The Independent Magazine*, *Newsweek*, and *The Guardian*. In 2001, he won the World Press Masterclass Award. Not surprisingly, he has worked in many countries, including Brazil, Cuba, Thailand, Japan, Hong Kong, China, the US, Mexico, France, and Malaysia.

Teh believes in giving his all for his photography, both personally and commercially, and his approach has seen him become one of the most sought-after photographers of his type in the world. "My personal work relates to reportage and documentary photography, and I like to see these as long-term projects. I'm working on two or three at the moment, which are based in China and Britain," he says. It is largely for this reason that Teh is reluctant to call himself a travel photographer, and clearly defines his role as a messenger and photojournalist. "I always try and stay true to my own personal style," he adds. "Although I've been working professionally for about eight years, my main concern has always been to express my story through a distinct visual language."

His most poignant work to date has been centered on the construction of the Three Gorges Dam on the Yangtze River in China, and the effect on the population of over a million who have been displaced by the Chinese government. His photographs build a fascinating story of the plight of the people whose lives are being affected.

"Over a thousand small towns and villages are being destroyed because the water levels will rise when the construction on the dam is completed—something like 175 meters [574ft]. It's due to be finished in 2009," he says.

Because of the subject matter involved, Teh has to be prepared for anything, and for this reason he likes to keep his equipment simple. "I use two Leica M6s, one with a 35mm lens and the other with a 50mm lens; I don't like to change during a shoot." He also carries a Ricoh compact camera with a 28mm lens, allowing him to take professional-quality pictures without having to lug another full-sized camera.

Teh says his camera equipment has to be, above all else, reliable, rugged, and easy to use. He also has a Nikon F100. "I use the Nikon when I have to work fast—it's a responsive camera. I can work fast with the M6, but it's better for more specific kinds of photography. Because it's manual, I can only wind it at about 2fps."

He prefers Kodak Supra film, and likes either 400 or 800 speed. This is unusual for many photojournalists, with most opting for finer-grained, slower films. "I like to shoot with very fast film, but occasionally I do use Kodak 100. Because I work abroad for long periods, I like to adopt the same film throughout to get consistent color saturation and highlight detail."

With the unique political situation in China, it's not surprising Teh has had one or two brushes with the law, the most memorable being when he was arrested by police after a minor furore with dam workers near the Sino–Russian North Korean border. "I was with another photographer and we came across workers on a construction site," he explains. "One of them wasn't happy about us taking pictures, and before I knew it about 40 or 50 workers surrounded the two of us. They were trying to take our cameras away.

"The police arrived, asked us for our passports, which we didn't have, and we were driven off. In the back seat, I slowly removed the film and managed to put in a fresh roll. I took a few frames with the Leica M6, which fires very quietly. The police asked for the film, at which point I just opened the back of the camera and shouted, 'Argghh! I've forgotten to rewind it!' The police thought the film was destroyed and let us go, but of course I had hidden the original. The other photographer was so fed up he just pulled the roll of film from his camera and gave it to them."

There can't be many photographers who enjoy this kind of professional freedom; this synergy between projects and commercial success. Most of us have to undertake work that provides little satisfaction, often just to pay the bills. But Teh's innovative pictures find a ready market among magazines, newspapers, and book publishers. He is one of the lucky few to have achieved this dream.

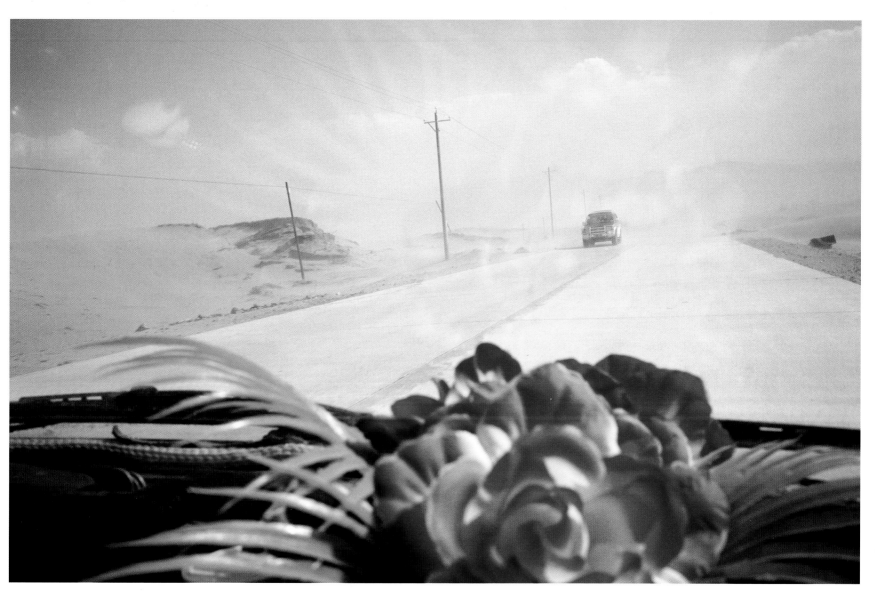

Toward the source of the Yangtze River, Quinghai, China *(left)*

"I was on a bus heading for a town near the source of the Yangtze River. On the bus were these guys who had been traveling for four days. They were migrant workers who had left their families to spend four months working in one of the far western provinces of China. The man who was telling me this was very matter of fact about his fate, giving the impression that this was a common situation for many like him. He was a road builder who, like so many others, was part of the Chinese government's big plan to develop the west of the country. Ten hours into the journey, two-thirds of the way to its final destination, the bus stopped on a stark plateau in the Tibetan and Uighur province of Qinghai. Despite being at 4,000 meters [13,120ft], there didn't seem to be any peaks for miles. The man I had been talking to bid me goodbye and got off with the rest of his colleagues. Outside, it was dusk and incredibly cold. Despite it being summer, there was snow covering the surrounding landscape. In the distance and to the side of the road, set against this vast expanse of nothingness, there were tents where the men would be based in the coming months, building roads far away from their loved ones. When I took this shot, they were just collecting their luggage."

Flower, China from "Merging Boundaries: the Sino–Russian/North Korean Border" *(above)*

"I had seen on the map that there was a spot where Russia, North Korea, and China would share the same border—essentially a tri-border—and it seemed to me an intriguing phenomenon. So I caught a taxi from this dusty border town I was staying in to this specific place. The journey there seemed promising, the surrounding scenery was austere, and the taxi had rather kitsch decorations in it. As it turned out, the trip there was the most interesting part. On arrival, all that was there to mark this location was an engraved bit of rock sticking out of some undergrowth, a pretext of a monument. I'm not sure what kind of romantic idea I had had when I decided to go there, but I love the sense of promise that this picture offers—in a way, it was very much like the trip to this 'unique' spot."

Ian Teh

Migrant workers, Wushan, China, from "The Vanishing: Altered Landscapes and Disappearing Lives"

"This was taken in Wushan, a town set along the banks of the Yangtze River in the area to be partially submerged due to the construction of the enormous Three Gorges Dam. Many peasants from the surrounding countryside had come to work as laborers in the demolition and clearing of these cities and towns. They earn a meagre £2 [$3.75 US] per day, which is still more than they would get in the fields. It was my second visit to this town in over a year and the place had been reduced to rubble. Once a vast swathe of land, teeming with people and buildings, it had become nothing more than a construction site. After a day of hard labor, these workers, both men and women, were on their way back to their makeshift homes, often located within the very buildings they would soon help to destroy."

Wanzhou, China, from "The Vanishing: Altered Landscapes and Disappearing Lives"

"The 'Vanishing' project is essentially about an ancient riverine world that was soon to be lost forever due to the construction of the gigantic Three Gorges Dam. The dam is the Chinese government's answer to the annual flooding of the Yangtze River and to China's increasing need for electricity due to its rapid economic growth and emerging global status. The sacrifice is that a thousand cities, towns, and villages have been destroyed over a 700km [435mile] stretch of riverbank and, as a result, a population of 1.5 million people have been displaced. I was in Wanzhou, a city that had undergone so much destruction it felt like a place in a war-afflicted country. On that day, I was visiting a historical bridge that was soon to be dynamited when I saw this beautiful Chinese girl in a blue dress and bright red shoes crossing the bridge. She was such an incongruous apparition, a breath of fresh air in such depressing surroundings."

Little girl with blue jacket running, Fengjie, China, from "The Vanishing: Altered Landscapes and Disappearing Lives"

"This picture was taken in Fengjie, a town where most of the local population had already been relocated. The construction of the Three Gorges Dam has a far-reaching environmental impact. The riverbank at this town had to be reinforced with concrete in anticipation of the rising waters. Eventually, the huge wall behind this laughing little girl would become the pier to this small, once historical town. The local population used this area as a recreational space during the last spring before the rising waters submerged it."

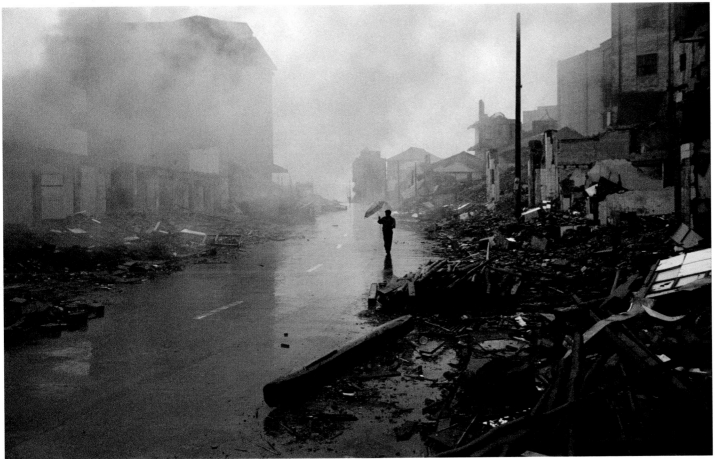

Destroyed old town, Wanzhou, China, from "The Vanishing: Altered Landscapes and Disappearing Lives"

"This shot was taken in Wanzhou. The construction of the Three Gorges Dam meant that a vast number of towns, villages, and cities had to be destroyed and cleared of debris to accommodate the rising waters of the Yangtze River. By the time I got there, the city had undergone a significant amount of destruction and most of the population, except for a few families and the workers who were carrying out the demolition, had already moved away. I had been there for three days and it had been raining nonstop. Every now and again, the quiet patter of raindrops would be broken by the sound of dynamite going off as buildings were destroyed. In one of these instances, when smoke was drifting across this apocalyptic scene, I saw a lone man with his umbrella, one of the few left behind in one of the largest relocation efforts in the world. For me, it symbolized the many problems that this ill thought out government project suffered."

Ian Teh

Playground, Havana, Cuba

"This was taken during one of the first trips on which I started experimenting with color—before this I had been shooting mainly in black and white. I was in Havana walking near the esplanade when I came across this energetic scene in a playground. There were children running around, jumping off climbing frames, and generally playing with abandon, as only the young can. High above the playground were two old men watching the scene. Most people don't seem to notice this in the photograph and although I don't think it's a particularly important detail, it's still a little aspect of the picture that I enjoy."

Tokyo Dome, Japan

"It was the Japanese baseball finals in Tokyo and the Giants were playing in their hometown. The atmosphere in the stadium during one of these matches is supposed to be fantastic, but all the tickets had already been sold out. I was disappointed but decided I would still go to the match in the hope of finding some black market touts who might be selling tickets outside the stadium. In the end I got in at half time and the mood of the place was electric. This photograph was taken at the end of the match during a slight lull before the prizegiving. Aside from the obvious graphic qualities of this image, I particularly like the various little stories being played out almost imperceptibly on the pitch during this relatively quiet moment."

Face in mirror, Shanxi province, China
"I recently started a new project exploring life in some of China's industrial towns and cities. The country is currently experiencing a massive economic boom and struggles to meet its energy needs. I had been exploring this city, Taiyuan, looking for the most industrialized areas when I discovered by accident this games hall underneath a massive roundabout situated near a petrochemical plant. Deep down a long flight of steps was an enormous space filled with pool tables and karaoke bars. The place was amazing. It was a man's world and the only women there were hostesses. Many of the customers were factory workers or workers from a nearby plant and they would come down most evenings to shoot some pool in this underground cavern."

Ian Teh

Men in bus, Dongmen, China, from "Merging Boundaries: the Sino–Russian/North Korean Border"

"For me, border towns have a particular atmosphere and although the mood was distinctly oriental, there was a feeling in this dusty place not unlike how I imagine the western frontiers of America once were. I was in Dongmen in late autumn and the weather was already blisteringly cold at night. Characteristic of this town were these banged-up buses that had been converted into snack joints. The people who frequented these places came there to drink and eat barbecued meat on sticks because it was warm. I was in there for exactly the same reason and had been invited to join some of these characters, many of whom were of Korean descent, for bouts of beer and rice-wine drinking. This was my parting shot."

Waitress, Dongmen, China, from "Merging Boundaries: the Sino–Russian/North Korean Border"

"I am not sure what I expected when I started the 'Boundaries' project. Certainly my imagination got the better of me and, unlike my other projects, it wasn't the photojournalistic angle that attracted me to this part of China. I suppose it was the mystery and the unique atmosphere that seems to pervade border towns that brought me here. It is this mood that I try to convey in this body of work. I was in a rather chic café in a town near the Russian border. It was trying a little too hard with its decor and as a result had developed its own particular flavor. Even the waitress had a uniform that seemed to have come out of a fashion magazine feature illustrating kitsch."

Blackpool, England
"I shot this along the promenade in Blackpool. The picture is from a series entitled 'The Blackpool Weekend,' a project about the famous working-class seaside resort in its current state ahead of ambitious plans to transform it into a big gaming town along the lines of Las Vegas and Atlantic City. I saw this poor, windswept family being caught in a raging gale along the seafront. It was typical English weather and they were screaming in delight at the experience of nearly being swept off their feet. It didn't seem to bother them that they never got their sunny weekend by the British seaside."

Ian Teh

Ami Vitale

American photojournalist Ami Vitale is currently based in Spain. She was a World Press winner in 2003 and 2005, and runner-up in the prestigious Pictures of the Year International in 2005. Her work from Europe, Africa, the Middle East, and Asia—specifically India—has been published widely in the US, including in *Discovery, Geo, National Geographic Adventure, Newsweek, New York Times Magazine,* and *Time,* as well as internationally.

She attended the University of North Carolina and took a course in International Studies, before working for Associated Press as a picture editor in New York and Washington DC. She worked overtime to get enough money to make the break to photography, initially basing herself in the Czech Republic, before working around eastern Europe.

"I decided to quit [as a picture editor] and concentrate more on my photography with the ultimate aim of going freelance," she recalls. "When I moved to the Czech Republic, I started working for a business paper. However, after closely following current affairs in the region, I became interested in the conflict in Kosovo. I was there when the war started and it was at this point that I was really able to work as a photojournalist at international level. I quit my job in the Czech Republic and went to live in Kosovo for about a year to follow everything."

Born in Fort Lauderdale, Florida, US, Vitale's thirst for documenting social inequality was born from her bike rides through Chapel Hill as a student. "My bike rides to university took me through Dairy Land Road and I was amazed at the variety of people who lived on this one stretch of pavement. Chapel Hill boasts the highest concentration of PhDs per capita in the entire US. Each day, I saw these highly educated and wealthy individuals in their sprawling homes, tucked next door to people living in shacks without indoor plumbing. It was shocking to see these two worlds living so closely, yet completely unaware of one another. I set out to document this bizarre reality."

The opportunity led her to realize that she wanted to show how the ordinary people of the world live, and to promote a real understanding of other cultures. Vitale is fervent: "I've never thought about any other kind of photography. I knew from the beginning this is what I wanted to spend my life doing. I've never done photography for money, because of my views on the world, and I feel very privileged to have this perspective, unlike many in the West. Growing up in the US made me want to experience life in places where every day is a struggle for survival."

In 1995, Vitale had visited her sister, then working for the Peace Corps in the tiny remote village of Dembel Jumpora in the east of Guinea-Bissau. A grant in 2000 from the Alexia Foundation for World Peace enabled her to return there to photograph in 2001. Vitale went intending to stay a couple of months, but ended up living in the village for six months. She stayed with a woman and her children, shared their lives— living, eating, sleeping as they did—and helped in their everyday tasks.

"I think my inspiration was photographing in Guinea-Bissau," remembers Vitale with fondness. "The village was really remote, with no electricity or running water and the people were living in mud huts. It was really beautiful, but incredibly hard. It had this huge impact on the way I saw the world. My American education and upbringing had somewhat ill-prepared me!"

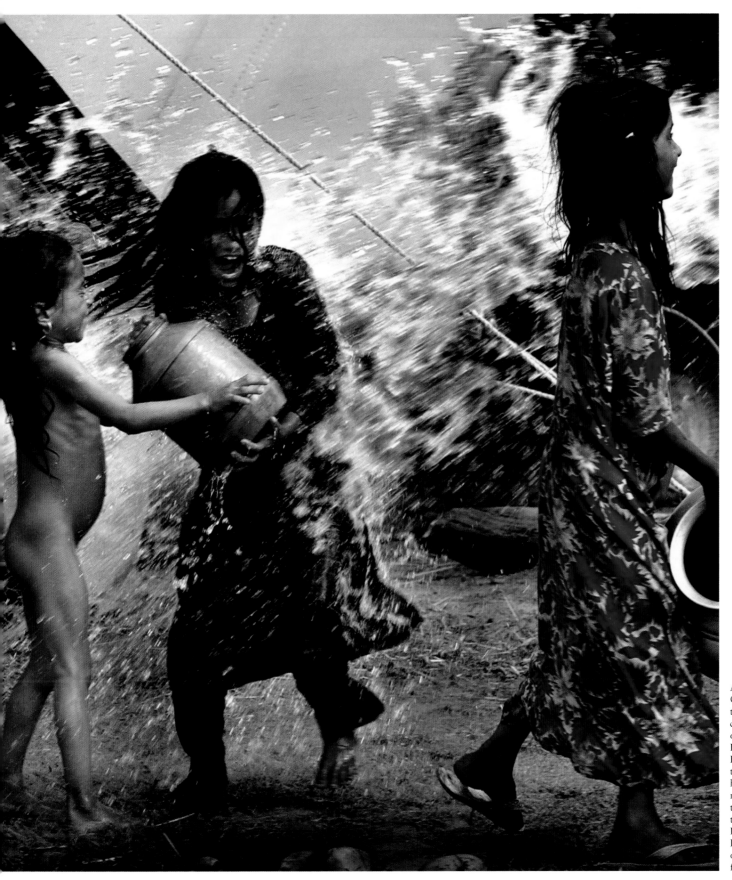

Akhnoor, Kashmir
Children forced to migrate from their home in Pargwal, India, cool off as a truck sprays water on them near Akhnoor in the Indian-held state of Jammu and Kashmir. Indian and Pakistani troops continue to exchange heavy mortar, artillery, and machine-gun fire along the line that divides Kashmir between them. India continues to press Pakistani President General Pervez Musharraf to crack down on the flow of Muslim militants from Pakistan into Kashmir.

Ami Vitale

After her time in Guinea-Bissau, Vitale was based in India for several years, producing memorable work from Kashmir, Gujarat, and Delhi. "For four-and-half years, I was based in India and I spent a great majority of my time in Kashmir; I am fascinated by this part of India and had a burning desire to understand it and all its complexities. The whole place really seems to capture my heart and you can see it in my photographs."

Now based in Barcelona, Spain, Vitale also has a contract with Getty Images. But she feels free and most of the work she does is self-generated. "I'm constantly coming up with story ideas and pitching them to all kinds of people. I try to shoot what I'm passionate about, but sometimes I must take on other kinds of assignments to put bread on the table. If I had a family to support, I would never be able to undertake the work I do, or travel to the places I want to go. But it is all my choice, so I do not see it as compromising other parts of my life. I could have been doing many other things, but I chose to be a photojournalist."

Vitale prefers to use film, although she does own two fast Nikon digital D1X SLRs. A pair of Nikon F100 35mm film cameras are responsible for the majority of her work, although

Badgam, Kashmir, March 2004
A Kashmiri woman comforts a relative as they mourn the death of five people killed, along with 48 injured, when a grenade exploded in the hands of a man seeking to extort money from a family in the Badgam district of Kashmir. Locals said the man was a former militant who was extorting money from villagers, and thousands came out to mourn the deaths. Tens of thousands of people have died in Kashmir since the eruption of the anti-Indian revolt in the region, which started in 1989. Separatists put the toll at between 80,000 and 100,000.

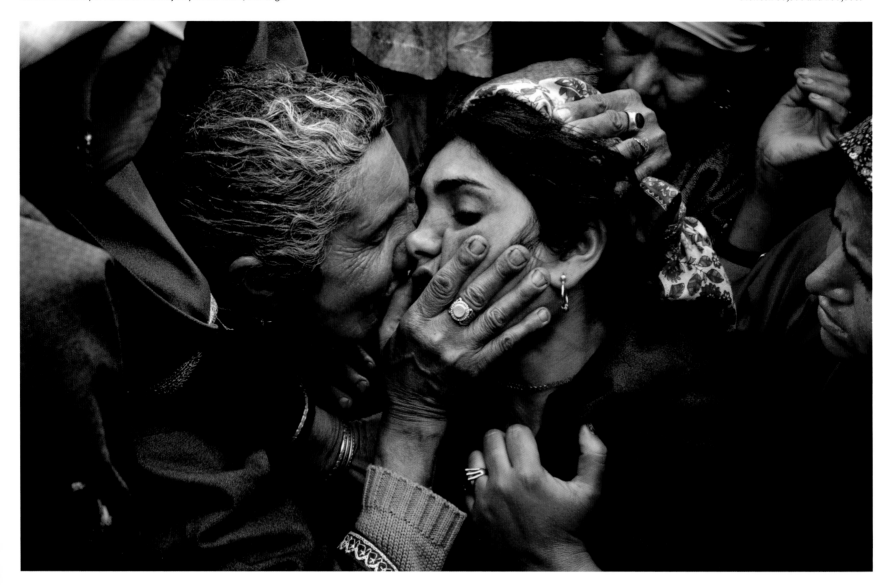

she also sometimes uses a Leica M6. She explains: "The M6 is quiet and subtle and works well when I have lots of time on my hands. I prefer working with natural light because it's just so beautiful and the Leica is perfect for using slow shutter speeds. If I can get away without using flash, I will—most of the situations I find myself in are pretty sensitive and I find that flash can be too intrusive. I work in cultures where people have never seen a camera before and it can be pretty terrifying. They aren't exposed to media in the same way that we are in the West."

Even though Vitale has spent little time in the US recently, she is considering moving back for good. "I'm just taking it day by day and trying not to take any moment for granted. I have lots of projects and ideas I'm proposing to different publications. Even though I don't agree with a lot of the things going on in the US, and have been living in Barcelona, my roots are in America and I am seriously considering moving back."

Badgam, Kashmir, March 2004
Villagers wait as the Indian army brings back the bodies of the five people killed in the grenade incident.

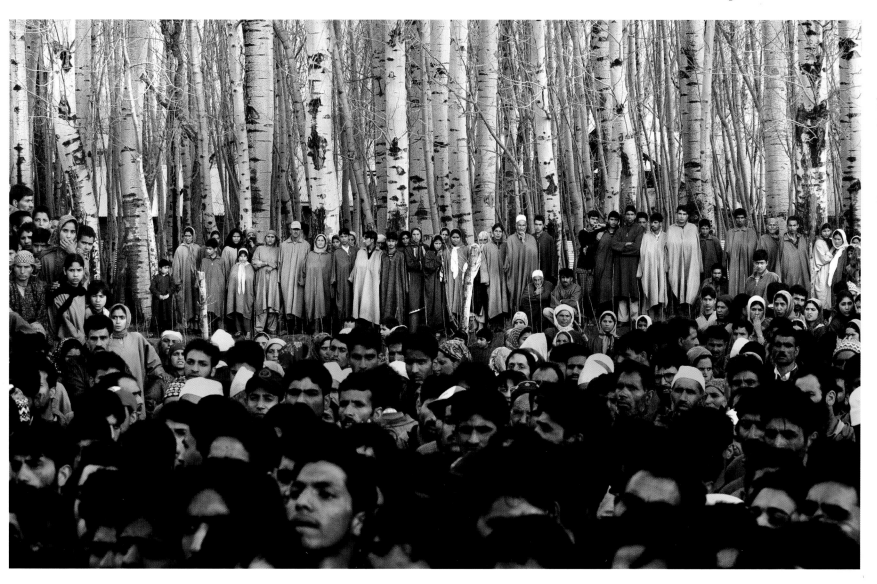

Ami Vitale

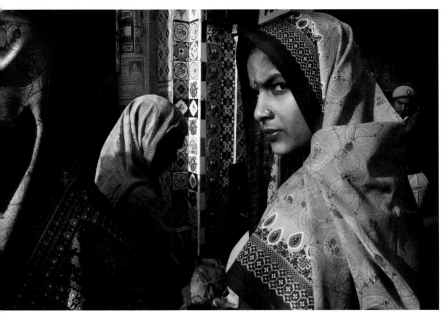

Hindu women, India
Hindus and Muslims once shared neighborhoods, schools, and friendships, but nearly all the Hindus fled Indian-governed Kashmir after being threatened by Muslim militants, and are now scattered across India.

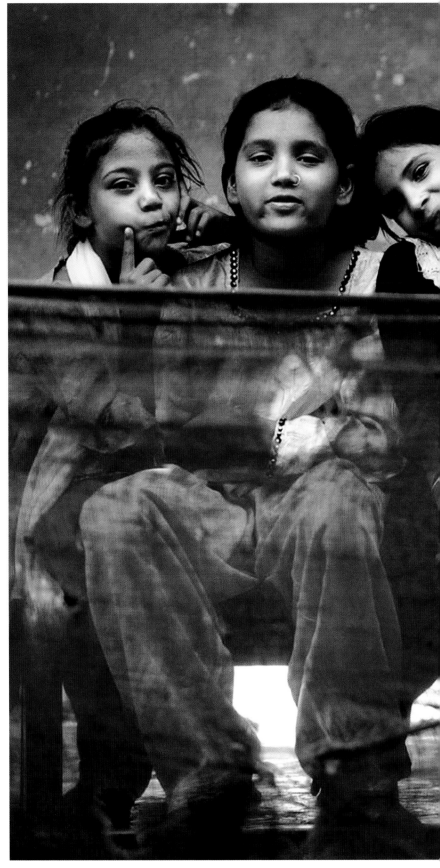

Ahmedabad, India, 2002
Muslim children sit inside the Dariya Khan Ghhumnat Rahat refugee camp, set up outside a school in the state of Gujarat in Ahmedabad, India. The extent of the damage and the displacement of more than 120,000 people has threatened the secular ideals of India and left the government under attack for its inadequate relief arrangements.

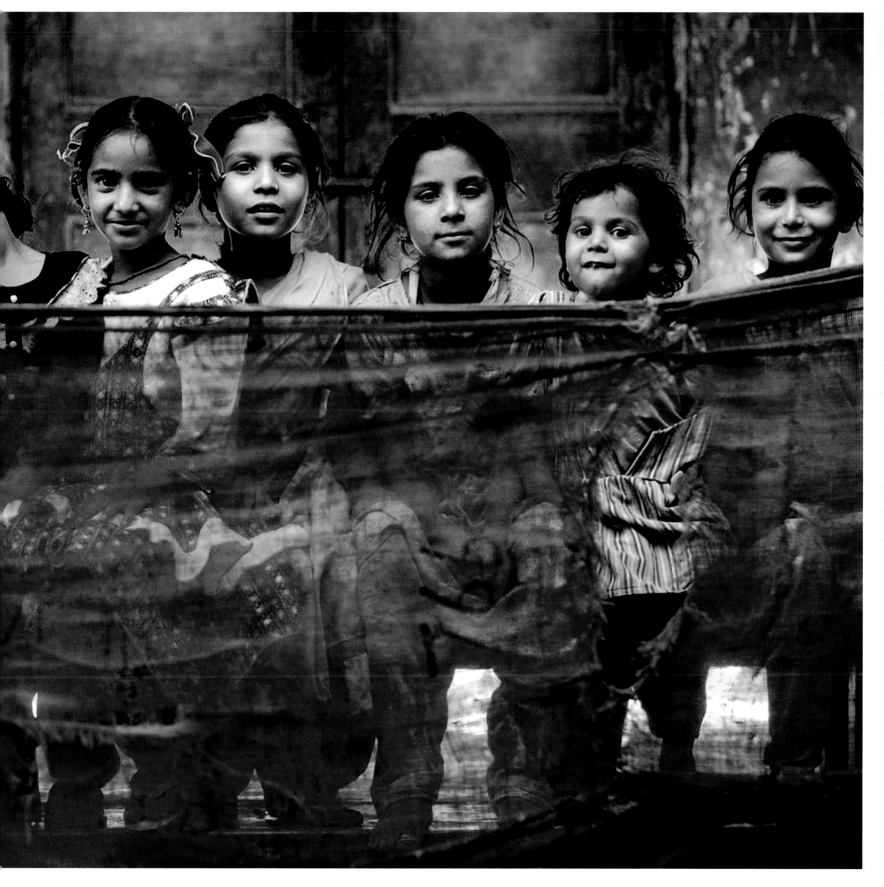

Ami Vitale

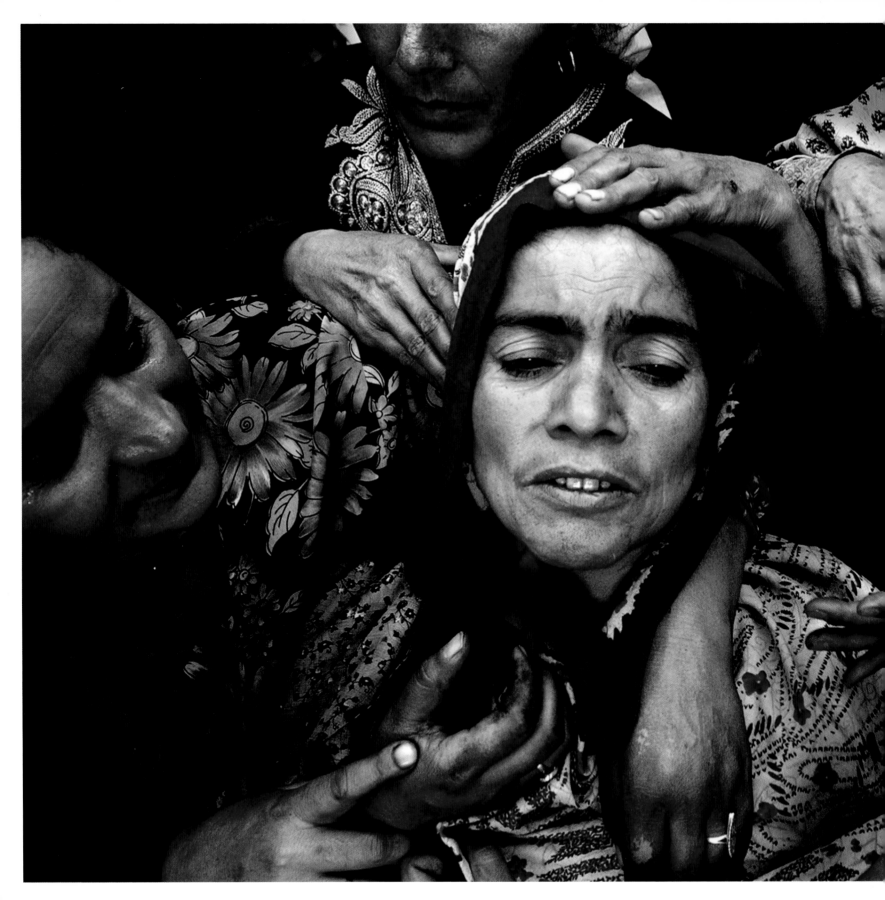

Mirhama, Kashmir, 2002
Relatives of Naz Banu, killed during an attack on leading politician Sakina Yatoo, mourn over her body during her funeral in the northern Kashmir town of Mirhama, in September 2002. At least 11 people were killed and a second abortive bid was made to assassinate a leading woman politician, just days before a crucial second round of polls in the strife-torn northern Indian state of Jammu-Kashmir.

Sopore, Kashmir, 2002
A Kashmiri woman watches the famous Sufi Saint from outside his fence in the hopes that he will answer some of her prayers and give her spiritual guidance. Though the majority of Kashmiri people are Muslim, there is also a strong legacy of Sufism in the region, creating a special brand of Islam throughout the area.

Ami Vitale

**Dembel Jumpora,
Guinea-Bissau** *(left)*
Children eating the staple diet
of rice from a communal
bowl. During the end of the
dry season, there is little to eat
and many villagers will have
only one meal of rice each day.

**Dembel Jumpora,
Guinea-Bissau** *(right)*
Boys play soccer underneath an
enormous Bontang tree. Though
the Fulani are a Muslim tribe,
they also believe this tree species
has a spirit. This mixture of
animist beliefs and Islamic law
creates a society that has a great
respect for the land around
them, the supernatural world,
and the laws of god.

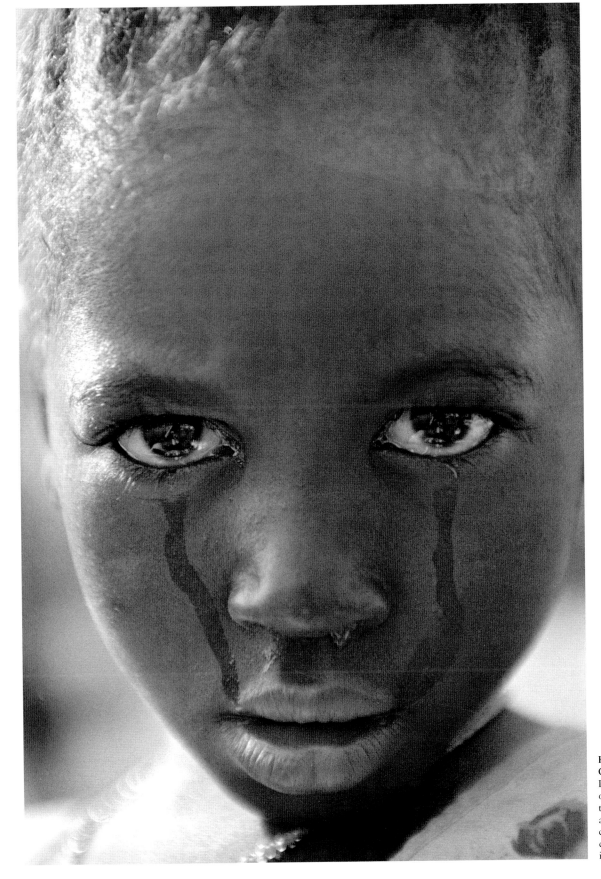

Female circumcision, Guinea-Bissau
In a culture where the opportunities for women to be honored, celebrated, and recognized are few, circumcision becomes disproportionately significant, in spite of the pain it brings.

Ami Vitale

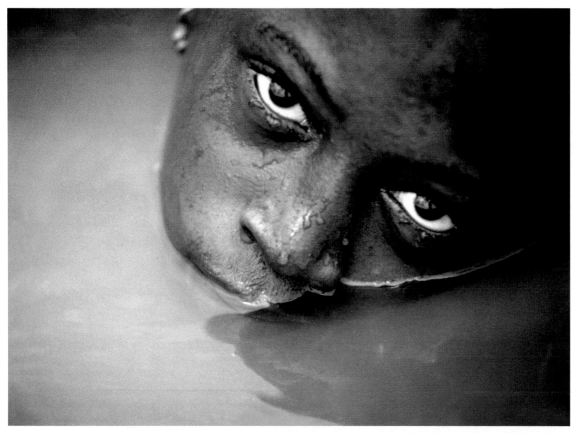

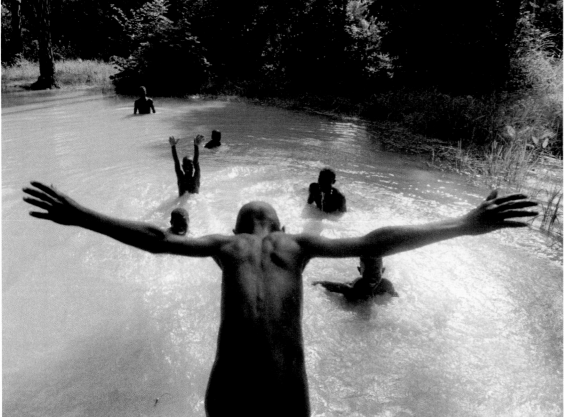

**Adema Balde, Dembel Jumpora,
Guinea-Bissau** *(top left)*
Adema Balde washes near her
family's rice fields. She died
as a teenager later that year
after trying to escape an
arranged marriage.

**Dembel Jumpora,
Guinea-Bissau** *(left and above)*
The climate in Dembel Jumpora is
hot and humid, but by the end of
the dry season there is surprisingly
little water to be found above
ground. The children take
advantage of rain and spend a lot
of time swimming in the touffe.

Ami Vitale

Kai Wiedenhöefer

"I've always had a strong interest in politics," says Kai Wiedenhöefer, who was born in southern Germany in 1966. "My father was exploited by the Nazis as an anti-aircraft gunner at just 15, which influenced the way I was brought up quite a lot. He was a very liberal man and gave me a lot of freedom. When I look back at my school days, the things I was interested in most were history, politics, and the arts."

Nowadays Wiedenhöefer's main focus is the Middle East. He read *Exodus* by Leon Uris at the age of 13, and the book had a big influence on his life. "It's a fascinating novel about the circumstances surrounding the birth of Israel in 1947 to 1948, though later I was to discover just how one-sided it really is. I've been fascinated by the problems in the region ever since I read that novel."

After graduating from high school, Wiedenhöefer's interest in the politics of the Middle East, combined with photography, led him to Jerusalem and the occupied territories in 1989. He was working on a portfolio for an application to university. "There I met Magnum photographer Leonard Freed at a photo symposium," he says. "He had just returned from Czechoslovakia. He thought something was going to happen in East Germany and told the students to travel and photograph there as soon as possible.

"We arrived in Berlin an hour before the wall came down. Everyone knows the photography term 'recording history,' though at that very moment it really was history. Today I deeply regret I was so inexperienced at the time."

From 1990 to 1995, Wiedenhöefer worked mostly in Israel, Gaza, and the West Bank. From 1991 to 1992 he lived in Damascus, Syria, where he learned Arabic at the Arabic Teaching Institute for Foreigners. "Previous visits to the Middle East made me realize I needed to speak the language of the people if I wanted to report about the affairs in this region."

Soon to become a specialist in the Israeli-occupied territories, Wiedenhöefer published *Perfect Peace* in 2002. It featured more than 10 years of his work, capturing both the hope and disappointment of the Palestinian people in the occupied territories. He has also photographed in Europe, China, and most recently, Iran and Afghanistan. His passion for his subject is second to few.

"The way the media works today is generally unsophisticated and unsatisfying; journalism has become a commodity governed by speed and money. In some cases, it makes the impact of journalism close to zero. Some editors are motivated by what sells and not by what is important. It's a shame because people won't have a clue what is going on, or what is going to happen."

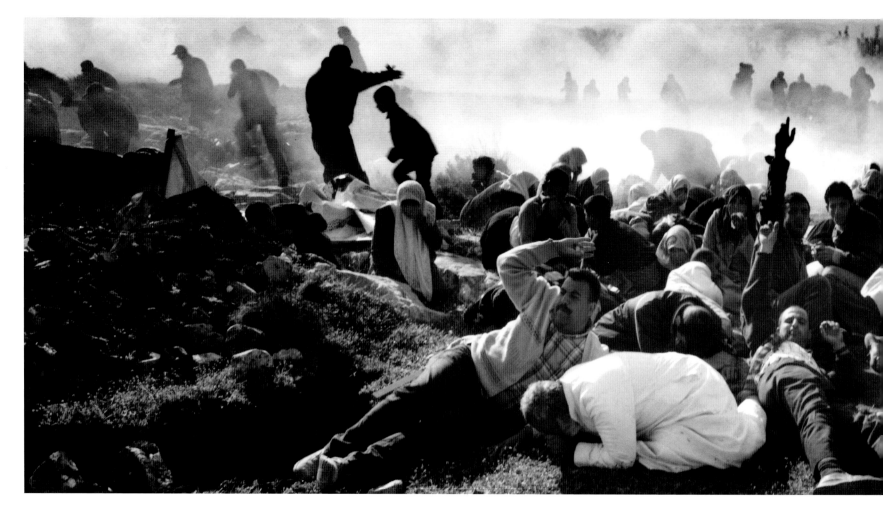

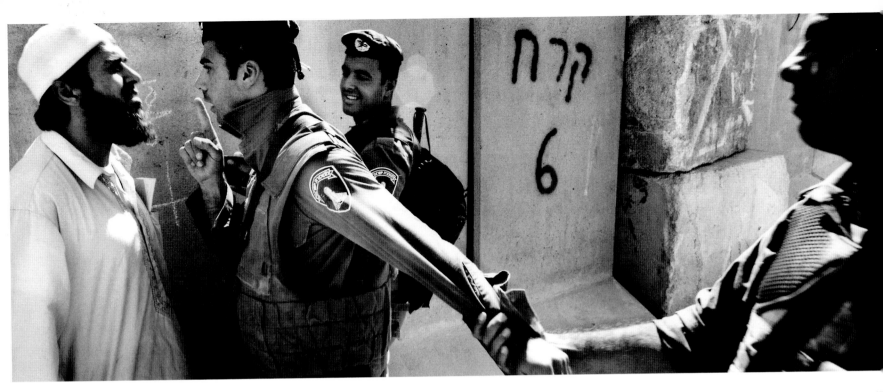

Over the years he has become recognized worldwide as a leading photojournalist and has received numerous awards, including the International Prize for Young Photojournalists of Agfa and Bilderberg; the Hansel-Mieth Prize; the W. Eugene Smith Grant for Humanistic Photography; the Leica Medal of Excellence; the Alexia Grant; World Press Photo Awards; and Joop Swart Masterclass, among others.

In 2005, Wiedenhöefer received a Getty Images Editorial Grant to continue his work on the wall in the occupied Palestinian territories. The project—executed with a large-format panorama camera—was published in 2006.

"I love the fact my job hasn't got a routine and I feel free with the way I want to work; I'm fortunate to be working with so many interesting characters, too," he says.

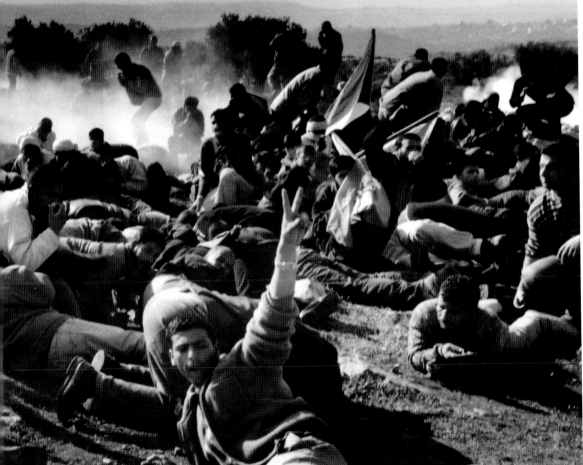

Palestine, March 2004 *(left)*
Palestinian demonstrators are pinned down by Israeli rubber bullets and tear gas in the occupied territories. They are protesting against the building of the separation fence in their olive orchards, near the village of Kharabatha Bani Harith. The peaceful demonstration was dispersed by massive force— even though international and Israeli protesters took part in the demonstration.

Abu Dis, October 2004 *(above)*
A Palestinian argues with a member of the Israeli Border Patrol in the Jerusalem neighborhood of Abu Dis, after crossing the wall. The original 8 foot (2.5m) wall was only provisional and was replaced by an 26 ¼ foot (8m) concrete wall.

Kai Wiedenhöefer

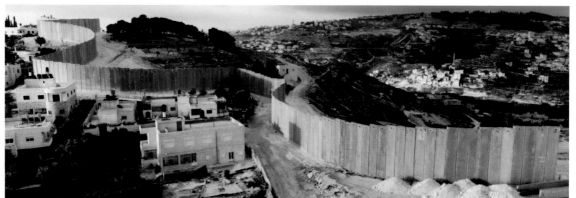

Abu Dis, March 2004 *(left)*
A piece of wall in the Jerusalem neighborhood of Abu Dis, seen from the building of the future parliament of a Palestinan state. The construction of the parliament started in 1999 but was never finished. The Palestinian villages to the right will be part of Israeli-administered Jerusalem, while the houses to the left will be administered by the Palestinian authority, staying under Israeli security control.

Abu Dis, April 2004 *(below)*
Three students pass over a piece of incomplete wall in the Jerusalem neighborhood of Abu Dis, next to the Al-Quds, Israeli-occupied territories.

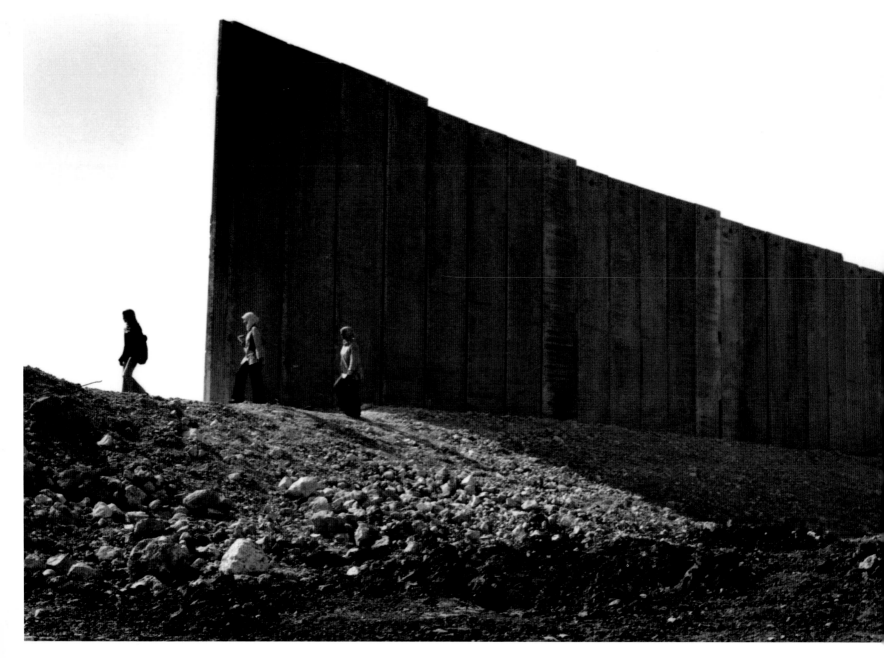

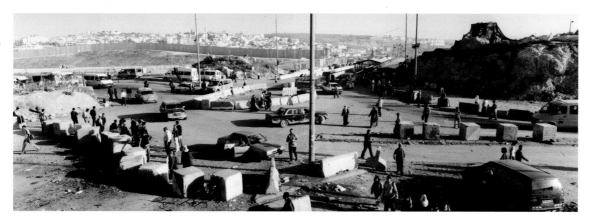

Jerusalem, Israel, November 2004
Most of the people from al-Ram in Jerusalem's Israeli-occupied territories, who hold Israeli identity cards (and are thus citizens of Jerusalem), were cut off from their town after the wall was cut in half.

Kai Wiedenhöefer

Paolo Woods

Paolo Woods' approach to photography is extremely pragmatic. "I am obsessed with the relationship between photography and reality. I still shoot commissioned portraits for magazines, but it is my passion to tell real stories to the real world through my photography. I am interested in projects that carry an important message, perhaps those that do not get the exposure they deserve."

Brought up in Italy by a Dutch mother and Canadian father, Woods started working in photography when he was 17. "I worked in art photography and I got increasingly frustrated. In 1999, when I was running a photography gallery in Florence, Italy, as well as a black and white lab, I organized a show for Magnum photographer Paolo Pellegrine. He was familiar with my work and invited me to go to Kosovo with him toward the end of the conflict. This was my first contact with the world of photojournalism."

Woods traveled to Albania, documenting the summer vacations of immigrants living illegally in Italy. His story was published in a small Italian magazine called *Diario della Settimana*.

"I try to get my work into magazines that have a wide readership, to tell my photo stories to as many people as possible. I like the idea that I can draw attention to a situation that is not very well known, and try and do it using an outlet with an influential audience."

Now based in Paris, most of Woods' documentary work is concentrated outside Europe. He has photographed in Afghanistan and Iraq, and is developing an interest in Iran, too. "If I can get a visa, I'm going back there," he says.

He has also taken pictures in Morocco, Egypt, Pakistan, Haiti, and Vietnam. In 2003, with journalists Serge Michel and Serge Enderlin, he produced the book *Un Monde de Brut* (A Crude World) on the subject of oil, which took him to Angola, Russia, Kazakhstan, Iraq, and Texas, US. In 2004, again working with

Tikrit, Iraq, March 2004
Approaching midnight in Saddam Hussein's palace occupied by American forces, GIs play basketball before kitting up and going out into the night with the cry "Let's go and kill the rabbits."

Serge Michel, he produced the book *American Chaos*, a detailed reportage on Afghanistan and Iraq. The books are an unusual mix of travel writing and photojournalism, and look beyond a purely photographic audience. His photographs have appeared in *Time*, *Newsweek*, *Geo*, *Le Monde*, *Le Figaro*, and many other respected international publications.

Woods says: "I was very lucky to meet Serge in Iran and we've been working together ever since. While he was a correspondent in Iran, we discovered we had a very similar vision of photojournalism. It has helped to construct the way I produce my work; I really believe in the relationship between text and images and how this may appeal to a wider audience."

He continues: "I am employed for my particular approach to a story. For me, photography is a language and I try to find a distinct voice. If I am working on location, a magazine may sometimes ask me to do something while I am there which will finance my stay in that place so I can generate a longer-term personal project."

Woods still uses film in the form of a twin-lens Rolleiflex and Hasselblad with a 50mm lens for pin-sharp reproduction. He recognizes the benefits of using subtle equipment in such sensitive environments: "My Rolleiflex is almost silent and not particularly visible; because it looks so antiquated, people think I'm a lost tourist. It is a very subtle machine. What I like about both cameras is that I don't have to shoot at eye-level—they are used from the waist—which means there is nothing between my face and the people I am photographing. Eye contact is important."

Contrary to some photographers' styles—mostly those working in a different photographic genre—Woods doesn't like to be the center of attention when taking pictures. He underlines that shots are hardest to take when he cannot disappear into a situation. "It is important my subjects do not feel I am being intrusive… Some may act differently because they are aware of my presence with the camera. I try to keep this to a minimum."

Because of the success of his images, Woods is excited by the future, especially his plans for documenting Iran. "In the past, I think Iran has been buried in a photographic cliché and I would like to photograph it in a different way; it is very important for me that the real Iran is brought to the attention of those who can effect change."

And, because of the tasks at hand, Woods has to be reactive to situations as they unfold. "My work is never regular. Two months can be absolutely crazy, followed by a month designing a future project, editing, or without actually pressing the shutter button.

"If I wasn't a photojournalist, I wouldn't be in some of these amazing situations I find myself in, or get as close to so many different people as I do.

"Photojournalism is the best excuse to be curious and to fulfil that curiosity. It is somehow a free path to tell the world what is happening."

On the Tigris, facing Beiji, Iraq, June 6, 2003
At Beiji, American bombers avoided the biggest refinery of the country, but not two bridges. The road bridge is out of use, but pedestrians continue to use the railway bridge, of which only one segment has collapsed.

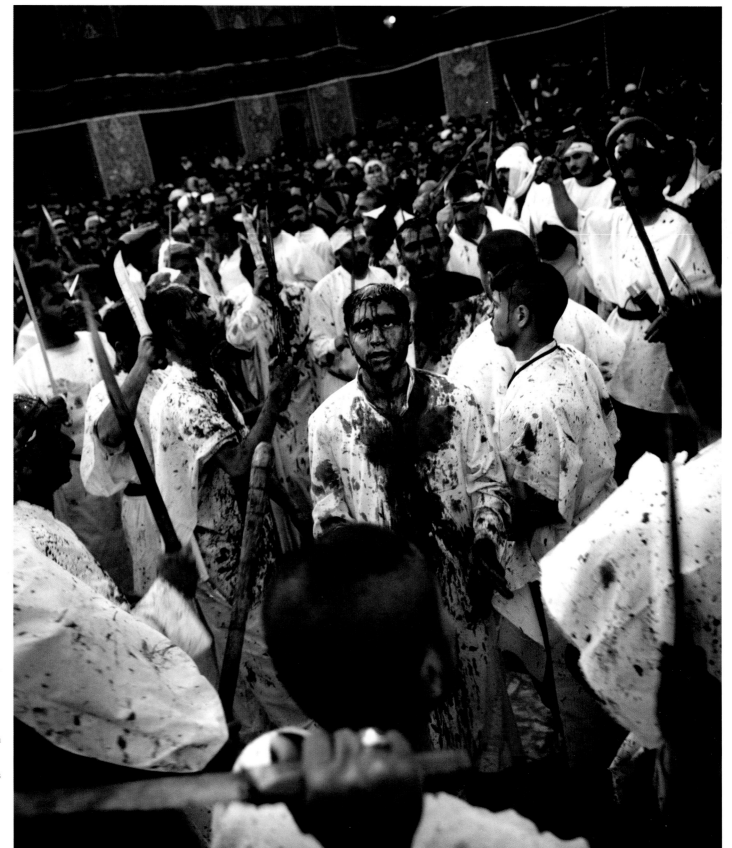

Karbala, Iraq, March 2004
At dawn on Ashoura, after days of prayer, processions, and mortification, passionate believers among the Shiite Muslim community cut their skulls with knives in a ritual emulating the suffering of Imam Hussein, killed 13 centuries ago by the Sunnis on the Plain of Karbala. "A few hours after this photo was taken, four bombs went off in Karbala, killing at least 120 Shia pilgrims in what is regarded as one of the most deadly attacks and the start of the sectarian violence," says Woods.

170

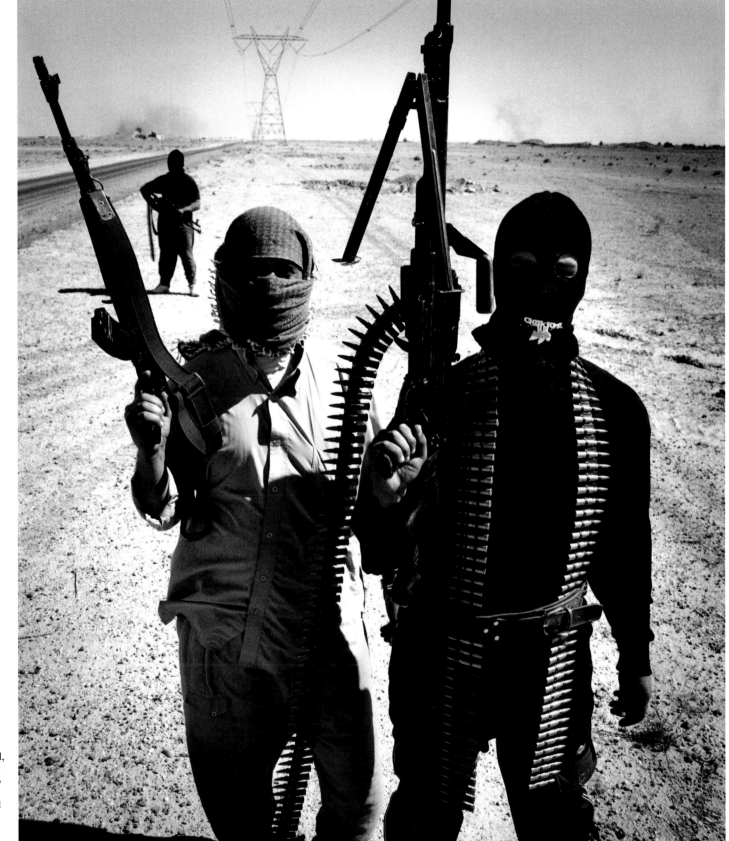

In the desert near Falluja, Iraq, April 2004
"At al-Garmagh, we were captured by a group of resistance fighters and taken into the desert to be executed, only to face a last-minute reprieve," remembers Woods. "The leader, Ahmed, explained, before agreeing to pose for this photograph: 'We don't want to hurt you, we only want to kill Americans.' We were informed that the man on the left of the photograph was killed later the same day in the fighting around Falluja."

Paolo Woods

Afghanistan, March 2002 *(left)*
A crowd gathers to celebrate No Ruz, the Afghan new year. It is 1381 in their calendar and the first time in years that members of the Shia community can freely celebrate this festivity of Persian origin that had been repressed by the Taliban.

Baku, Azerbaijan, March 2003 *(left)*
Shia faithful climb toward the mausoleum of Bibi Heybat on the day of Achoura, which commemorates the lost battle against the Sunnis. In the background are the largest mosque of Baku and the largest offshore oil platform of the Caspian under construction.

Baku, Azerbaijan, March 2003 *(above)*
Swimming in black gold, only possible in Baku. The Naftalan clinic advertizes its crude oil baths as a cure for arthritis, rheumatism, spondylitus, eczema, sciatica, infertility of the ovaries, and radiculitis. Azerbaijan is one of the oldest producers of oil and its people venerate it in an almost religious manner. Unfortunately, oil has cast its blessings on only a fraction of the population, while most still live in poverty.

**Kabul, Afghanistan,
November 2003**
In 1979, the Russians built an
Olympic swimming pool on one
of the hills overlooking Kabul.
The swimming pool had been
completed just months before
the Russian invasion of the
country. It has never been filled
with water and never been used.
The children of Kabul come and
hang around here and play
with kites.

Paolo Woods

Picture Credits and Directory

Church sign outside the town of Justice, West Virgina, from "Hillbilly Heroin" *(opposite)*
Zed Nelson

The sign reads: GREENBRANCH FREE WILL BAPTIST CHURCH — A CLEAN CONSCIENCE MAKES A SOFT PILLOW

This book is produced in gratitude to the photographers whose pictures and sense of justice continue to influence millions of people throughout the world. None of this would have been possible without their unselfish support; many of them have given their precious time and images to enable me to author this book.

Although I cannot mention all of them, I embrace their much valued contribution and offer my respect and help in return. I feel very privileged to share their work with so many.

I simply cannot forget the assistance I received from numerous lab and image library staff from around the world, who have supplied such excellent photographic material and whose professionalism I have come to rely upon many, many times.

To all the friendships I have—both personally and professionally—for collectively being my drive to overcome stressful hurdles. I've learnt so much from putting this title together, in particular underlining my already deep passions for photography—and its politics.

My particular thanks go to Jenny, Karen, and Becky, whose love, patience, and understanding throughout the past year have enabled me to find the motivation to complete a small lifetime ambition.

And, finally, a special thanks to my late father Chas, for his overwhelming love and encouragement, which has deeply touched my life and career. I am so proud of your courage and fighting spirit. You will live in my heart forever.